American Style

American Style

Classic Product Design
from Airstream to Zippo

Written and Photographed by
Richard Sexton

Designed by Thomas Ingalls

CHRONICLE BOOKS • SAN FRANCISCO

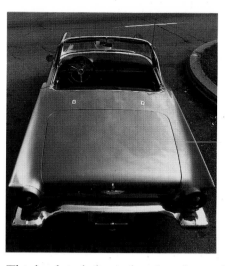

This book is dedicated to the aficionado of material culture and the all-too-often misunderstood concept: *Materialism.*

Printed in Japan.

Library of Congress Catalog in Publication Data
Sexton, Richard.
 American style.

Includes index.
1. Design, Industrial — United States — History.
I. Title.
TS23.S49 1987 745.2′0973 87-882
ISBN 0-87701-392-6 (pbk.)

Editing: Deborah Stone
Book and cover design: Thomas Ingalls + Associates
Designers: Thomas Ingalls and Gail Grant
Composition: On Line Typography

Black and white photo retouching:
Charles Mize Studios
Photo montages of Frisbee, A-2000 baseball glove,
Chris-Craft motor boat: Sieg Photographics

Distributed in Canada by:
Raincoast Books
112 East 3rd Avenue
Vancouver, B.C.
V5T 1C8

10 9 8 7 6 5 4 3 2 1

Chronicle Books
One Hallidie Plaza
San Francisco, CA 94102

CONTENTS

ACKNOWLEDGEMENTS

This book involved the arduous task of executing original photographs of all the products selected. This process would not have been possible without the help and expertise of a number of individuals. My sincere thanks go to all the people listed below, without whose contribution this project would never have happened.

For sharing their expertise in their fields and for advice on product selection:

Jemison Beshears
Inez Brooks-Myers, Mickey Carpas; History Department, The Oakland Museum
David Dutra
Tim Fritz, Al Miburn; Bananas at Large
Russ Goddard, Wayne Garcia; The Audible Difference
Michael Heller
Laura Katz
Robert Mainardi
Jan Alff Wiegel

For valuable assistance in locating products to be photographed:

Albera Bros. Jeep, San Francisco
Mickey Carpas
Corvette Body & Service Center, San Francisco
Empire Sailing, San Rafael
Michael Heth
Gordon Larum, Shasta Beverages
John Moore

For the generous loan of products:

Air Ambulance: Lear Jet
American Rag Cie: Tuxedo
The Audible Difference, Palo Alto: audio components
Bananas at Large, San Rafael: musical instruments
David Barich: Advent radio
Bay Area Airstream, Santa Rosa: Airstream trailer
Bay Bobcat, Fremont: John Deere lawn tractor
Mike Blumensaadt: IBM Selectric
Henry Brimmer: Eames chair
Cine Rent West/Stage A: Panaflex camera
Bill Cowsert: McIntosh amplifier
George Ernstson: Hamilton Beach Drinkmaster
David Fanelli: Ford Thunderbird
Groger's Western Store: Stetson hat
Marti Grossman: Ford Mustang
Tom Grossman: Corvette
Russell and Margaret Heath: Hobie Cat 16
Michael Heller Store, San Francisco: items of clothing
Thomas Ingalls: Osterizer blender
James Langley: Schwinn bicycle
John Leavitt: Chris-Craft
The Magazine, San Francisco: all periodicals
Al Milburn: Fender Bass
Ted Moore: Jeep Cherokee
Par Interval, San Francisco: Philco Predicta, Diamond chair
Park Presidio Marine, San Francisco: Mercury outboard
Dudley-Perkins Co., San Francisco: Harley-Davidson motorcycle

Photographer's Supply: photographic items
James Ross: Boston Acoustics speaker, Kodak disc camera, Stanley Ratchetdriver
San Francisco Gun Exchange, San Francisco: Colt .45 revolver
Mrs. Clayton Sexton: American Modern dinnerware, Tupperware
Sierra Designs, San Francisco: Stretch Domicile tent
Jeff and Brenda Teel: Kitchen Aid mixer
Paula Tevis: Head tennis racket
Twentieth Century Furnishings: Nelson bench, Rohde table, Smokador
Valencia Cyclery, San Francisco: Kryptonite bike lock
Whole Earth Access, Berkeley: housewares and tools

For assistance with the photography this project entailed, I'd like to thank Kazuya Tsubata and Cheming Chiang, who participated through The Academy of Art College internship program.

And finally I'd like to thank all the manufacturers who researched their archives and supplied valuable information about the products included here.

THE PRODUCT NARRATIVES

Each product featured in this showcase has an accompanying narrative divided into two parts—a descriptive commentary, followed by factual data. The descriptive commentary consists of personal comments; brief forays into company, product, and designer history; user testimonials; and other trivia which I hope will be of interest. The factual data briefly details information about the product identification, manufacture, design credits, and date of introduction or design. This information was obtained directly from the current manufacturers, who responded to a questionnaire. Most of the information is not a matter of public record and therefore cannot be corroborated independently. As important as this factual information may seem now, in many cases it has been lost or scattered in company files over a period of time. Where factual information is not given for a particular product, none could be uncovered by any practical means or the accuracy of the information was questionable. I would rather omit information than supply incorrect information.

The products chosen for the photographs are not necessarily the best or most classic of their type or manufacturer. With many of the product selections, the manufacturer's entire product line is notable. For instance, the Revereware saucepan that illustrates the Revereware narrative is not meant to be singled out as the most outstanding piece in the line; it is merely an arbitrary, but representative, example. Wherever known, specific model numbers, colors, size, and so on, are given for the product photographed.

The name of the original and current manufacturers of a product are included in the factual information. Some products have had numerous manufacturers during their production life. There are many reasons for changes in a product's maker— some are merely name changes, some result from buy-outs and takeovers, and some product designs or product names are sold to other makers. Because these changes can be frequent and complex, no explanations are attempted for changes in manufacturers.

The design credit for each product lists the name of the person(s) responsible for the creation or development of the product. Because many people may have collaborated on different aspects of a product's design, establishing unabridged credit for a product can be extraordinarily difficult. Few products are conceived, designed, and marketed by a single individual. Rather than leave out credit information because of the impossibility of determining the names of all the individuals involved, I have credited the individual(s) who were an important part, but not necessarily the total part, of the creative process behind the product's existence.

The relevant dates in the product's history have been included; where exact dates are not known, qualifying language is given.

FOREWORD

American Style is a subject that has intrigued me all of my life. As a boy growing up in Munich and later as a student in London, my imagination was stimulated by the great accomplishments of American industrial designers—people like Henry Dreyfuss, Gustav Jensen, Gilbert Rohde, Raymond Loewy, and others. In fact, much of the European design community looked with intense interest (and perhaps some alarm) at the great strides being made across the Atlantic.

When I first arrived in America back in the late thirties, I was predictably impressed with both the quantity and quality of the work being done by these pioneer American designers. But to my delight, I discovered that there was still room for a young and eager designer like myself. In fact, I discovered that from my distant vantage point in Europe I had only seen the bright lights. Now that I was immersed in the great American marketplace, I could see that there were vast areas that still required illumination. There was much work to be done.

But what really surprised me was that America seemed unaware of its many accomplishments and continued to look back to Europe for direction. Perhaps it was because the objects expressing the new American style were so ubiquitous—the now-famous Campbell's soup can or Coca-Cola bottle, for example—that it didn't occur to many American observers that they were consciously designed. Whatever the cause, the ironic fact remained: what the Europeans looked at with envy, Americans took for granted—or worse—even denigrated.

Unfortunately, this attitude prevails to this day. Too few Americans are aware of the great contribution American industry has made to the field of design, which is why I am so delighted that the creators of this book have assumed the difficult task of taking, evaluating, and distilling mountains of photographs, so that you, the reader, could discover and enjoy the essence of American Style.

As you peruse these pages, you will stumble on many old friends—your first bicycle, a toaster or coffee pot that conjures up your school days, perhaps the Mustang car that took you on your honeymoon. And while I am not opposed to your indulging in a little nostalgia, I urge you to take the opportunity to *see* these objects in a new light—as design, as a form of art. The great advantage of having a book like this is that it places the familiar in a different context, forcing us really to evaluate it, perhaps for the first time. It's a bit like finding a toaster in an art museum, handsomely spotlighted and mounted on a block of Carrara marble.

So, think of this book as a stimulant to your aesthetic sense. When asked to address design students I often remind them to go through life looking—really looking—at everything around them, every product, every package, every piece of furniture, even the designs on manhole covers. It's a wonderful exercise and an exhilarating way to go through life.

Whether you are a professional or an amateur, student or a connoisseur, allow your eye to roam the shapes and contours of the objects illustrated in this book. I assure you that you will gain a new appreciation for American Style.

And if you are in marketing I'm certain you will find it inspiring to see how effectively design has served commerce and industry in the past. You are sure to benefit from the timely reminder that we have a fine tradition to build upon. We have only begun. There is abundant evidence that design appreciation is a fast-growing force in the world. Manufacturers are introducing better designed products to an increasingly competitive global marketplace. Packaging has become even more critical to the marketing success of the thousands of new consumer products introduced every year, and corporations are keenly aware of the importance of well-designed corporate identity systems that enhance their presence in an ever more crowded and visually "noisy" environment.

But perhaps this collection will be most rewarding to those whose interests are neither professional nor commercial. For those who are interested observers of the American scene, the illustrations on the following pages offer the greatest reward of all—an opportunity to celebrate the diversity, exuberance, and anything-goes attitude that has always been the hallmark of our national character.

WALTER LANDOR

INTRODUCTION

This collection comprises some 130 odd products, the great majority of them still produced in some form, that embody an American Style; even those products no longer produced remain very much a part of the contemporary age by virtue of their collectibility and their design influence on contemporary products. While Eurostyle is a phrase used to describe a specific style of design, the essence of American Style remains more elusive. Less common here, European products have the advantage of being more easily perceived in contrast to their American counterparts; this, unhappily, causes many of them to be labeled as "better" rather than simply "different."

Masked in domesticity and not easily recognized, American Style seems imperceptible; from our perspective of intense familiarity, it is difficult to appreciate the common objects we see and use everyday. Defying description, any definition of American Style is frustratingly elusive and riddled with exceptions. Trying to define it is like trying to define art.

One important aspect of American Style is that its design seldom comes off as a tribute to design for design's sake. An innovative "aesthetic envelope" can sheath fairly mundane technology, but with American products like the Bell telephone or the Kitchen Aid mixer the emphasis is on function and durability. Another important aspect of American Style is manifested in its generous use of raw materials. American products like the Airstream trailer or Zero Halliburton luggage have a carefree quality of unconcern about the raw materials that go into them. By contrast, European and Japanese designers seldom are afforded this luxury with a mass-produced item because of their high cost of raw materials.

Perhaps American Style's most dramatic quality is the way it has influenced the culture and lifestyle of everyday Americans. Products like Coca-Cola and Levi jeans, the Weber grill and the Ford Mustang have simultaneously evolved a way of looking at ourselves and created needs that otherwise might not have existed. Another important aspect of American Style is the "better mousetrap" approach to product design. This approach favors radical redesign over incremental refinement of traditional methods. Products like the Zeroll ice cream scoop and the Steinberger bass are examples of radically designed products where there were no preconceived notions of how the product should look or work before the design process began.

My original inspiration for doing this book came from simple products like the 5-in-1 tool, a generic tool that does five different things. Its elegant yet unconscious design makes this tool useful for scraping paint, removing putty, and cleaning paint rollers, among other tasks. Perhaps because it is both simple and inexpensive (it probably costs no more to man-

ufacture than an ordinary scraper), we seldom stop to contemplate its sculptural shape or its ability to perform a variety of functions.

Another source of inspiration to me came from products like the traditional rural mailbox. Although mailboxes are found all over the world, the American version is visually unique. Its functionality is affirmed by more than fifty years of use without any design changes; its durability and changelessness have made it an icon of rural America. The iconographic stature of the traditional mailbox led me to realize a major facet of this project: that while on one level this book is a design showcase, on another it attempts to examine American culture through the window of product design.

Because America is perhaps the ultimate consumer society, what better way to examine its culture than through its products? We have been exhorted from earliest youth through a barrage of ceaseless advertising to consume, consume more, consume the best. Wherever possible, the products in this collection focus on the trends the American consumer has established and the contribution of our products to the milieu of Western civilization, however dubious that contribution may be considered among intellectuals. As mercilessly as excavated ruins expose past cultures, we are exposed at the local department store.

In undertaking this project, I do admit to having an axe of my own to grind. Americans lust after German cars, Italian light fixtures, Danish stereos, and Japanese cameras without considering the quality, technically and aesthetically, of products manufactured here. This prejudice does not exist only in consumer circles. The product design collection of New York's Museum of Modern Art is heavily weighted toward European designers' work. While I realize it is not the intention of MOMA to assemble a provincial American collection of product design but rather an international one, even so, many American designs deserving of international stature have been left out or underexhibited.

The curating of the Museum of Modern Art's product design collection favors the monodimensional criterion of the aesthetic envelope, the aspect of a product's design that art historians feel most qualified to judge. Museums like the Smithsonian Institution or The Oakland Museum's Cowell Hall of California History, on the other hand, curate their collections based on artistic, cultural, and historical criteria, thus creating a balanced, multidimensional view of a product's significance in the marketplace. Because the artistic merit of the aesthetic envelope isn't the only consideration, the curators of these collections have greater latitude in selecting products, free from concern about offending design intellectuals. Consequently, more of the creativity within the design process can be rewarded.

The current generation of American consumers, having ripened in an atmosphere of prosperity and unprecedented exposure to television advertising, subscribes to the belief that European craftsmanship and design are superior to their American counterparts. With a propensity greater than any previous

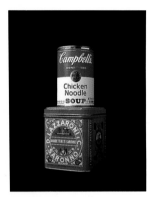

**Campbell's Soup
& Amaretto Cookies:**

American vernacular designs compare favorably to their European counterparts. Witness this comparison between two products of American and Italian provincial design. The Campbell's Soup Can has a clean, simple design that in many ways is more pleasing than its cluttered Italian counterpart.

generation of Americans, they aspire wholeheartedly to ownership of foreign goods. Often well aware of the design legacy of the German Bauhaus, this generation of consumers is often ignorant of the legacy of the American Shakers, whose simple style has quietly influenced subsequent generations of American design.

With their religious beliefs thoroughly intertwined with their pursuit of arts and crafts, the Shakers developed such significant designs as the flat broom, beautifully minimal furniture, and a timelessly contemporary architecture. The Shakers' religious credo decried ornament as evil and wasteful and touted simplicity as virtuous; they opposed the trend of excessive ornamentation that prevailed during their time. The Bauhaus later served primarily as a focal point for mainstream design trends evolving on an international scale during the first half of the twentieth century, nearly a century after the Shakers. Shaker design rhetoric, like the "form follows function" rhetoric of the Bauhaus, still holds up remarkably well on many levels today, yet the religious and socio-political implications of both are questionable: In today's world, form following function is not any more "correct" politically than any other design philosophy, and ornamentation, far from being inherently evil, can have a function of its own.

The word *potpourri* is probably as good a description as any for the products included here. As varied as the range is, I felt it to be essential that the products included derive their design essence from the American Style. Many worthwhile products designed and manufactured in the United States but which derive their design essence elsewhere have been excluded. Because it is impossible to cover all the worthwhile products in all the categories, there are some notable omissions from this volume: the Singer sewing machine, the Parker 51 pen, and the Chrysler Airflow are a few. (However, the possibility remains open for that great American creative exploit—the sequel.)

For instance, the Ford Mustang appears in these pages because, apart from its striking and enduring design, it is an important part of American automotive history—the first pony car. The Pontiac Fiero, although well designed, does not turn up here because its pure Eurostyle has few redeeming *American* features. With an Italian name and primarily Euro engineering innovations, it is the American offspring of European mid-engine sports cars such as the Porsche 914.

One criterion not applied to the products in this collection but important in institutional design showcases is that of originality, the search for the true innovator. For instance, Apple's Macintosh computer appears here, while the short-lived Lisa computer, the true innovator, does not. The first computer to use the mouse, pull-down menus, and the innovative software the Mac later borrowed, the Lisa was not a commercial success. Towards the end of its short production cycle, the Lisa's name was changed to the Macintosh XL in an effort to link it to the more popular Mac. The Macintosh system put the technology developed by the Lisa to use in a smaller, simpler, and less expensive computer that could be mass

marketed more effectively.

Also, I did not consider the involvement of a professional product designer important to the merits of the products included here. In my view, all products are designed, whether consciously or unconsciously, whether by professionals or amateurs. Many of the products in this book were designed by product designers; many were not. A striking example of unconscious—or vernacular—design versus intellectual—or professional—design can be observed by contrasting Camel and Lucky Strike cigarette packaging. The Camel pack was "designed" by a hodge-podge of individuals, most of whom remain anonymous and who lacked any formal training in design, the arts, or marketing. The Lucky Strike pack, however, was designed by the most famous product designer of his day and perhaps of all time, Raymond Loewy. As he did with all commissions, Loewy carefully and analytically thought through his assignment and applied his vast experience in product design. His highly successful result is an outstanding example of the effect of simple redesign on product sales. Despite the enormous differences in process, both Camel and Lucky Strike packaging are appropriate; having stood the test of time, they have become icons in the marketplace.

One criterion I did impose, however, that many design showcases lack was to integrate the aesthetic envelope with the product's other merits—I felt no product merited inclusion based solely on its aesthetic envelope. For me, the word *design* refers to all aspects, both aesthetic and technical, of a product; I use the word *styling* to describe a product's looks and the word *engineering* to describe a product's functional apparatus. Design, at least by my definition, is an inseparable blend of styling and engineering where both qualities intertwine and, when properly executed, lift the product to pantheon status. The quality of a product's design should be evident whether you are admiring it or using it. The Zippo lighter, for example, possesses a visual, timeless elegance; it is extremely reliable; comes with a lifetime guarantee; and, perhaps most important, using it displays a cultivated dexterity that has been, for decades, a nuance of personal style. All of these attributes I consider intrinsic to any truly pantheon product.

Among other things, I hope this book will serve as a reminder that American product design is not *inferior*, as some think, nor Japanese and European design *superior*. I hope the products included here have the universal appeal the criteria used to select them theoretically cultivate. The book will be successful in my mind if the design intellectual, the collector, the materialist, the historian, the sociologist, and the patriot in each of us is intrigued.

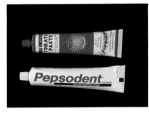

Pepsodent & Italian Tomato Paste:

The common perception is that European designs possess a sleek and elegant "designer look" that American products lack. However, comparing the Pepsodent toothpaste tube, designed by Raymond Loewy in 1945, to an Italian tomato paste tube, it is obvious that the opposite is often true.

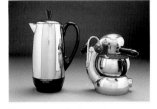

Farberware & Atomic Espresso/Cappuccino Maker:

Here are two contrasting coffee maker designs of the streamlined modern style: the Farberware percolator and the Atomic Espresso/Cappuccino maker. In an interesting comparison, the completely automatic Farberware exemplifies an American tradition of easy-to-use, neophyte-proof design, whereas the Atomic espresso maker appears as complicated to operate as it really is.

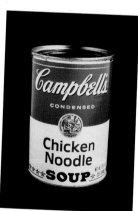

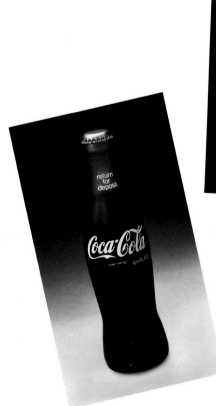

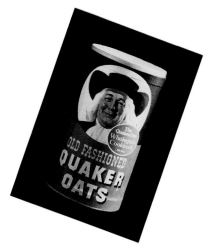

CONSUMABLES

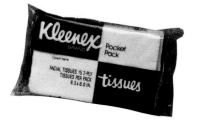

The packaging, marketing, and development of consumable products is an area of unparalleled American expertise. Few cultures rival the uninhibited success of America in this arena. The recognition of brand names is truly astounding, and brand names, in many cases, have become synonyms for a type of product. For many Americans, the term *Hershey bar* means "a chocolate bar" and Kleenex long ago passed into the lexicon, synonymous with "disposable tissues."

American consumers grow attached to their brands and have, on occasion, raised a hue and cry when one is tampered with or changed. They have come to be as possessive of the Quaker Oats man and the Arm & Hammer trademark as they are of the American way itself. Brand names are so pervasive that experts tell us that we cannot live a day of our lives without encountering the Coca-Cola logo. In their pervasiveness, brand names take on added meaning; for example, the Campbell's Soup Can has come to rival significant works of art in iconographic value.

The Old World may have been responsible for much of the substance of classic consumables—chocolate, whiskey, and oatmeal came to us via Europe—but American ingenuity was responsible for marketing and packaging these products with a distinctive flair. The open-shelved, self-service store is an American innovation developed by F. W. Woodworth in 1875—the ubiquitous dime store. Packaging, as we know it today, which serves the dual function of container and sales lure is also an undeniably American concept. Generic goods such as baking soda and oatmeal were being sold here in nifty containers picked by the consumer from open shelves, while in Europe similar items were still being sold in bulk. Ultimately, a combination of the American self-service and packaging concepts helped create an entire nation of insatiable consumers.

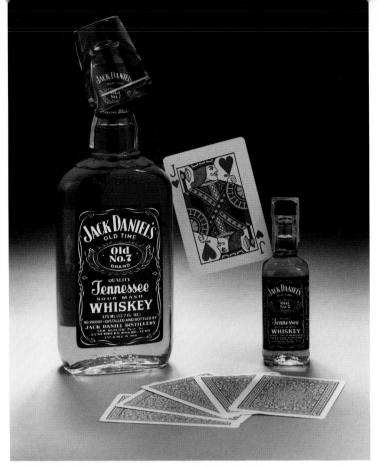

Jack Daniel's Whiskey, a local favorite at the White Rabbitt Saloon in Lynchburg, went on to international success.

Jack Daniel's Whiskey

Jack Daniel's Whiskey has been made in Lynchburg, Tennessee since 1866. The Jack Daniel distillery, the oldest registered distillery in the country, has the added distinction of being on the National Register of Historic Places.

Jasper "Jack" Newton Daniel began selling his sour mash whiskey bottled in a cork-stoppered, glazed pottery jug. The bottles and jugs used for bottling Jack Daniel's Whiskey are widely collected by bottle and label collectors. Prior to the first paper labels, which appeared after the turn of the century, all bottles used plate-mold embossing for labeling. Something about the Jack Daniel contemporary label and bottle design conveys the ambience of a nineteenth-century product from a small town in the hills of Tennessee. In a vernacular way, the black and white label is perfectly designed for the type and style of product in much the same way that the Campbell's Soup label is perfect for its product.

No one is quite sure where the product name, Old No. 7, came from, but it first appeared on a pottery jug in 1887 and has been used ever since. Jack Daniel's Old No. 7 Brand Whiskey has won several awards for excellence over the years. The charcoal mellowing process removes the taste of corn and gives Jack Daniel's its distinctive flavor. This process makes the product a Tennessee whiskey—not to be confused with Bourbon, also made from corn. Since 1866, as Jack Daniel would have wanted it, a Tennessean has been in charge of the still house at the distillery.

Product: Jack Daniel's Old No. 7 Brand Tennessee Sour Mash Whiskey, 375 milliliter oval and 50 milliliter bottles

Manufacture: Jack Daniel Distillery

Design Credit: Developed by Jack Daniel, company founder

Date: Introduced in 1866; current bottle shape first appeared in 1895; first use of paper labels circa 1906

Jim Beam Bourbon

Jacob Beam began making Bourbon whiskey in 1795. This whiskey-distilling tradition began in Kentucky when Pennsylvania settlers were faced with a new whiskey tax. Rather than pay it, they fled to Indian country in the backwoods of southern Indiana and Kentucky. There they found water filtered through limestone rock, whose clear, sweet quality made for perfect whiskey-making. The whiskey they distilled from corn instead of grain produced a sweeter, lighter bodied whiskey than Pennsylvania rye whiskey. This corn whiskey gained renown and demands for it increased. The rest is, as they say, history. In 1964 Congress declared Bourbon—named after Bourbon County, Kentucky—a distinctive American product.

The distillery Beam's family has run for six generations forms a major part of the legend surrounding Kentucky whiskey-making; the Beam family has steadfastly maintained the Bourbon formula developed by Jacob Beam. Col. James B. "Jim" Beam, the member of the Beam family for whom the Bourbon is named, was Jacob's great-grandson. He was the fourth generation leader of the family business and successfully guided the company through the troubled years of Prohibition.

Product: Jim Beam Bourbon, liter bottle

Manufacture: Originally manufactured by Jacob Beam, distiller; currently by James B. Beam Distilling Co.

Design Credit: Development of Bourbon whiskey attributed to Rev. Eliza Craig; the Beam Bourbon formula developed by Jacob Beam

Date: Introduced in 1795

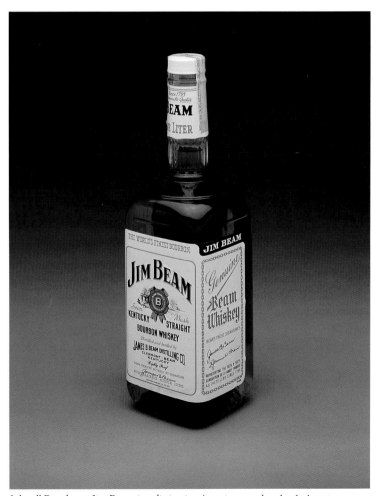

Like all Bourbons, Jim Beam is a distinctive American product by declaration of Congress.

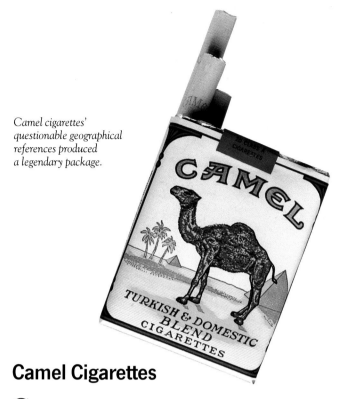

*Camel cigarettes'
questionable geographical
references produced
a legendary package.*

Camel Cigarettes

Camel Cigarettes remained at or near the top of American cigarette sales for forty years; they were seriously challenged only by Lucky Strike. Introduced in 1913, the cigarettes' intended name, Kaiser Wilhelm Cigarettes, was vetoed by R. J. Reynolds himself. Showing the insight on which he founded his empire, Reynolds declared, "I don't think we should name a product after a living man. You never can tell what the damn fool will do." The name Camel, chosen instead, emphasized the Turkish tobacco the cigarettes contain (the tobacco blend in Camel has come to be known as the "American blend"), even though the pyramids in the pack illustration's background could not be in Turkey.

Camel's legendary package design was supplied by the Richmond, Virginia lithographer who printed the pack. While the overall design met with approval, the camel illustration was not appealing. Convinced that a real camel looked different, Roy Haberkern, Reynolds' secretary, went down to the Barnum & Bailey Circus, which had arrived in Winston-Salem on September 29, 1913. With a photographer in tow, Haberkern arranged to photograph "Old Joe," a one-humped dromedary. From that photograph the Camel illustration was created; it has remained an integral part of the package design ever since.

In 1958 Reynolds' executives decided, disastrously, to "update" the classic Camel pack. The outrage was so immediate and vociferous — R. J. Reynolds, Jr. angrily sold a chunk of his company stock to protest the move — that the directors reinstated the original Camel pack. On reflection, naming a cigarette after a camel is rather tenuous, but somehow it always fit, as did the illustration on the front. There is a certain "rightness" about Camel that defies intellectual analysis, an indication that the Camel pack is an example of vernacular design at its finest.

Product: Camel Cigarettes

Manufacture: R.J. Reynolds Tobacco Co.

Design Credit: Developed by R. J. Reynolds, president; package design supplied by Richmond, Virginia lithographer; camel illustration based on photo of Barnum & Bailey circus camel

Date: Introduced in 1913

American Style

Lucky Strike Cigarettes

Lucky Strike Cigarettes were introduced in 1916, the brainchild of American Tobacco president George Washington Hill. A blend of Burley and Bright tobaccos specially formulated to compete with Camel and Chesterfield brand cigarettes, the name for the new cigarette was taken from a popular brand of pipe tobacco of the time. In April 1940, Lucky Strike Cigarettes were sold in a new pack—the same pack in use today—redesigned by Raymond Loewy. Where the old Lucky pack was green and had the target logo on one side only, Loewy made the pack white and in a stroke of genius put the logo on both sides, so that it could be seen twice as often. These subtle changes made all the difference. Sales increases were immediate and sustained, in one of the more dramatic examples of the effects of package design on product sales.

Loewy built an international design practice and a reputation as the most "famous" product designer in the world from humble beginnings as a window dresser in a New York department store. Though Loewy referred to himself as an industrial designer, he might be more accurately described as a *re-designer.* (Other Loewy design classics include the Sears Coldspot refrigerator, the Avanti sports car, and the S-1 locomotive.)

The Lucky Strike commission came during Loewy's prime. Considered by many historians of industrial design to be one of his landmark designs, the Lucky Strike makeover is a perfect example of what Loewy did better than anyone else: His subtle design changes in existing products precipitated quantum changes in the marketplace. Lucky's, aided by their sublime package, are a true classic.

Product: Lucky Strike Cigarettes

Manufacture: American Tobacco Co./Div. of American Brands

Design Credit: Developed by George Washington Hill, American Tobacco president; Raymond Loewy redesigned existing package

Date: Introduced in 1916; current package design introduced in 1940

Lucky Strike's package design hit the target.

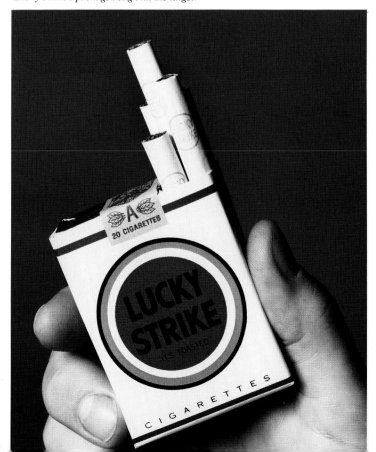

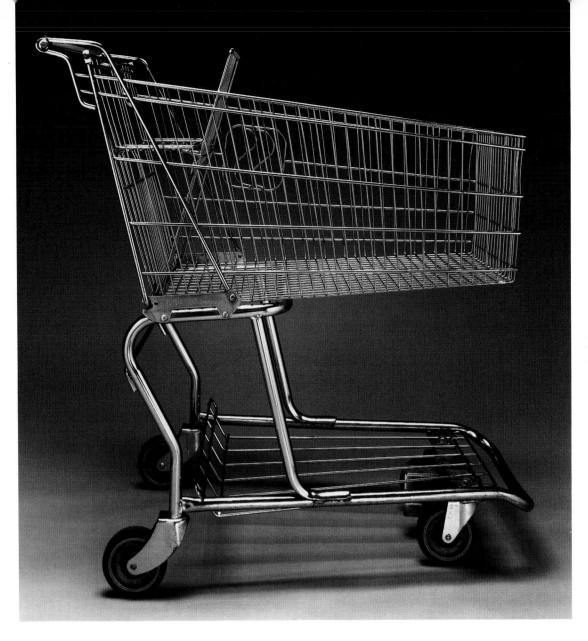

*It is difficult to imagine
what life was like
without the Shopping Cart.*

Shopping Cart

The shopping cart is one of those rare products whose development changed the lives of shoppers forever. It has been featured on the covers of *Life, Look,* and the *Saturday Evening Post.* The original shopping cart is on display at the Smithsonian.

Supermarkets began to take shape following World War I. At first, three independent concessionaires (usually meat, produce, and processed foods) shared floor space. Later all these departments were consolidated under single ownership and management. However, there was a vital link missing in the supermarket formula: the shopping cart. The important innovations of the supermarket were self-service and one-stop shopping. The shopping cart was vital to both.

The shopping cart was the brainchild of Sylvan M. Goldman, an Oklahoma grocery chain owner, who realized the need for such a product during the Great Depression. Before shopping carts, shoppers used hand-carried wire or wicker baskets for their purchases. Goldman was inspired by the folding chair to develop a folding device with wheels that could hold two hand-carried wire baskets. At check-out, the wire baskets could be stacked away (as they always had been) and the folding carrier collapsed and poised for reuse by the next customer. The shopping cart rapidly evolved from this beginning to the cart we are familiar with today, the Nest Kart, introduced by Goldman's company in 1947. The child-carrier, a Nest Kart feature, was

not a Goldman brainstorm but was added out of necessity because mothers had been observed almost from the outset sticking infants in with the groceries on the baskets of earlier carts. Fearing lawsuits Goldman's company incorporated the child-carrier in the Nest Kart.

Goldman went on to devise other carts and carriers used in the grocery business for stocking shelves and transporting merchandise. He redesigned check-out stands to better accommodate the shopping cart and expedite check-out. Goldman also developed the luggage carts used at airports. In his later years, Goldman received quite a lot of publicity for his shopping cart invention and was interviewed by Charles Kuralt for CBS Television. His life story was chronicled in the book *The Cart That Changed the World* by Terry Wilson, University of Oklahoma Press.

Product: Unarco Shopping Cart

Manufacture: Originally manufactured by The Folding Basket Carrier Co.; currently manufactured by various companies; shopping cart pictured manufactured by Unarco Commercial Products, the largest manufacturer and the descendant of the original manufacturer

Design Credit: Sylvan N. Goldman, inventor and product developer

Date: Designed 1936 and first introduced in 1937; Nest Kart, the contemporary shopping cart design, introduced in 1947

Coca-Cola

During its steady climb to international popularity, Coca-Cola was packaged in a variety of containers, but the 6.5-ounce returnable bottle is the package that attained iconographic status. Its elegant contours perfectly complement the universally recognized script logo. Among Coke connoisseurs, the Coke packaged in the 6.5-ounce bottle is *the* Coke to buy: The cola formula in the smaller bottle is rumored to contain a greater percentage of syrup. Although more than 99 percent of the ingredients of Coke are known, the mystery ingredient, referred to as Merchandise 7X, has defied analysis by chemists and competitors for more than eighty years. A vault at the Trust Company of Georgia in Atlanta contains the secret formula.

The creation of Dr. John Pemberton, Coca-Cola was first served on May 8, 1886 at Jacob's Pharmacy in downtown Atlanta. It contained both coca—the stuff from which cocaine derives—and caffeine and was sold as a medicinal beverage. Asa Chandler, the man who turned Coke into an international commodity, first tried it to relieve a headache. A letter circulated to soda fountain operators in Nashville, Tennessee by Asa himself reveals another Coca-Cola secret—that of Coke's phenomenal marketing success:

> Now to any retailer or soda fountain man who will allow me to issue 128 of these free cards which will require 1 gallon (128 ounces) of Coca-Cola syrup, I will send gratis 2 gallons of Coca-Cola syrup... Then if he will send me the names of 128 ladies or gentlemen I will mail them each a free ticket to his fountain and he will have as compensation 128 more ounces to sell to those who will certainly want more. Now I don't want to make a merchant or peddler out of you but if you could either send me the name of a party who wants to engage to introduce it into Nashville (the best soda fountain town South I am told) I will make it interesting to him. I enclose circulars. It is a fine thing-certain.

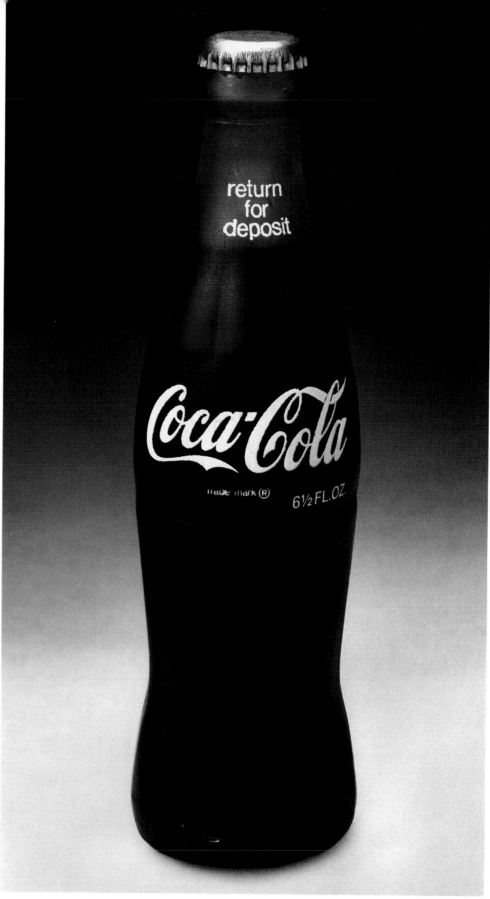

According to Coca-Cola, 90 percent of the world's population recognize this bottle.

Product: Coca-Cola, 6.5-ounce returnable bottle

Manufacture: Coca-Cola Co.

Design Credit: Coca-Cola beverage invented by Dr. John Styth Pemberton; bottle pictured first designed by Alex Samuelson and T. Clyde Edwards; Raymond Loewy later redesigned the bottle, making it more slender; the script logo changed from embossed lettering to white paint

Date: Beverage first sold in 1886; bottle design dates from 1915

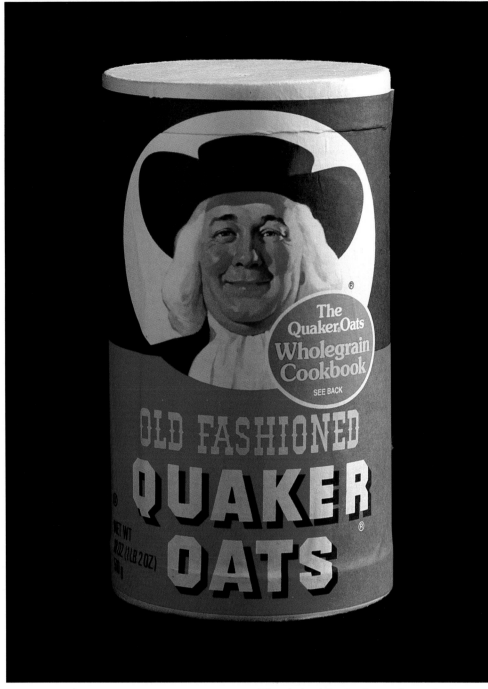

The cylindrical Quaker Oats package is familiar to generations of Americans.

The true merit of Quaker Oats is evident on the grocery shelf. Its cylindrical shape creates a distinctive contrast to the rectangular boxes of other cereals. The package design extols homespun and nutritional virtues, unlike the cereal packaging designed to appeal to children. The company's commitment to the design gives the product a timeless feel.

Product: Quaker Oats, 18-ounce tube

Manufacture: Originally manufactured by Quaker Mill Co.; currently by Quaker Oats Co.

Design Credit: First use of the Quaker name and trademark attributed to Henry Seymour, partner of Quaker Mill Co.

Date: Quaker trademark registered in 1877; current Quaker Man illustration introduced in 1957

Arm & Hammer Baking Soda

The familiar "arm & hammer" logo was originally used by Vulcan Spice Mills on spice and mustard products around the time of the American Civil War, the arm-and-hammer symbol representing the Roman god, Vulcan. The steadfast use of the Vulcan logo has made Arm & Hammer Baking Soda a trusted and familiar product to many generations of Americans. The logo is also used on other Arm & Hammer products, including washing soda, laundry detergent, oven cleaner, and carpet deodorizer — all of which are now marketed under the Arm & Hammer brand name. The classic logo has been stolen at least once, appearing on Honest Labor chewing tobacco.

The owner of Vulcan Spice Mills, James A. Church, merged his company with his father's baking soda company in 1867; the elder Church had been manufacturing baking soda in conjunction with his brother-in-law John Dwight since 1847. Used along with various other labels on baking soda packages, the Vulcan logo first appeared in 1867. It soon became the company's most popular label, besting the "Cow" brand used since the company was founded (the Cow label can still be seen today on Arm & Hammer products in the Canadian market).

Product: Arm & Hammer Baking Soda, 16-ounce box

Manufacture: Church & Dwight Co.

Design Credit: Designer unknown; logo first used by James Church

Date: Product manufactured since 1846; Vulcan logo used on the package since 1867

Quaker Oats Oatmeal

Registered on September 4, 1877, the Quaker Man is America's first registered trademark for a breakfast cereal. The Quaker Man looked much different then, appearing full figure and carrying a scroll in his left hand bearing the word *pure*. The current Quaker Man appeared in 1957; his trust-inspiring visage bears a faint resemblance to George Washington. He is the focal point of the product packaging, itself an excellent example of the value-for-price packaging concept.

The Quaker Oats Company was established with the collaborative efforts of Ferdinand Schumacher, a pioneer miller; Robert Stuart, a management and financial organizer; and Henry Parsons Crowell, an innovative merchandiser. Quaker Oats was the first food label of national significance and the first nationally marketed and advertised breakfast cereal; they were also one of the first companies to approach packaging as a sales lure rather than a mere handling convenience.

Campbell's Soup

Campbell's Soup has been a tradition in American homes since 1897. The iconographic red and white soup can became a part of that tradition in 1898, and the Campbell Kids came along in 1904 — a creation of Philadelphia artist Grace Gebbie Drayton. Campbell's chronology is a steady litany of success. The company has won international awards for quality going back to 1900 and has paid an unbroken chain of cash dividends to investors since 1902.

The red and white label is based on the colors of Cornell College's football uniforms. The name of the person responsible for the design of the label was not recorded by Campbell's, which is not unusual since its design predates the era of the package designer and the appreciation and recognition of such designs. The fact that Campbell's package design has been in use since 1898 is a testament to its quality and timelessness, a quality to which Andy Warhol and other modern artists have paid tribute in their work.

Product: Campbell's Soup, chicken noodle, 10.75-ounce can

Manufacture: Campbell Soup Co.

Design Credit: Dr. J. T. Dorrance developed concept of canned condensed soup; label designer not available

Date: Condensed soup developed 1897; current label first appeared in 1898; gold medallion added 1900

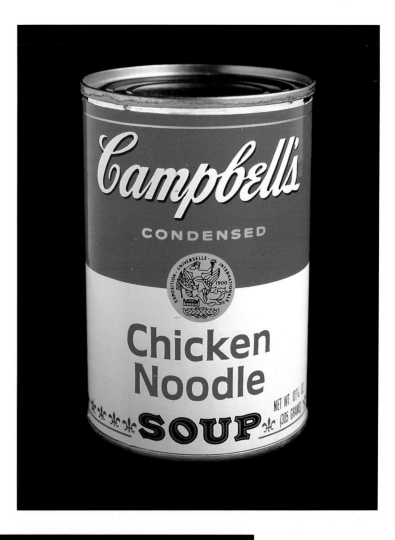

The Campbell's Soup can has become an American icon.

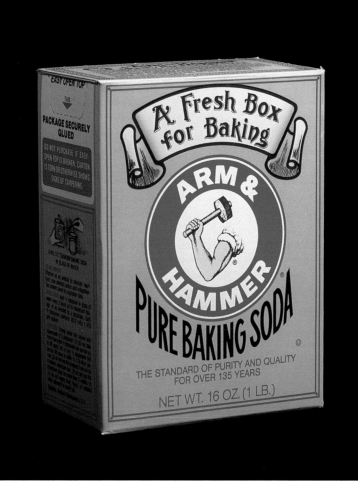

The Roman god, Vulcan, proved to be a lasting symbol of value for Arm & Hammer Baking Soda.

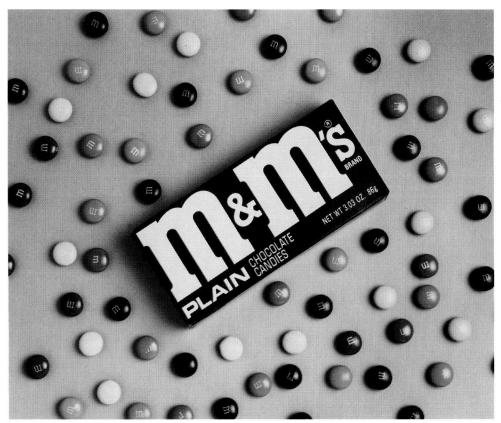

M&M's Plain Candy "melts in your mouth, not in your hand."

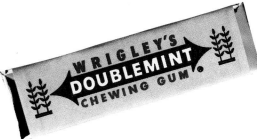

Doublemint Gum is one
of three Wrigley classics.

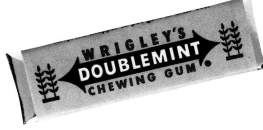

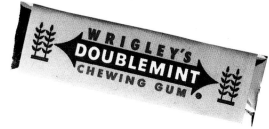

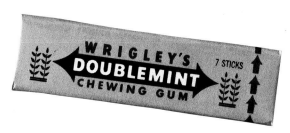

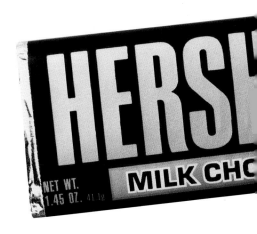

M&M's Candy

M&M's, based on the British sugar-coated chocolate candy called Ministrels —also a product of the English branch of the Mars company—were introduced to the United States by Forrest Mars, Sr., the M of M&M. (The other M represents former associate, Bruce Murrie.) The popularity of M&M's candies goes unquestioned: In the early 1980s peanut M&M's ranked number three and plain M&M's number four in popularity in the United States.

Plain M&M's classic chocolate-brown and white box is a gem. The small, ovoid multicolored candies rattle around inside the box. They can be munched by the handful; methodical types can pick through the colors to find their favorites. Don't look for any red ones, though: Since the untimely demise of red dye No. 2 in the mid-seventies, there have been no red M&M's.

Product: M&M's Plain Candy

Manufacture: Originally manufactured by M & M Ltd.; currently by M & M/Mars

Design Credit: Forrest Mars, Sr. began producing M&M's in U.S. based on the English Mars candy, Ministrels

Date: M&M's plain candies introduced in 1941; peanut candies introduced in 1954

Hershey Bar

The Hershey Bar needs no precise or elaborate definition. Everyone knows, almost as if by intuition, that a Hershey Bar is a thin slab of milk chocolate. The maroon and silver package emblazoning the Hershey name in bold helvetica type forms a perfectly appropriate package for the chocolate candy bar introduced by Milton Hershey in 1894. Expertly marketing itself as a purveyor of chocolate, the Hershey Chocolate Company is as identified with chocolate as Campbell is with soup or R. J. Reynolds with tobacco. In addition to the Hershey Bar, another outstanding Hershey product is Kisses—small chocolate droplets wrapped in foil with a pull tab bearing the product's name.

Product: Hershey's Milk Chocolate Bar, 1.45 ounce

Manufacture: Originally manufactured by Lancaster Caramel Co; currently by Hershey Chocolate Co.

Design Credit: Developed by Milton S. Hershey, company founder

Date: Introduced January 1, 1894

Wrigley Doublemint Chewing Gum

Wrigley's Doublemint gum is the youngest of Wrigley's famous triad: Juicy Fruit, Spearmint, and Doublemint. Spearmint, introduced in 1893, was the first Wrigley product to use the spear logo and was designed by William Wrigley Jr. himself, who remained unhappy with a number of submitted designs. Pulling out a pencil and paper, Wrigley sketched out the basic design, which became one of the world's classic trademarks. At the suggestion of Maurice Fitzgerald, ad manager in 1962, the spear design was incorporated into the tear-tape package opener.

The story of the development of the Wrigley company is a classic tale of American entrepreneurship. Wrigley arrived in Chicago in 1891, at twenty-nine years of age, with thirty-two dollars in his pocket. He eventually settled on selling baking powder as a livelihood; with each can sold, he gave away two sticks of gum. Sensing that the chewing gum market was undeveloped, he gave up baking powder sales and marketed his first two flavors of gum, Lotta and Vassar, in 1892. He introduced the Juicy Fruit and Spearmint flavors the following year and added Doublemint in 1914. Throughout his selling career, Wrigley never gave up his penchant for premiums, giving away everything—from lamps to razors—to merchants who agreed to carry his gum.

Product: Wrigley Doublemint Gum

Manufacture: William Wrigley Jr. Co.

Design Credit: Product developed and package designed by William Wrigley, Jr.

Date: Introduced in 1914

Hi-Cone Carrier

The concept of selling a half-dozen of a thing is an ancient one. However, the ingenuity of the American packaging and canning industry effectively exploited and definitively refined this concept. The Hi-Cone Carrier, the plastic pressing that holds six cans together, is astoundingly minimal in its material requirements yet creates an effective package with a carrying handle. The task of holding six cans together is performed so anonymously that the plastic pressing itself goes unnoticed. Because of its inconspicuousness, the Hi-Cone Carrier does not need to be customized to each individual product; identical Hi-Cone Carriers can be used on all canned beverages at minimal additional expense to the consumer. The Hi-Cone Carrier is by far the least expensive packaging device ever developed for

six-pack type containers. In America alone, 95 percent of all canned beverages purchased in multiple quantities leave the store in a Hi-Cone Carrier.

The Hi-Cone Carrier is only one of the myriad American innovations in canned beverage history. The Beer Can Collectors of America chronicle twenty-eight notable dates marking American design innovations for canned beverages. One of the earliest significant developments was the invention of the "church key" opener created by D. F. Sampson, a designer for American Can Company. A church key opener was included free with each case of flat-top beer sold in 1935, the first year beer was packaged in cans. Among other innovations are the aluminum can, introduced in 1958; the pull-top can, introduced in 1963; and the StaTab one-piece pull-top lid, introduced by Reynolds Aluminum in 1975.

Product: Hi-Cone Carrier

Manufacture: Originally manufactured by Illinois Tool Works; currently manufactured by Hi-Cone Division of Illinois Tool Works and by Owens-Illinois under license granted by Illinois Tool Works

Design Credit: Designed by Jules Poupitch, engineer

Date: Introduced in 1961

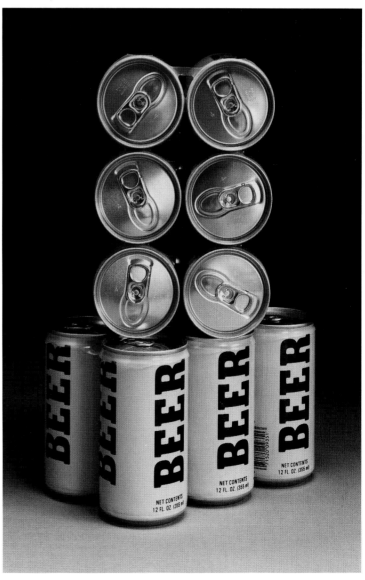

Hershey is a name synonymous with chocolate.

The Hi-Cone Carrier creates a subtle but highly effective packaging device.

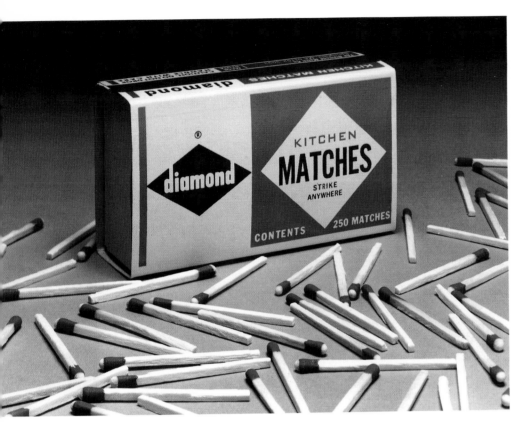

Diamond Kitchen Matches harken back to an era when matches were a necessity in every kitchen.

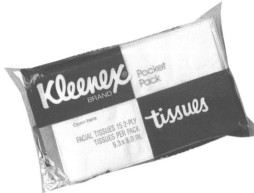

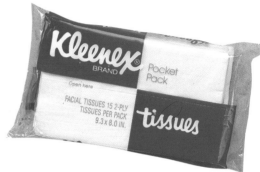

Kleenex Tissue is so pervasively successful that the name has become synonymous with facial tissue.

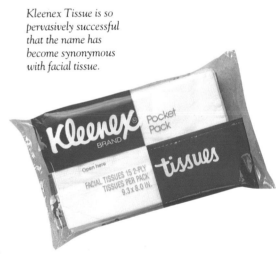

Diamond Matches

Although Diamond Matches do not enjoy the iconographic status of products like Campbell's Soup or Coca-Cola, they are a classic whose package has endured, unchanged since the 1950s. The Diamond Match Company continues to make sturdy matches out of wood instead of less substantial paper products. In many ways a vestige of a bygone era, Diamond Matches aren't needed much around the kitchen anymore. They are, however, still quite useful around the home. To reflect their product's contemporary use, Diamond has changed its product description from "kitchen matches" to "large wooden matches."

Product: Diamond Kitchen Matches

Manufacture: The Diamond Match Co.

Design Credit: Not available

Date: "Slide and shell" box created in the mid-1930s; present graphics first appeared in the 1950s

Kleenex Tissues

Introduced in 1924, Kleenex tissues made use of a material developed during World War I as a substitute for cotton surgical dressings: cellucotton. Kleenex tissues were initially marketed to women as a cold cream remover. Sales did not really blossom until product advertising stressed their value for relieving nasal congestion. An important innovation in the Kleenex box was the Serv-a-Tissue or "pop-up" feature introduced in 1929. By mechanically interfolding two separate rolls of Kleenex, the impetus created when one tissue was removed caused the tissue beneath to pop up, ready for use. The phenomenal growth in popularity of Kleenex throughout the 1930s has been attributed to this design feature.

In 1938, an important year in Kleenex history, the now-classic blue and white box was introduced. Noted for its design from the outset, the Kleenex box was included in a design exhibit at New York's Museum of Modern Art featuring products ostensibly influenced by the artist Mondrian. In all likelihood, both Mondrian and Kleenex owe their inspiration to a design convention a little farther down art's evolutionary ladder. Whatever the source of inspiration, the Kleenex box was exhibited at MOMA and also nominated to the Packaging Hall of Fame.

The pocket pack introduced in 1948 is the only current Kleenex package that still uses the blue and white motif of the late 1930s; the lettering has been changed from sans serif capital lettering to a script style.

Product: Kleenex Tissues, pocket pack

Manufacture: Kimberly-Clark Inc.

Design Credit: Andrew P. Olsen, package designer

Date: Introduced in 1924; Serv-a-Tissue or "pop up" feature added in 1929; blue and white package of Olsen's design introduced in 1938 and pocket pack introduced in 1948

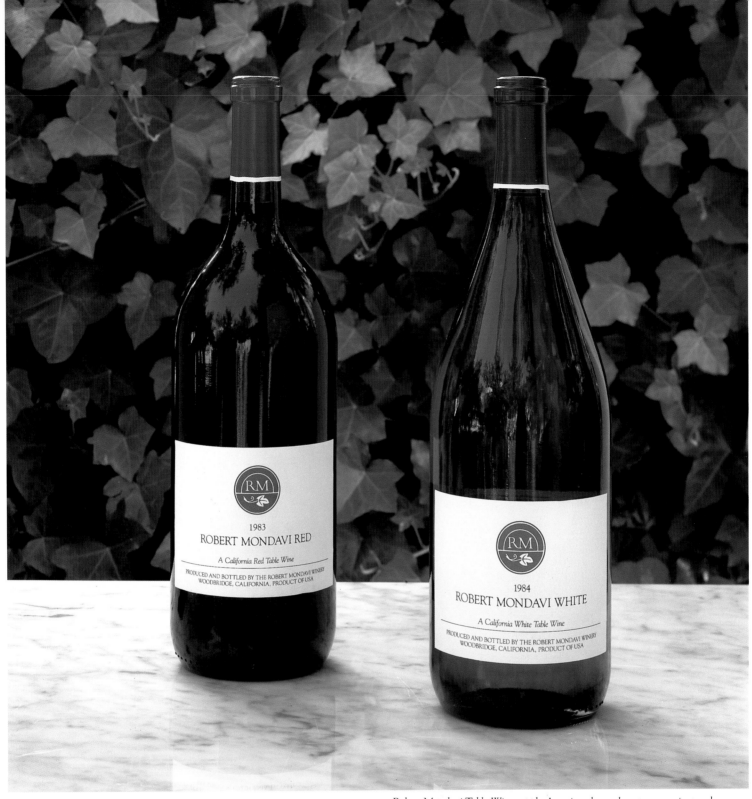

Robert Mondavi Table Wines apply American know-how to an ancient and traditional process.

Robert Mondavi Wine

The Robert Mondavi Winery of Napa Valley, California is an important part of a growing and innovative American wine industry. The art of making wine clearly predates America, but in recent years American wineries, with California wineries at the forefront, have been gaining an international following and reputation in an industry traditionally dominated by Europeans.

The Robert Mondavi Winery was the first winery to produce an oak-aged, vintage-dated, inexpensive wine of high quality in a volume sufficient to satisfy national distribution. The Robert Mondavi Winery has continued to lead in the application of new technology and experimentation to the age-old winemaking process. Whereas the Europeans have viewed some of the important American winemaking innovations with a degree of disdain and consider them sacrilegious, they have had to accept that these techniques are effective in producing a high-quality product.

Product: Robert Mondavi Wine, red and white table wines, 1.5-liter bottles

Manufacture: Robert Mondavi Winery

Design Credit: Developed by Robert and Tim Mondavi, winemakers; James Beard, label designer; Malette Dean, illustrator

Date: Introduced in 1978

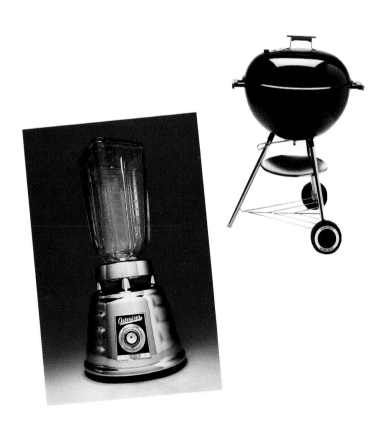

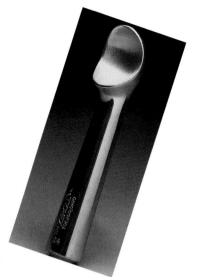

HOUSEWARES

Many of the items included in this chapter were introduced in the Great Depression. Though some came later, their styling is clearly influenced by the streamlined modernism of the thirties. In the late twenties, just prior to the Depression, the profession of consultant industrial designer, as we know it today, began to take shape; by the thirties this profession developed into a major design force, with visionaries such as Raymond Loewy, Norman Bel Geddes, Walter Dorwin Teague, Henry Dreyfuss, and Russel Wright streamlining and modernizing everything in sight. The styling trends they established yielded stationary objects from toasters to pitchers that seem poised to speed down the kitchen counter and take flight.

American housewares and appliances of the thirties were the first mass-produced products to have "designer labels." To help sell goods at a time when no one had money to buy, advertisers brought together manufacturers and product designers for the first time, in an effort to create a better looking product that would be easier to sell. This integration of advertising, manufacture, and product design created an environment for consuming that television advertising has long since raised to a fever pitch.

The status of designed products was considerable during the 1930s. A cartoon in a 1934 issue of *Fortune* showed a committee of fat, cigar-smoking businessmen around a conference table. Its caption read, "Gentlemen, I am convinced that our next biscuit must be styled by Norman Bel Geddes."

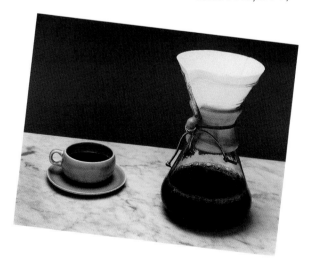

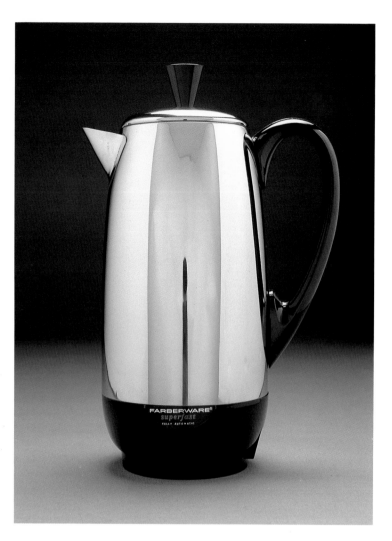

Farberware Coffee Percolator

Farberware's coffee percolator has become, like Revereware and Tupperware, an American household icon, even though percolation is not as popular a brewing method as it once was. Using the percolation brewing method, the Farberware 142B percolator automatically brews from two to twelve good cups of coffee at a rate of one cup per minute. In addition, the same utensil that brews the coffee keeps it warm and serves as the decanter from which it is served.

Product: Farberware Coffee Percolator, model 142B
Manufacture: Farberware
Design Credit: Developed by Milton Farber, company president
Date: The model 122, from which the contemporary 142B evolved, introduced in 1955

The Farberware Coffee Percolator is the essential machine for brewing fresh perked coffee.

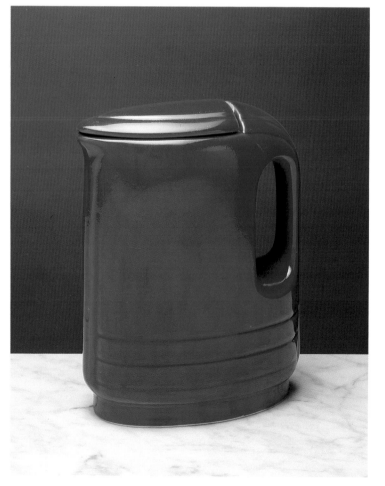

Hall Ceramics

The graceful contours of the Aristocrat Pitcher by Hall China indicate its design origins in the early 1940s. Frequently included with refrigerator purchases, the Aristocrat was originally made by Hall for Westinghouse under the name Peasant Ware. Coveted by collectors of American ceramics, like many Hall pieces of its era, the Aristocrat Pitcher is one of the most striking designs in the line, along with other classics like the Doughnut Pitcher and the Rhythm Teapot. After a lapse in its production, the Aristocrat was reissued in 1985. Hall ceramics are still available in bright colors—red, yellow, blue, green, and white.

Product: Hall Aristocrat Refrigerator Pitcher, blue
Manufacture: Hall China Co.
Design Credit: J.P. Thorley, designer
Date: Introduced in 1940

The graceful modernism of the 1940s endures in the Aristocrat Refrigerator Pitcher.

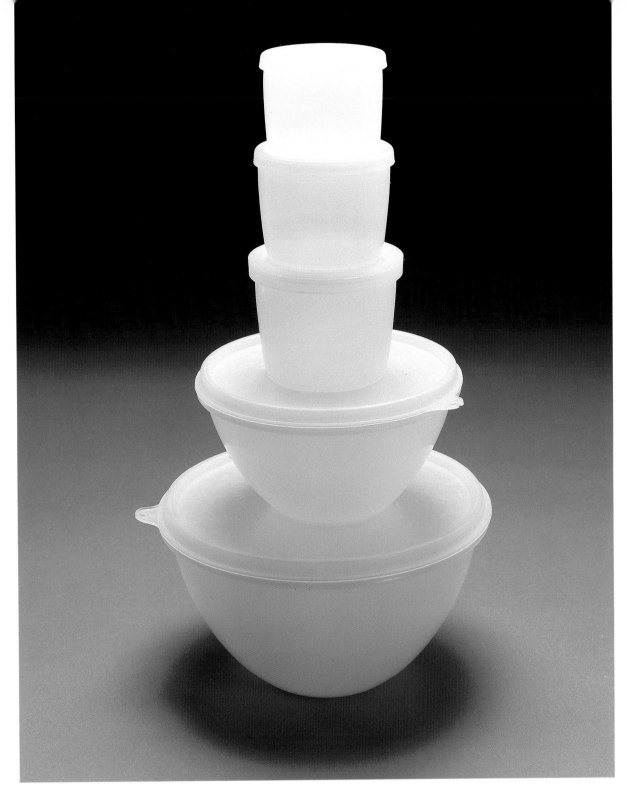

Tupperware created
practical "art objects"
for the homemaker.

Tupperware

Earl Tupper used two of his inventions when he developed Tupperware: his method for molding polyethylene made the container pliable, and an airtight seal created a superb way to keep perishable items fresh. The first Tupperware container was the Bell Tumbler; it still remains in the Tupperware line today. In 1947 *House Beautiful* compared Tupperware's beautiful form to "art objects" and likened the qualities of the polyethylene surface to alabaster and jade. Despite the critical accolades, it was a marketing decision made in 1951, influenced by the selling methods of Stanley Home Products, that produced Tupperware's great financial success and broadened its market to virtually every American kitchen: Tupperware was sold directly to the public for the first time through what has since become an American institution—the Tupperware home party.

Product: Tupperware Containers, assorted
Manufacture: Tupperware Corp.
Design Credit: Earl Tupper, inventor and company founder
Date: Introduced in 1945; items pictured produced in mid-1950s

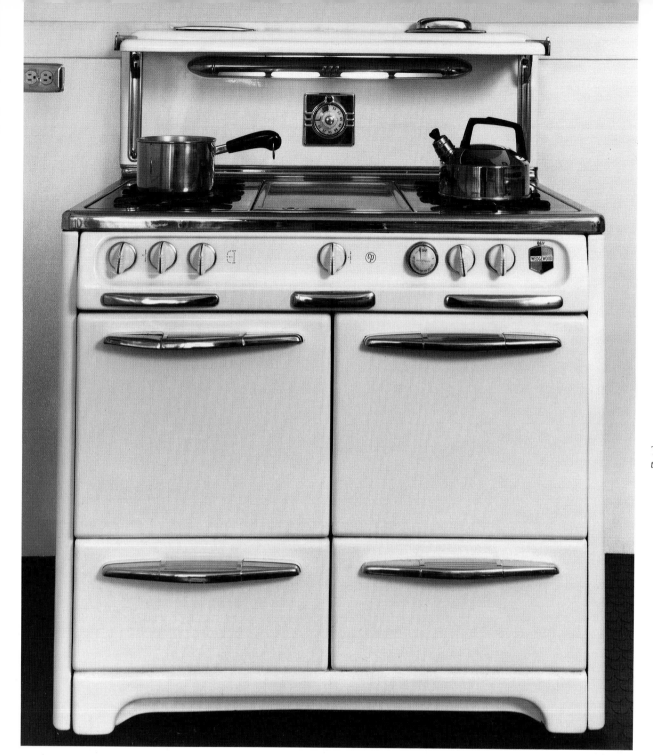

The Wedgewood stove was the Cadillac of the kitchen.

Wedgewood Stove

The James Graham Manufacturing Company, which made the Wedgewood line of kitchen stoves, was established in 1882. They eventually became one of the top-end manufacturers of kitchen stoves, along with such competitors as O'Keefe & Merritt and Gaffers & Sattler. The Wedgewood Stove enjoyed the greatest popularity in its home state of California but was also distributed and sold nationally.

The Wedgewood pictured here comes from an era of stove manufacturing, before modularization became popular, when the stove was the centerpiece of the American kitchen. It had almost as much chrome as the Cadillac in the garage and just about as much gadgetry. This Wedgewood, for instance, features a griddle, a broiler as well as an oven, a built-in timer, fold-out top shelf, toaster, and removable grease pans below the burners. In the late fifties one Wedgewood model had a round oven door that resembled a porthole on a ship.

The distinctive style and generous use of opulent materials was increasingly difficult to maintain. As competition increased and the price of materials rose, Wedgewoods became more and more ordinary. Ultimately, Graham Manufacturing was bought out by West-ern Holly, and for a few years stoves were produced under the Wedgewood-Holly name. By the early 1970s production of them terminated. The Wedgewood legend is currently kept alive by retailers and collectors in the used appliance field who refurbish the classic stoves—parts continue to be available for them—and conduct a brisk business in their resale.

Product: Wedgewood Stove, model no. N8358SG10

Manufacture: James Graham Mfg. Co.

Design Credit: Not available

Date: Estimated to be early 1950s

Revereware

Revereware is named for that great American patriot, Paul Revere, who apart from that fateful night in history, spent his life as a silversmith. Unchanged since its introduction in 1939, Revereware is an institution in the kitchens of America.

After extensive product research, W. Archibald Welden, a product designer working for Revere Copper & Brass, meticulously designed Revereware. His handle design was patterned after the handle of the silversmith's hammer, a time-proven design. He chose as his materials stainless steel for corrosion resistance and a copper-plated bottom for uniform heating. Excellent balance helped prevent spillage. Revereware's streamlined modern contours actually have immense practical value—unlike most other streamlined designs of the thirties—because the lack of abrupt corners eliminates crevices and facilitates cleaning. Prior to working for Revere, Welden's metal fabricating firm executed giftware designed for Revere by Norman Bel Geddes.

Product: Revereware Cookware

Manufacture: Revere Copper & Brass Inc.

Design Credit: W. Archibald Welden, designer

Date: Introduced in 1939

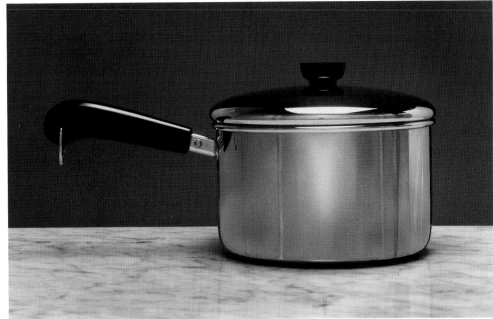

Revereware's modern beauty is eternally in style.

Calphalon Cookware

Calphalon cookware features a utilitarian, institutional design look that complements its practical cooking features. Made of lightweight aluminum, Calphalon has an anodized finish that gives it a characteristic dark color and provides a considerably denser, harder, more abrasive-resistant surface than nonanodized metal. In fact, anodized aluminum is not a coating but a molecular change in the metal that approaches the strength of diamonds. Made of cast iron, the Calphalon handle is riveted in place for durability. Commercial Aluminum Cookware, Calphalon's maker, is an industry leader in using the innovative anodization process, which has spawned numerous imitators in the cookware field.

Product: Calphalon Cookware, assorted pieces

Manufacture: Commercial Aluminum Cookware

Design Credit: Commercial Aluminum Cookware staff

Date: Introduced in mid-1970s

Calphalon Cookware's use of anodized aluminum yields distinctive looks and performance.

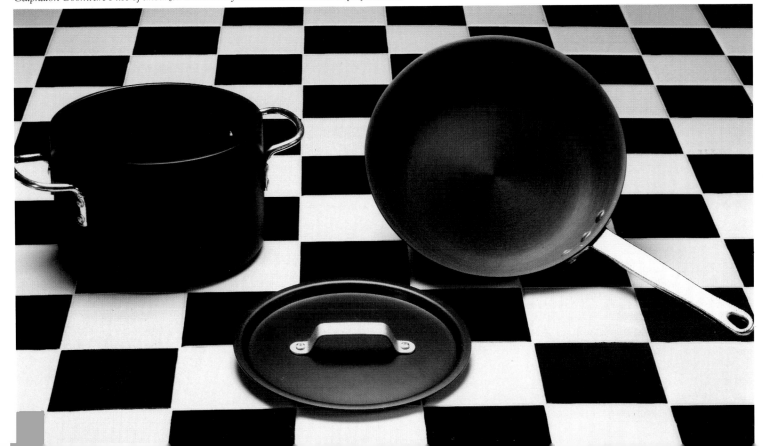

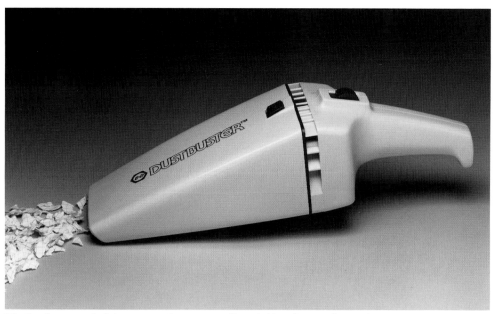

The Dustbuster marked the creation of a new type of household appliance—the portable, cordless vacuum.

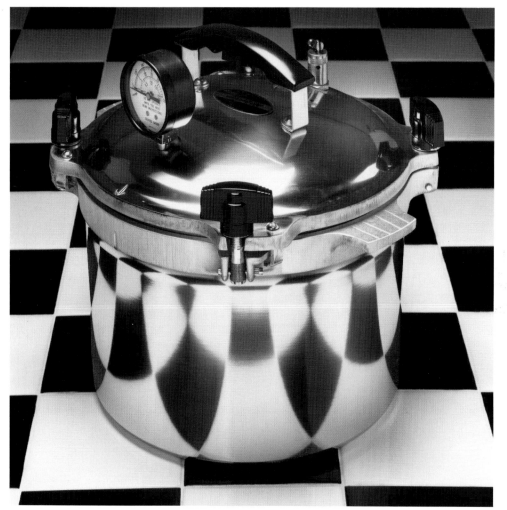

The All-American Pressure Cooker remains virtually unchanged in design since 1929.

Black & Decker Dustbuster

The Dustbuster was the first successful housewares product developed by a company that built a reputation on making power tools for the home workshop. Black & Decker's Dustbuster portable vacuum is perfect for small tasks where pulling out the regular vacuum is too much trouble. Its wall-mounting unit keeps the vacuum handy and constantly recharges the unit. Competing firms anxious to profit from the Dustbuster's success have copied its sleek profile extensively.

The Dustbuster's phenomenal sales have transformed its manufacturer. In 1984 Black & Decker purchased General Electric's entire line of small appliances, from toasters to hair dryers; by 1987 all of these appliances will be sold under the Black & Decker label. Additionally, Black & Decker has introduced several well-designed electrical housewares products of its own.

Product: Black & Decker Dustbuster
Manufacture: Black & Decker Mfg. Co.
Design Credit: Carroll Gantz, product designer
Date: Introduced in 1979

All-American Pressure Cooker

Home canning of fruits and vegetables and the making of preserves and jellies, particularly in rural America, is a tradition going back many generations. The All-American Pressure Cooker has been a part of that tradition since its introduction in 1929. The design of this canner/cooker was unique even when first introduced because it did not use a gasket seal, which breaks down with repeated use, but instead had a metal-to-metal seal. The All-American also featured a pressure gauge which was more accurate than a weighted "jiggler" control.

Product: All-American No. 907 Pressure Canner/Cooker
Manufacture: Wisconsin Aluminum Foundry Co. Inc.
Design Credit: Albert Loefler, chief engineer and project director
Date: Designed 1926–1928 and introduced in 1929

Mason Jar

The Mason jar is an indispensible part of the home canning process in America. Generations of Americans are familiar with it; it is the overwhelming container of choice for home canners. There is no Mason Jar Co., however; the Mason name refers to the design of the jar. Mason "type" jars are manufactured by various American companies.

The jar bears the name of John L. Mason, an American glassblower who introduced it in 1858. Its distinctive feature is a screw-on cap that made the home canning process much simpler by eliminating the need to seal containers with paraffin or cork, both of which were cumbersome and not easily resealable once opened.

Product: Mason Canning Jars

Manufacture: Various manufacturers currently produce a Mason-type jar

Design Credit: John L. Mason, inventor

Date: Introduced in 1858

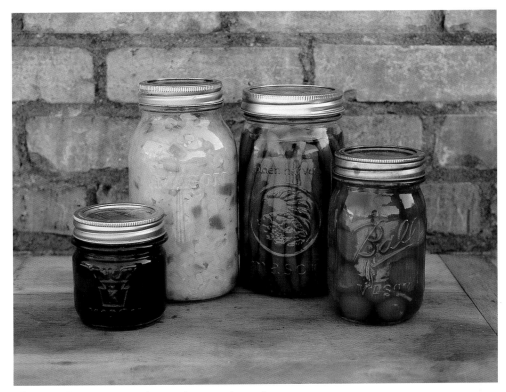

The Mason Jar is a superior solution to home canning needs.

Eureka Mighty Mite Vacuum Cleaner

The Mighty Mite is an innovative product in touch with changing American household needs. An old name in vacuum cleaner manufacturing, the Eureka Company began in Detroit in 1909; by 1927, through door-to-door sales, they held one-third of the American market.

The Mighty Mite makes innovative use of alternative materials—ABS plastic instead of metal—for construction of the housing. No less powerful than the standard vacuum, the Mighty Mite is much smaller and lighter—small enough to hand-hold on stairs and to navigate through crowded spaces. Attachments are kept externally on the housing, so they are always handy.

The Mighty Mite's design has garnered numerous accolades from the design community. *Time* magazine considered it one of the ten best products introduced in 1982, the only mass-produced consumer product included in that year's awards. The Mighty Mite was also included in the *Design Since 1945* exhibit and catalog organized by the Philadelphia Museum of Art.

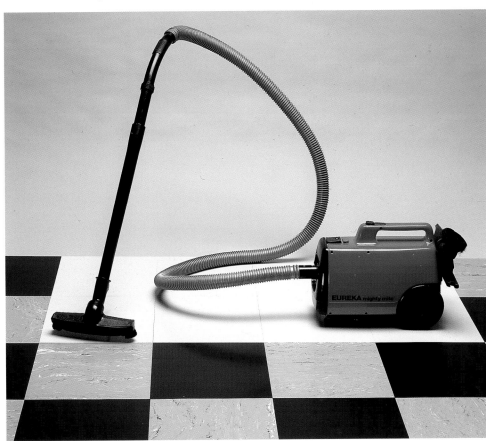

The Eureka Mighty Mite is a new and innovative design for America's vacuuming needs.

Product: Eureka Mighty Mite Vacuum Cleaner

Manufacture: Eureka Co.

Design Credit: Samuel Hohulin, chief industrial designer and Kenneth Parker, senior industrial designer

Date: Introduced in 1982

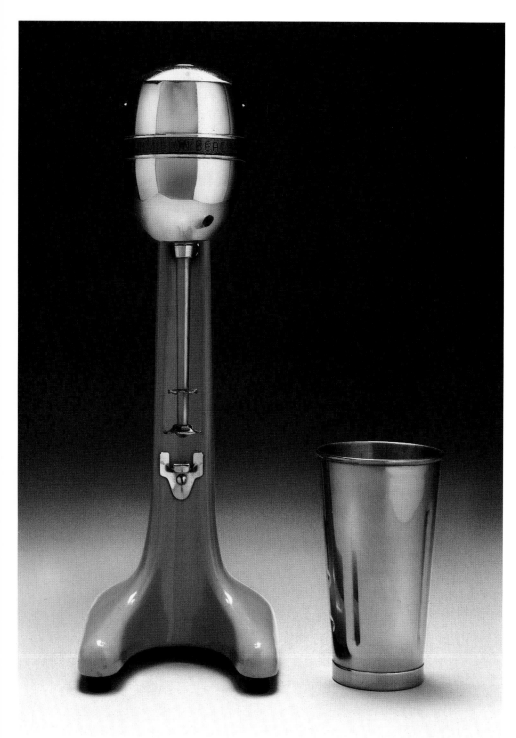

One glance at the Hamilton Beach Drinkmaster triggers a Pavlovian desire for a malt.

Hamilton Beach Drinkmaster

The Hamilton Beach Drinkmaster, with its pea green base and chrome motor housing, evokes fond memories of that great American institution—the soda fountain. In fact, it's difficult to envision a malt or milkshake made without the benefit of a Drinkmaster.

Chester Beach teamed with financier L. H. Hamilton and salesman Fred Osius to develop and market the fractional horsepower, universal electric motor which operated on either alternating or direct current. The development of this compact motor became the cornerstone of the electrical appliance industry. Their electric drink mixer, introduced in 1911, was the first appliance to make use of this technology; the Drinkmaster No. 30 was used to mix Horlick malted milk powder into shakes sold by druggists and praised by doctors for their healthy, strength-building properties.

Though as functional as ever, the styling of the Drinkmaster has changed dramatically since the No. 30 model. Fortunately, due to its extreme durability, No. 30 Drinkmasters are still found poised for duty in soda fountains all across America.

Product: Hamilton Beach Drinkmaster No. 30

Manufacture: Hamilton Beach Co.

Design Credit: First drink mixer developed by Chester Beach; designer of No. 30 model not available

Date: Introduced in late-1920s

Chemex Coffee Maker

Known as a pristine coffee maker, Chemex employs all the chemically correct methods for brewing. Its hourglass-shaped flask is made entirely of glass, a chemically inert material that does not absorb odors or chemical residues. The Chemex has no moving parts and will work forever, unless it is dropped or in some other way demolished. Chemex filters are the same as those used by chemists for filtering and decanting.

The dynamic and somewhat controversial force behind the development of the Chemex Coffee Maker, Peter Schlumbohm referred to himself as an inventor, not a designer, stating that "inventors are original, noncompromising pioneers; designers are parasitic politicians." At the time of his death in 1962, Schlumbohm held over 300 patents. Among his other inventions was a frying pan that did not require washing and a beautifully designed, high-tech, air filtering fan.

Product: Chemex Coffee Maker

Manufacture: Chemex Corp.

Design Credit: Peter Schlumbohm, inventor and designer

Date: Introduced in 1942

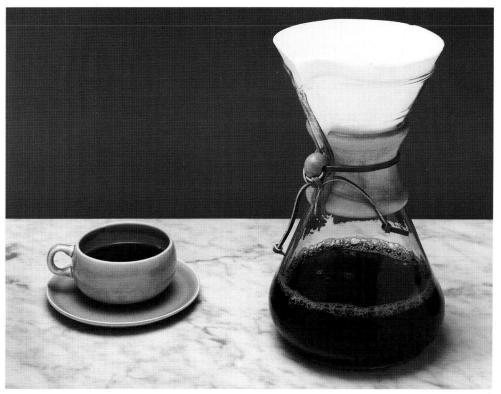

The Chemex Coffee Maker presents a pristine method for brewing coffee.

Kitchen Aid Mixer

The lines of a Kitchen Aid mixer show a design heritage with roots in the curvilinear forms so prevalent in the 1930s. In fact, the basic shape of the mixer has remained intact for some time. Compared with many kitchen appliances, the Kitchen Aid Mixer has an incredible feeling of solidity and ruggedness— it weighs in at a hefty twenty-three pounds. The attachment hub on the front of the mixer accepts an array of attachments from pasta maker to can opener, all of which operate from the mixer's motor.

Product: Kitchen Aid Mixer, model K45SS

Manufacture: Originally manufactured by KitchenAid Div. of Hobart Mfg. Co.; currently by KitchenAid, Inc.

Design Credit: Original model developed by Herbert L. Johnson, engineering manager

Date: Original model introduced in 1919; current model introduced in 1960

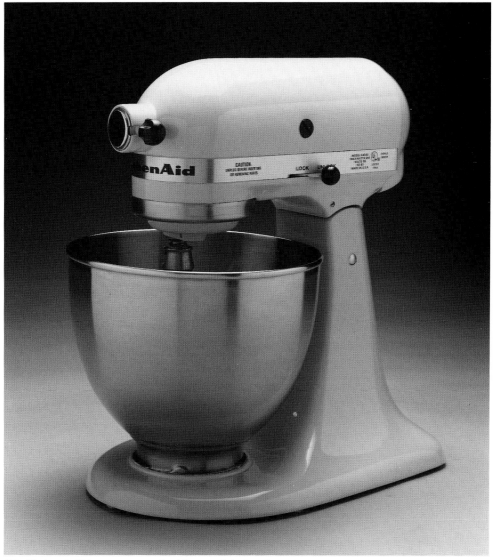

The Kitchen Aid Mixer is an example of the rugged, built-to-last-a-lifetime reputation that American-made appliances are valued for.

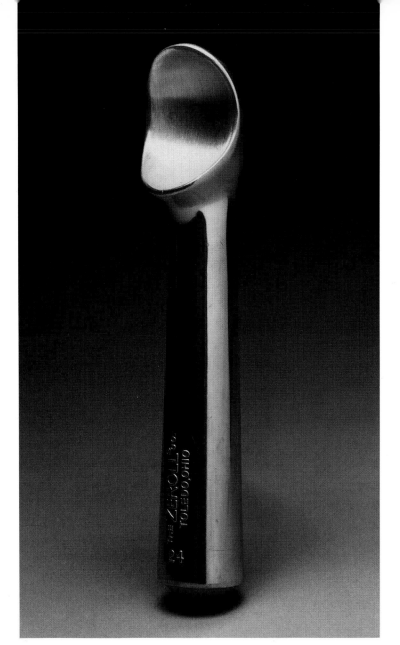

Zeroll Ice Cream Scoop

Unlike many competing ice cream scoops, the Zeroll has no moving parts. Instead, this first nonmechanical scoop relies on a defrosting liquid in its hollow core that, when warmed by the user's hand, melts the contact layer of ice cream as the scoop is inserted. This same feature prevents ice cream from sticking to the scoop as portions are dispensed. The Zeroll "rolls up" ice cream instead of compressing it into a clump— a ball of Zeroll-scooped ice cream appears larger but contains 10 to 20 percent less ice cream than a conventional scoop. The Zeroll scoop is a brilliant, simple, and virtually fail-safe design that works subliminally, relying on natural phenomena and not the user's knack. It works just as effectively whether you are using it for the first time or for the millionth time.

The Zeroll is patented; it has been in production continually and has undergone no substantial design changes since its introduction in 1935. The Zeroll Ice Cream Scoop has been included in the design collection of New York's Museum of Modern Art.

Product: Zeroll Ice Cream Scoop No. 24

Manufacture: The Zeroll Co.

Design Credit: Sherman Kelly, inventor and product developer

Date: Introduced in 1935

Zeroll Ice Cream Scoop's fail-safe method of dispensing ice cream makes each portion appear larger.

The opulence of the Sunbeam Toaster makes it a popular contemporary choice.

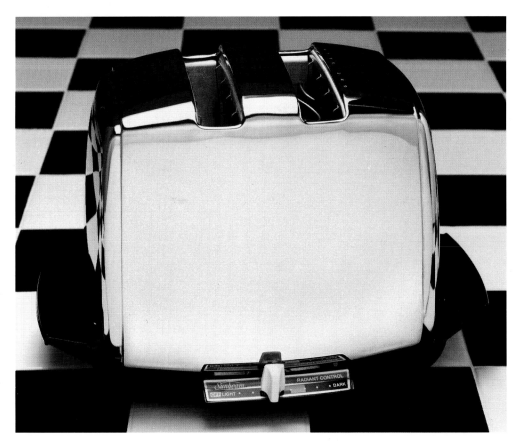

Osterizer Blender

The Osterizer Blender, much like the Kitchen Aid mixer, combines a reputation of solidity and dependability with classic styling. The Model 403 pictured has been in constant use since the 1950s. The chrome beehive base and overall simplicity made the Osterizer Blender special from a styling standpoint. The 403 line has been recently reissued by Oster as the "Classic."

As well as being a blender, the 403 has a juicer/slicer/shredder attachment. The glass container fitting that couples to the blender base is compatible with Mason jars, which allows food to be processed in them as well.

Product: Osterizer Blender Model #403, chrome base

Manufacture: Oster Corp.

Design Credit: Don Carlson and Al Madl, designers

Date: Introduced in 1953

Sunbeam Toaster

Although not introduced to the marketplace until 1949, the Sunbeam 20030 toaster is a striking example of the aerodynamic styling influences of the Depression era. The choice of construction materials—chrome and bakelite—contribute a touch of class; the continued use of these materials make the Sunbeam toaster an expensive toaster by some standards. Its success is proof that consumers are willing to pay for streamlined elegance.

The 20030 toaster features vertical slots across the top, making it distinctive in comparison to the traditional horizontal slots of most toasters. A self-lowering mechanism and radiant temperature control allow the user to select the degree of toasting preferred.

Product: Sunbeam Toaster, model 20030

Manufacture: Sunbeam Appliance Co.

Design Credit: Ludvig Kosi, designer

Date: Introduced in 1949

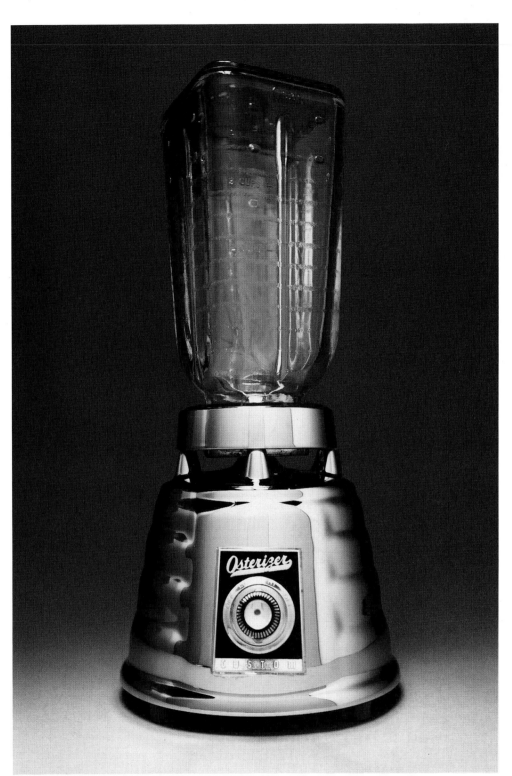

The Osterizer Blender is a kitchen classic.

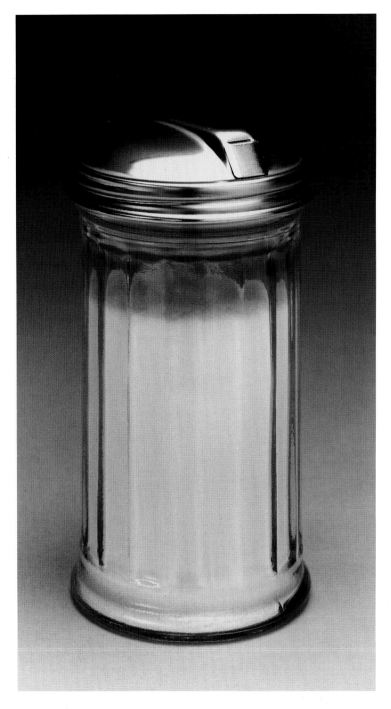

Bloomfield's sugar
dispenser is a fixture
on American diner
counters everywhere.

Bloomfield Sugar Dispenser

On diner counters all over America — nestled next to the salt and pepper shakers, the napkin dispenser, and the menu–sits Bloomfield's sugar dispenser. It possesses all the design attributes required by the restaurant industry. Easily refillable, it can be checked visually for content. The fluting on its glass cylinder gives it the beauty of a Greek column while making it structurally stronger and easier to grip. The pouring flap on the cover regulates flow and prevents excess humidity from solidifying the sugar.

Bloomfield's sugar dispenser has developed an iconographic status that makes a definition of its purpose unnecessary. We need no label identifying its contents nor do we require instructions to explain its use. We have come to understand its function as intuitively as the concept of the wheel.

Product: Bloomfield Industries Sugar Dispenser

Manufacture: Bloomfield Industries; the glass cylinder, a major component of the product, is made for Bloomfield by Pierce Glass Co.

Design Credit: Bloomfield staff

Date: Introduced by Bloomfield in 1968; the design is generic and other manufacturers have similar designs that may have been in production earlier

The Minute Minder
provides the perfect
kitchen complement to
such classics as the
Wedgewood Stove and
Revereware Cookware.

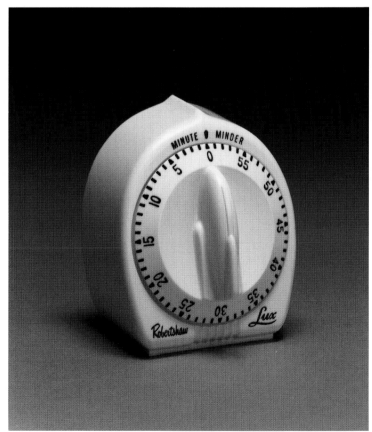

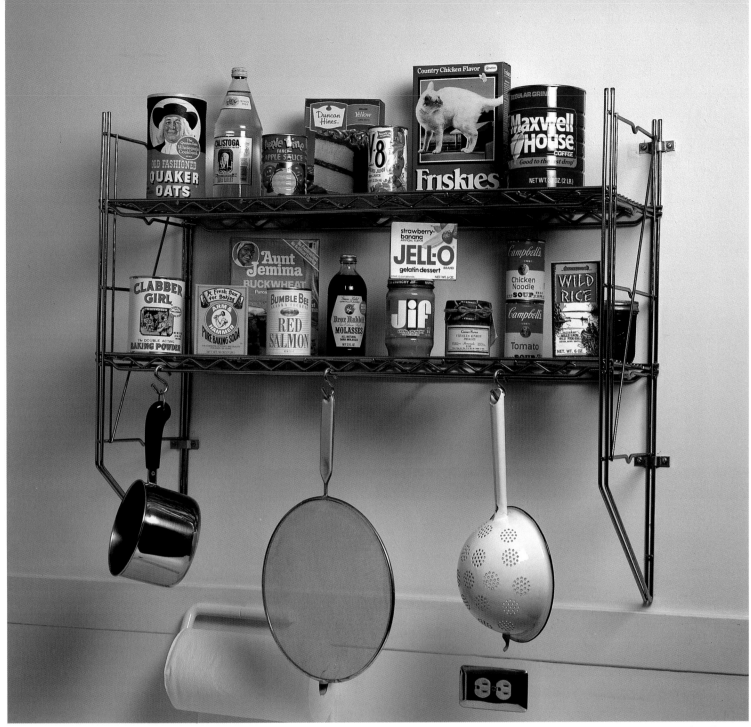

Metro Shelves offer a design solution appropriate to both industrial needs and to the home.

Robertshaw Minute Minder Kitchen Timer

An extraordinarily small number of products exemplifying the styling features we now refer to as art deco have persevered unchanged to the contemporary era. The Minute Minder, with its early 1930s design and introduction to the marketplace, is one of them.

The Minute Minder is a simple mechanical timer that counts down to zero from time settings of up to one hour. The setting of the timer also winds the clock mechanism. The majority of kitchen timers still make use of this engineering, despite the demise of mechanical time-keeping in most other applications.

Product: Robertshaw Minute Minder Kitchen Timer

Manufacture: Originally manufactured by Lux Clock Co.; currently by Robertshaw Controls Co./Lux Time Division

Design Credit: Not available

Date: Circa 1932

Metro Wire Shelving System

Metro Erecta and Super Erecta shelves were designed for commercial and institutional applications, but their appeal is so widespread they easily found their way into the kitchens and living rooms of America. Metro shelves come in a variety of finishes and configurations for just about any purpose imaginable. With a wide range of design attributes, the wire shelves offer great strength-to-weight ratios; the shelves do not collect dust and air circulates freely around stored items. Because they are completely modular, Metro shelves can be adapted to almost any situation. No tools are needed for assembly.

Product: Metro Shelving, Erecta Shelves, chrome finished and wall-mounted

Manufacture: Originally manufactured by Metropolitan Wire Goods Corp.; currently by InterMetro Industries Corp.

Design Credit: Louis Maslow, inventor and product developer

Date: Introduced in 1955

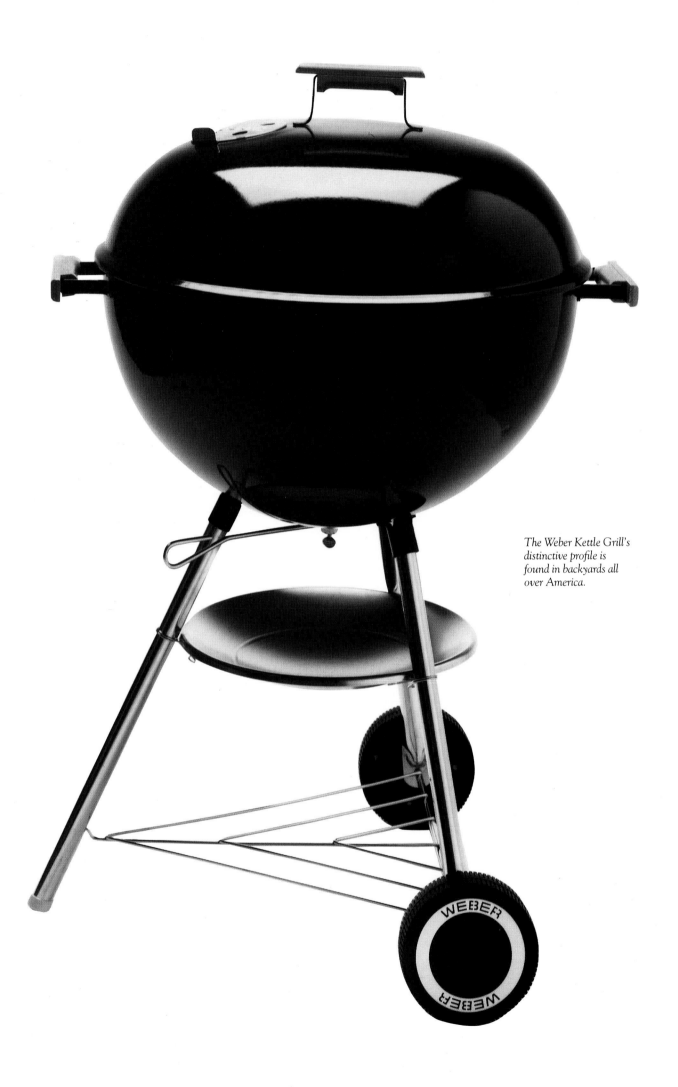

The Weber Kettle Grill's distinctive profile is found in backyards all over America.

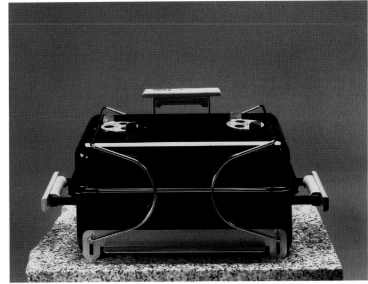

Weber Grill

The great American tradition of backyard grilling is attributable to, of all people, Henry Ford. In the thirties, when wood-sided autos were finished with real wood, Ford decided that the wood scraps should not be wasted. He charred and pressed them into charcoal briquettes with the idea that they could be marketed as a coal substitute. Ford dealers were required to accept a railcar load of them along with each railcar of autos. Although briquettes never quite caught on as a heating fuel, someone got the idea that they could be used for outdoor cooking and a backyard pastime was born.

The Weber was developed in the early 1950s by George Stephen, a part owner of Weber Brothers Metal Works. He built a grill with a ventilated cover for his personal use because the acrid smoke of his old brick grill made it extremely unpleasant to use. His homemade version worked so well and became so popular among his neighbors that he decided to make more of them to sell. So successful was this venture that by 1958 Weber Brothers ceased production of all products but the grills.

Weber has become synonymous with backyard grilling, and for good reason. Weber kettle grills are moderately priced, as cooking instruments go, and they work remarkably well. The kettle's domed cover retains flavor, and the one-touch vent system allows for fire control. The vent system also works like a flour sifter, emptying the accumulated ashes at the bottom of the grill. Although the Weber Kettle remains the classic grill, the portable tabletop grill is an absolute design gem. It sets up quickly and produces the same quality results as the kettle. When finished with grilling, you flip up the legs neatly and secure them to the top.

Product: Weber 22-Inch Kettle Grill, black
Manufacture: Weber-Stephen Products Co.
Design Credit: George Stephen, designer and product developer
Date: Introduced in 1952

Product: Weber Table Top Grill, black
Manufacture: Weber-Stephen Products Co.
Design Credit: Developed by Jim Stephen, Mike Kempster, and Erich Schlosser
Date: Introduced in 1980

The Acme Supreme Juicerator's name is synonymous with its reputation for durability.

Acme Supreme Juicerator

Juicers are relatively new appliances in most American households; they have become increasingly popular as health-crazed Americans began to favor fresh fruit and vegetable concoctions for the nutritional value they provide.

The Acme Supreme Juicerator is a centrifugal juicer that separates the pulp from the juice of fruits and vegetables. Its features include a patented gyro base that eliminates "walking" and reduces vibrations to a minimum, a self-adjusting clutch, stainless steel basket, and a heavy duty electric motor with no

brushes that can wear out. The Acme Juicerator is a handsome product, unlike most other juicers which have a decidedly homemade look. Like many other well-respected, American-made home appliances, Acme boasts of their product's lifetime durability.

Product: Acme Supreme Juicerator, model 6001

Manufacture: Originally manufactured by Moline Mfg. Co. Inc.; currently by Acme Juicer Mfg. Co.

Design Credit: Designed by Robert Dodge

Date: Designed in 1953; introduced in 1954

American Modern Dinnerware

Americal Modern dinnerware was designed by Russel Wright in 1937. It was inexpensive and came in a variety of colors: mustard, chocolate brown, gray, and teal. Color-coordinated so that its pieces could be mixed and matched at will, American Modern was extremely popular, particularly with the young married set. Its organic shapes contrasted with the geometric forms common at that time and predicted the free-form shapes predominant during the 1950s.

An important designer during his era, Russel Wright was very American in his design sensibilities. In addition to his design of American Modern dinnerware, he also created outstanding furniture designs in blond maple for the American Modern dining and living room. In the mid-sixties, late in his career, he designed more than 100 products for Japanese manufacturers.

Product: American Modern Dinnerware, assorted pieces
Manufacture: Steubenville Pottery Co.
Design Credit: Russel Wright, designer
Date: Introduced in 1937

American Modern Dinnerware, inexpensive and elegant, was a perfect design solution for the needs of the late Depression.

TOOLS

Throughout its history, this has been a nation on the upswing, constantly growing and expanding. This growth has been facilitated by the innovation and development of new products, both for the home and the workplace, that played key roles in a country continually on the make. This chapter consists of a potpourri of such products. Many of them illustrate the do-it-yourself mentality so prevalent from the American upper-middle class on down. Other products included are American innovations, from the telephone to the computer, that have done much to shape the workplace.

America has long been a leader in the manufacture of building tools catering both to the contractor and the handyman. With home ownership a national norm (up until quite recently), a lot of leisure time goes into puttering around yard and home. Many products are successful because of this propensity for do-it-yourself activity: Americans love a gadget that will enable them to do the work themselves rather than to hire someone to do it for them.

Vemcolite Task Light

A high-tech version of the gooseneck lamp, the Vemcolite task light uses an ingenious head design that conceals the on/off switch and also provides ventilation. The ten-foot cord generally does not require an extension. The lamp can be clamped to a desk surface or is available with a table base; its goose neck makes positioning the light source easy.

Product: Vemcolite VL-5 Task Light

Manufacture: Vemco Corp.

Design Credit: Mike Miller, project manager; Andrew Ogden, designer; Zoltan Goncze, engineer

Date: Introduced in May 1985

The Vemcolite VL-5 is a high-tech version of the gooseneck lamp.

Grid Blankbook

Grid blankbooks offer an elegant solution to the need for a well-designed writing pad. The grid pages have a light gray grid imposed on 60 lb. white opaque paper; they function extremely well whether used for writing, sketching, or roughing out floor plans for the backyard doghouse. The books are perfect bound for retention and the pages perforated for easy removal. The distinctive style and bright red logo make these grid blankbooks easy to spot on the desktop, even in clutter. They come in several sizes.

Product: Grid Blankbook, item no. 083739, 8 x 9 inch

Manufacture: Originally manufactured by Pentalic Corp.; currently by Taplinger Publishing Co.

Design Credit: Developed by Louis Strick, company president

Date: Introduced in 1984

Grid Blankbooks apply effective design solutions to the basic writing pad.

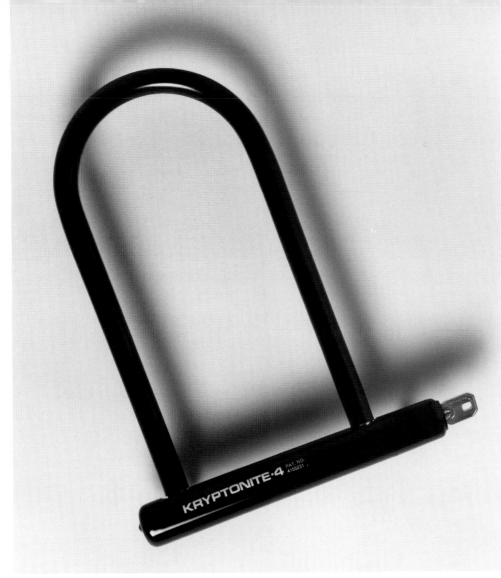

The Kryptonite Bike Lock is a winning design from any perspective.

Kryptonite Bike Lock

The Kryptonite Bicycle Lock is practical and visually elegant. Its minimal shape belies its incredible effectiveness at securing bicycles and all manner of objects. The Kryptonite's hardened carbon alloy steel defies hammers, bolt cutters, and hacksaws. The vinyl coating on the lock prevents corrosion to the lock and damage to painted or chrome surfaces. The patented disappearing hinge lock fits over both ends of the shackle. As sales of the Kryptonite lock increased in New York City, bicycle thefts dropped significantly. In this milestone design, styling, engineering, and creative problem solving dovetail to produce an outstanding product.

In addition to consumer satisfaction, the Kryptonite is revered by the design community. The Kryptonite is in the permanent design collection of Museum of Modern Art, The Product of Design Exhibit, Katonah Gallery, NEA Traveling Expo, and others.

Product: Kryptonite-4 Bike Lock

Manufacture: Kryptonite Bike Lock Corp.

Design Credit: Developed by Michael Stuart Zane, president; and Peter Lee Zane, vice president

Date: Introduced in January 1977

The Master Padlock No. 5 has made its manufacturer the world's largest padlock company.

Master Padlock

The Master Lock Co. was founded in 1921 by inventor and locksmith, Harry Soref, who improved padlocks by constructing them from laminated layers of steel, a process then in common use in bank vaults and battleship hulls. Today the Master Lock Co. makes many types of locks, from gun to ski locks; many of them still use Soref's time-proven laminated steel design.

The Master Padlock No. 5 has a laminated steel body, cadmium rustproofing, and a double-locking, maximum security pin tumbler mechanism. The protective bumper along the bottom of the padlock keeps it from damaging door and wall surfaces. The retail price is less than $10.

Product: Master Padlock No. 5

Manufacture: Master Lock Co.

Design Credit: Developed by Harry Soref, locksmith and company founder

Date: Introduced in 1931

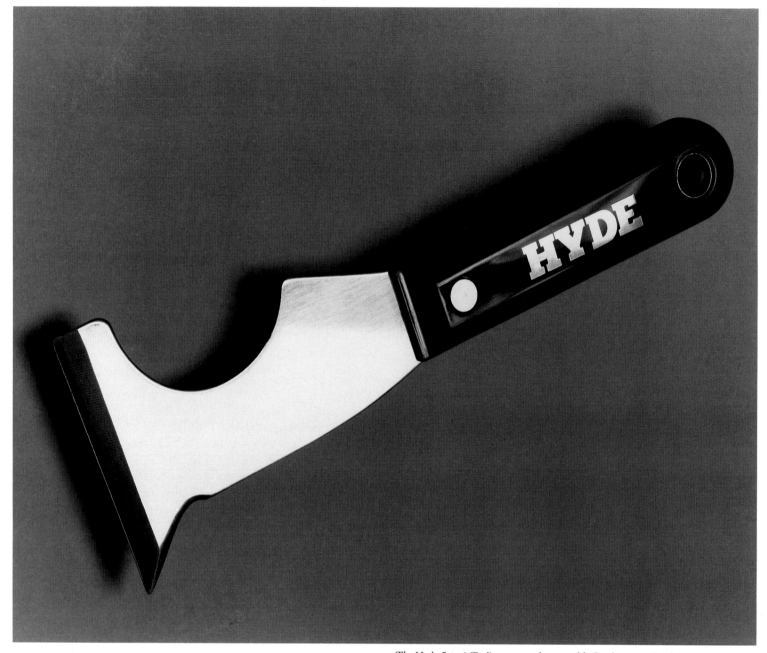

The Hyde 5-in-1 Tool's superior design yields five functions for the price of one.

5-in-1 Tool

The English, on occasion, refer to the American method of tackling design problems as the "new broom" approach (perhaps a reference to the flat broom developed by the Shakers); on this side of the Atlantic, we describe our method as the "better mousetrap" approach. Whatever the expression, the design and marketing attitude is the same: A product is subject to thorough scrutiny to determine if its design offers the best solution to the problem. No design, or the conventions behind it, is sacred and new approaches, including radical redesign, are considered if the design doesn't offer the best solution to the problem.

The 5-in-1 Tool is an example of the "better mousetrap" approach to product design. The 5-in-1 tool is virtually identical in both cost and construction materials to a paint scraper. Through evolutionary changes in the shape of the blade, a tool that performed a single task now performs five related tasks commonly required in paint preparation and application. It is a blade scraper, putty remover, spreader, paint roller cleaner,

and a crevice cleaner. Like many tools, it has become a generic design and is produced by a number of manufacturers. The design of the 5-in-1 Tool does as much as can be asked of any product's design—the scope and usefulness of the product is vastly expanded while its cost remains relatively unchanged.

Product: Hyde 5-in-1 Tool, no. 02970

Manufacture: 5-in-1 tool pictured manufactured by Hyde Manufacturing Co., neither the first nor only American manufacturer of 5-in-1 tools

Design Credit: Generic

Date: Hyde has had a 5-in-1 tool in their line at least since the mid-1960s; it is predated by other manufacturers who made 5-in-1 tools

Stanley Tools

The development of the Stanley Works is not a story of cutting edge innovation but one of steady growth and acquisition. Frederick Stanley founded the Stanley Bolt Manufactory in New England in 1843; the company has produced hardware noted for quality ever since. The name of the company was changed to The Stanley Works in 1852; in 1920 they merged with a neighboring company, The Stanley Rule & Level Company, founded in 1857 by Henry Stanley, a distant cousin of Frederick Stanley. During this time, The Stanley Works acquired other tool companies, resulting in a more diversified company committed to tool manufacture. The hand tools factory opened by them in the mid-1960s in New Britain, Connecticut was the world's largest at that time.

Stanley was the first company to package screws with hinges; this meant that hardware salesmen didn't need to search for the proper screws each time a hinge was sold. Stanley was also the first company in hardware manufacturing to produce cold-rolled hinges, circa 1870, unmatched in quality in sheet iron processing. Stanley products and packaging were featured in IDSA's *Design in America*.

Product: Stanley Toolmaster Ratchetdriver, product #68-750

Manufacture: Stanley Tools Div. of The Stanley Works

Design Credit: Joseph DeCarolis, product engineer

Date: Designed 1981–1982 and introduced in 1983

Product: Stanley Utility Knife No. 199

Manufacture: Stanley Tools Div. of The Stanley Works

Design Credit: Not available

Date: Introduced in 1936

A fairly recent addition to the Stanley line, this Ratchetdriver has interchangeable bits stored in the handle.

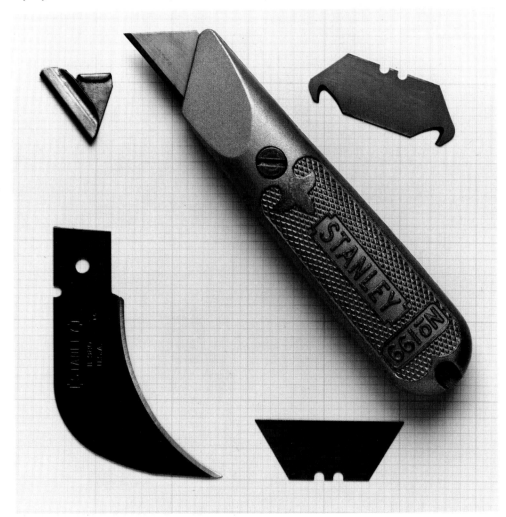

A Stanley classic, this utility knife has been in production since 1936.

Duracell Battery

The Duracell is an alkaline battery offering superior design and performance over regular zinc carbon batteries. The Duracell's minimal styling and high-tech look convincingly portray its effectiveness in all kinds of contemporary gadgets. Known for their staying power and reliability, unlike many normal batteries that lose power and die even if never used, Duracell's distinctive black and copper case communicates efficiency to the consumer.

Product: Duracell Battery, D cell

Manufacture: Originally manufactured by P.R. Mallory & Co. Inc.; currently by Duracell Inc.

Design Credit: Duracell developed by Mallory staff; designer of graphics on the battery's case is not available

Date: Introduced in mid- to late-1960s

No carbon battery looks like, or lasts like, the Duracell Battery.

Maglite Flashlight

Maglite flashlights belong to an elite class, revered for their rugged construction and indestructibility. Made of anodized, precision-machined, aircraft aluminum, Maglites are shock and water resistant. The Mini Maglite is one of the best examples of their line. Shorter than six inches long and weighing fewer than two ounces, the Mini Maglite emits a beam of light up to seventy times brighter than flashlights of similar size. It can be focused from a broad flood to a spot beam. With a varied selection of holsters, the Mini Maglite can be clipped to clothing, attached to a key ring, or hung from a belt. The tailcap holds a spare bulb.

Product: Mini Maglite Flashlight, black

Manufacture: Mag Instrument Inc.

Design Credit: Designed by Anthony Maglica, company founder

Date: Introduced in 1983

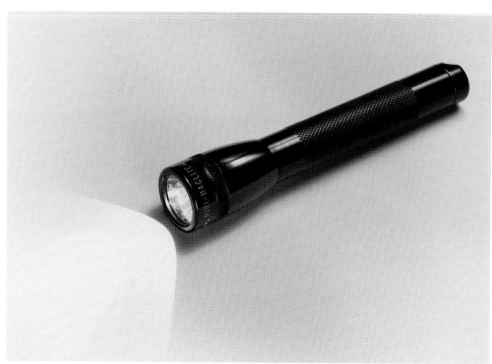

The Mini Maglite is petite, but built like a tank.

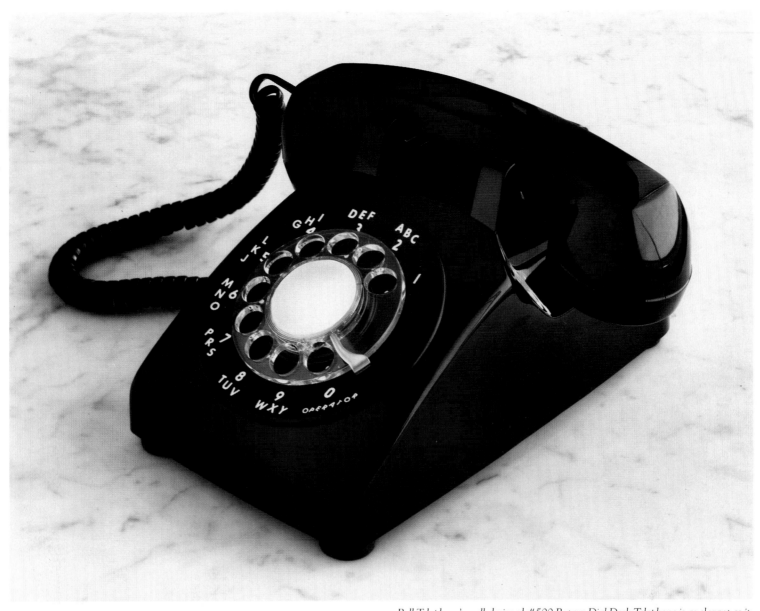

Bell Telephone's well-designed #500 Rotary Dial Desk Telephone is as elegant as it is indestructible.

Bell #500 Rotary Dial Desk Telephone

The design relationship between Henry Dreyfuss and Bell Laboratories is a classic example of how consultant design practice and manufacturing research and development work together. Dreyfuss originally turned down a $1,000 honorarium from Bell Laboratories to develop a phone design in 1929, feeling that a more extensive collaboration was necessary. A year later Bell presented a proposal that Dreyfuss accepted. The first product developed in this collaboration was the combined handset phone of 1937, considered a classic in telephone design. The project suited Dreyfuss' strong interest in designing products with high utilitarian value that did not need to adapt to capricious design trends.

By 1946 Bell Labs began a program to update the combined handset phone; they again called on Dreyfuss. The project presented Dreyfuss and Bell Labs with formidable obstacles. Before the breakup of the telephone monopoly, all phones were essentially identical and needed to be appropriate for use in both corporate boardrooms and the homes of working class families. Since Bell was responsible for maintenance and re-

pairs, the phone also had to be extremely reliable. Introduced in the early fifties, the #500 Rotary Dial Desk Telephone was the result of this collaboration. During Dreyfuss' exhaustive design effort, he used 2,248.5 man-hours for design development and drawing and 1,302.5 man-hours for design with preliminary clay models.

The #500 Desk Telephone is worthy of the effort. Now that telephones are privately owned, the American consumer can contrast this phone, which was always taken for granted, with a number of truly inferior designs. Deregulation has given a new perspective on a product that is indestructible, ergonomically efficient, and classically elegant — attributes we have discovered are not common to all telephones.

Product: Bell #500 Rotary Dial Desk Telephone, black

Manufacture: Phone pictured is manufactured by ITT; also manufactured by Western Electric

Design Credit: Henry Dreyfuss, in conjunction with Bell Laboratories

Date: Design studies began in 1946; introduced in early 1950s

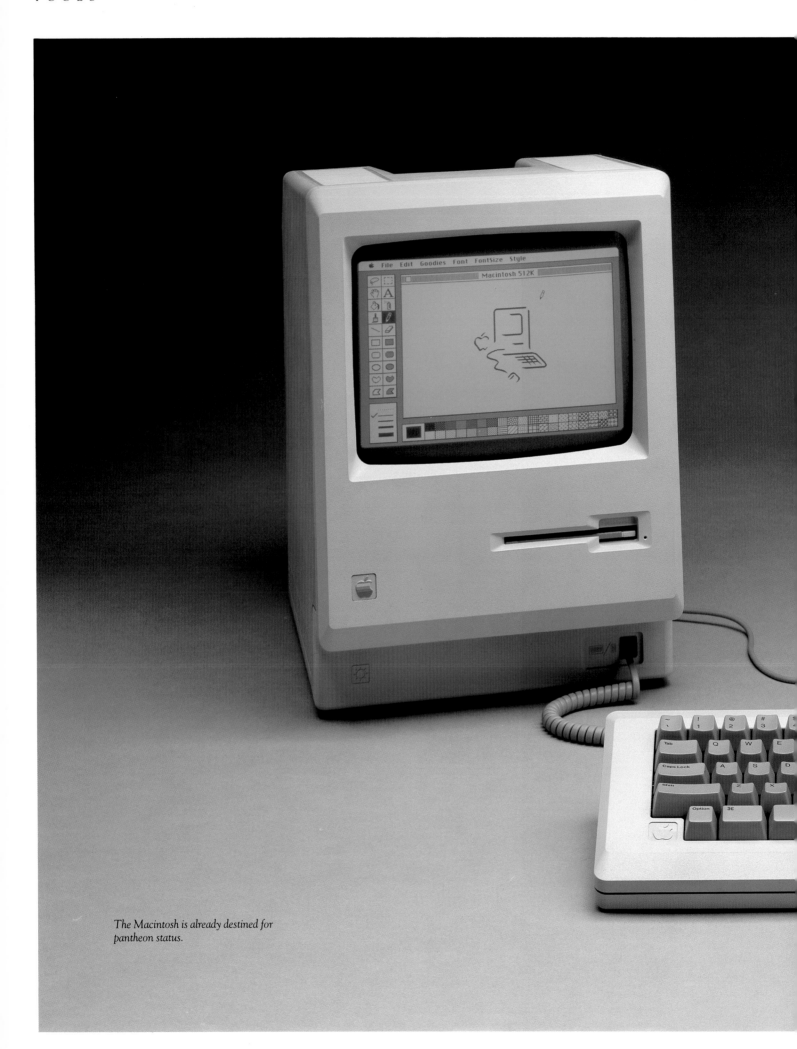

*The Macintosh is already destined for
pantheon status.*

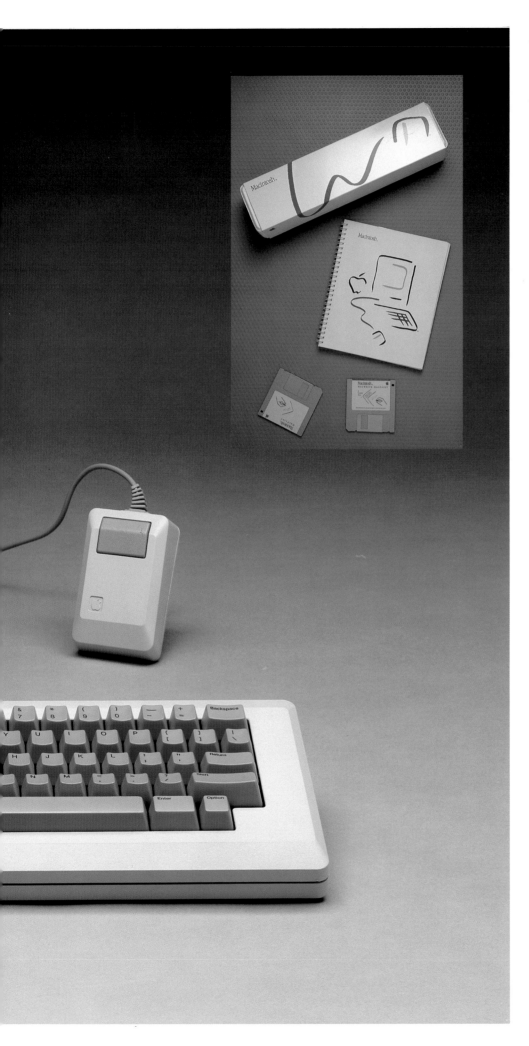

Apple Macintosh Personal Computer

A relatively new product, the Macintosh computer's pantheon status is already being predicted by authorities in the wide-ranging worlds of computer technology, product design, packaging, and marketing. From the design of the manuals to software graphics, the packaging perfectly suits the product. Scaled so that it will fit directly on a desktop (the Mac doesn't require a special workstation), the Macintosh is as portable as all but a few of the latest laptop computers. With its elegant, understated, and ergonomically sound shape, the Macintosh remained anonymous until the advent of the Macintosh Plus model, when the name of the computer appeared on the front of the machine for the first time.

The Macintosh's sophisticated operating system, the most transparent yet made, powers tremendous graphic, layout, and illustration capabilities which have virtually created a new and burgeoning desktop publishing industry. One look at the Macintosh's screen display reveals the quality of the operating system design. Instead of exhibiting by-product attributes of a cathode ray tube, as other computers do, the Macintosh screen display actually appears to be designed; it was in fact designed by Susan Kare to present information in much the same way as on the printed page or in a book. Pull-down menus represent indexes or tables of contents; scrolling is analagous to flipping pages and selecting copy to highlighting text; and electronic cut-and-paste emulates the manual method. For once a computer exhibits real-world attributes rather than existing in an electronic netherworld.

Product: Apple Macintosh 512K Personal Computer

Manufacture: Apple Computer, Inc.

Design Credit: Steve Jobs, project director; Mike Boich, software evangelist; Donn Denman, software engineer; Andy Hertzfeld, engineer; Joanna Hoffman, user interface designer; Jerry Manock, product designer; Dave Egner, engineer; Barbara Koalkin, product marketing manager; Mike Murray, project messenger; Susan Kare, software graphic design; Burrell Smith, hardware engineer; Chris Espinosa, user publications; Jerome Coonen, software group manager; Bob Belleville, product manager; George Crow, hardware designer; Bill Atkinson, application designer; Steve Capps, text editing designer; Bruce Horn, software engineer; Larry Kenyon, software engineer; Rony Sebok, ROM code tester and engineer; Tom Hughes, designer/art director for packaging and illustrations; John Casado, designer/illustrator; Clement Mok, designer

Date: Introduced in January 1984

Traditional Rural Mailbox

In 1902 rural free delivery became a permanent service provided by the Postal Service. Though controversial—many thought delivering mail to the backwoods parts of the country was impractical and costly—rural mail service became a social and cultural agent uniting city and country. And in many rural areas, roads and bridges were upgraded to accommodate rural delivery.

Before 1915 patrons of rural delivery furnished their own receptacles for mail; many were homemade and did not protect mail adequately from the elements. To alleviate this problem, the Post Office Department commissioned the design of a rural mail box and began an approval program for manufacturers. What has come to be known as the Traditional Rural Mailbox resulted.

Designed by Roy Jorolemen, who was employed by the Post Office, (Jorolemen later designed a contemporary rural box

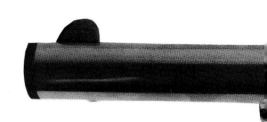

in 1959 as well as the storage/relay box found on street corners all over America) the Traditional Rural Mailbox is now an icon whose familiar shape is recognized by virtually everyone; it is as intrinsic a part of rural America as corn growing in the fields and cows grazing in the pasture.

The iconographic style of the Rural Mailbox has resulted in its use for tasks other than holding mail: In the internationally acclaimed Sea Ranch Swim and Tennis Club in northern California, the mailboxes are used as lockers. Their presence lends just the right "rural" touch to a building responsive to its pastoral environment.

Product: Traditional Rural Mailbox, size #1

Manufacture: Various; currently ten manufacturers approved by the Postal Service manufacture the traditional rural mailbox; box pictured manufactured by Jackes-Evans Co.

Design Credit: Roy Jorolemen, Postal Service designer

Date: Designed in 1915

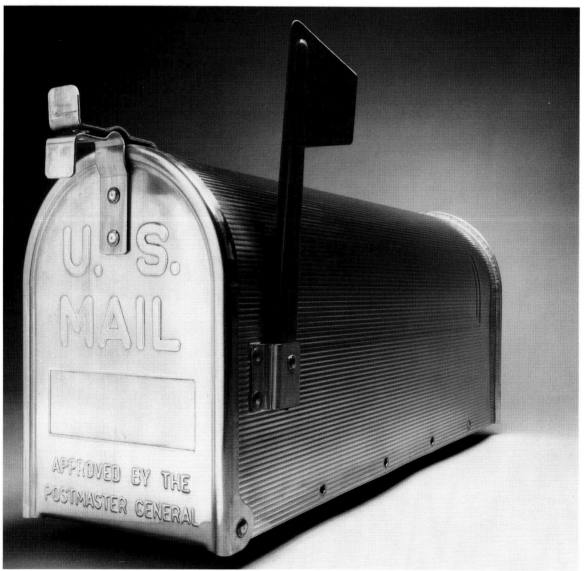

The Traditional Rural Mailbox has become an icon of rural America.

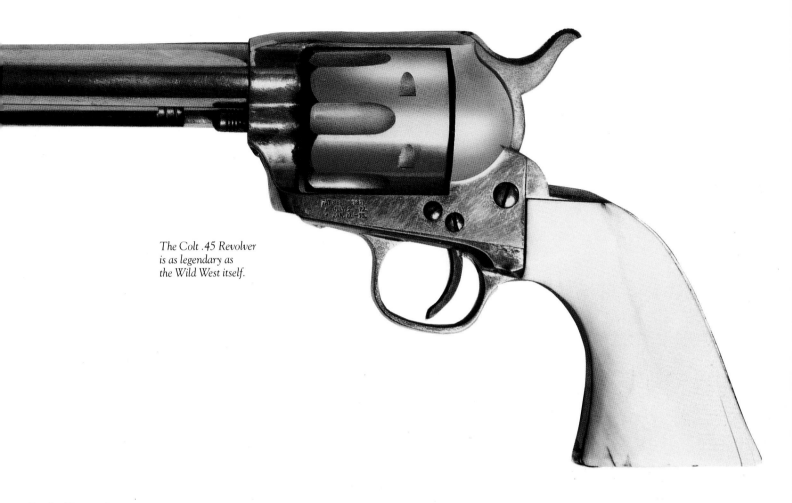

*The Colt .45 Revolver
is as legendary as
the Wild West itself.*

Colt Revolver

Samuel Colt's renowned revolver is perhaps the most famous firearm of all time. Colt, a child prodigy, could assemble firearms at the age of seven and he conceived the idea of the revolver at the age of sixteen. The revolver's rotating cylinder was inspired by the operation of a ship's wheel. Colt patented his revolver in 1836. Originally manufactured by the Whitney Works (the firearm manufactory owned by Eli Whitney), Colt established his own factory in the mid-1850s. The first products to be manufactured on an assembly line, American firearms were also the first products to use standardized interchangeable parts. (It is a common misconception that Swiss watches hold that distinction.) Samuel Colt's Hartford, Connecticut factory incorporated both innovations.

The .45 caliber, single-action, army revolver (nicknamed the Peacemaker, Six-Shooter, and Hog-Leg, among others) was a refinement of Colt's original revolver design. It is undoubtedly the most famous handgun of all time. Used extensively in the American West, the Colt .45 revolver lived up to its slogan, "the gun that won the west." The Colt .45 played a part in the Mexican War and was particularly popular with the Texas Rangers. A generic term both in America and Europe, the Colt .45 has been immortalized by Hollywood and by American television Westerns. Though there have been lapses in its production periodically, it is currently manufactured and purchased primarily for its collectibility and investment value.

Product: Colt SAA .45 Revolver, nickel finish with ivory grips

Manufacture: Colt Firearms Div. of Colt Industries Inc.

Design Credit: William Mason, designer; based on original revolver design of Samuel Colt

Date: Introduced in 1873

The John Deere Lawn Tractor is a product tailored to the American style of estate maintenance.

John Deere Lawn Tractor

There are few products as intrinsically American as lawn tractors: Only in America will individuals spend nearly $3,000 for the privilege of mowing their own lawns. Sitting atop a John Deere lawn tractor, the lord of the manor mows the lawn and performs other gardening chores in comfort and, more important, in style. Anywhere else in the world, those who could afford to spend that kind of money would hire gardeners to do the work for them—a social statement of the American work ethic if ever there was one.

Primarily known for their extensive range of farming equipment, John Deere, a classic name in American industry, is a recognized leader for developing a distinctive style in industrial equipment. Henry Dreyfuss, the pioneering American designer, created much of John Deere's line of equipment. The Hydro 165 Lawn Tractor features a hydrostatic transmission, disc brakes, and electric cranking and will mow an acre of lawn per hour. A wide range of accessories is available for other lawn and gardening chores.

Product: John Deere Hydro 165 Lawn Tractor

Manufacture: John Deere Horicon Works

Design Credit: Mike Flennikan, division manager engineering; and Gary Lindquist, marketing division manager

Date: Introduced in 1986

Lufkin Red End Extension

For over a century, carpenters and craftsmen have used folding wooden rulers, like the Lufkin Red End Extension, to measure things. While metal tape rulers are more compact and can measure greater distances, wooden folding rulers are rigid when extended and make measuring easier for one person. Practical issues aside, using a Red End Extension ruler is a matter of style over function. Some people prefer to do things the time-honored, old-fashioned way. For these people the tool that fits their style is the Lufkin Red End Extension.

Product: Lufkin Red End Extension Ruler, 6-foot length

Manufacture: Cooper Industries

Design Credit: Generic

Date: Wooden folding rulers have been in production for over a century

Milwaukee Magnum Hole Shooter Drill

American power tools are world famous for their rugged dependability and quality of design. One of the leading names in American manufacturing in this area is the Milwaukee Electric Tool Corp. Their Magnum Hole Shooter is a heavy-duty, one-half-inch reversible drill with a side handle, a brush cartridge allowing for field replacement or servicing of motor brushes, and a "quick-lok" cord that attaches at the handle base. The Magnum Hole Shooter combines the visual styling of a Buck Rogers ray gun with a long-standing reputation for being equal to any drilling task. Another Milwaukee power tool classic is the Sawzall, the ultimate reciprocating sawing tool, a cornerstone in Milwaukee's power tool line since 1949.

Product: Milwaukee Magnum Hole Shooter Drill, ½-inch reversible

Manufacture: Milwaukee Electric Tool Corp.

Design Credit: Milwaukee engineering staff

Date: Introduced in 1974

Lufkin Red End Extension is an old-fashioned measuring tool.

The Magnum Hole Shooter Drill is a rugged drilling tool with Buck Rogers styling.

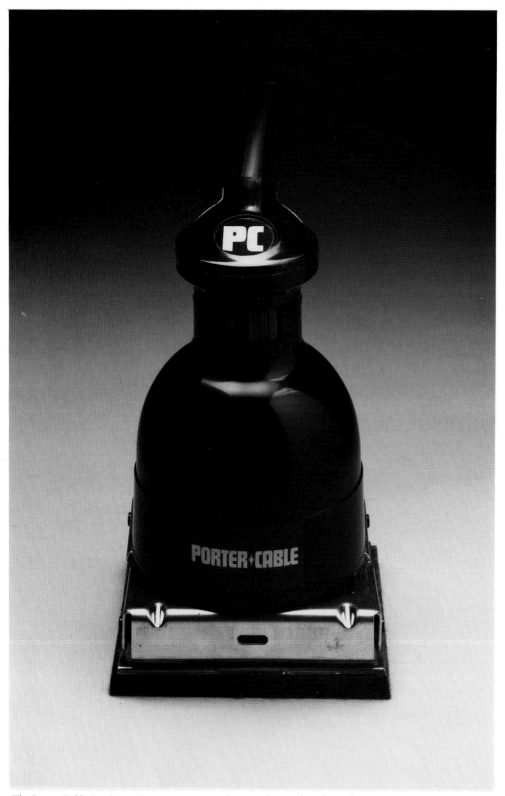

Porter-Cable Finishing Sander

In 1940 the Porter-Cable Machine Company introduced the first orbital finishing sander to the construction market. Developed during the twenty-year-long era when Porter-Cable was owned by Rockwell, the Model 330 was originally marketed under the Rockwell name but has been all-American throughout its production life. The ergonomically designed 330 can be operated with one hand in any work position—even overhead.

Porter-Cable has enjoyed a long history of innovation and development in the power tool field. Its products are known for their durability under the strain of constant use and abuse. As foreign made, lighter-duty power tools have gained popularity in the handyman market, professional contractors continue to swear by the heavy-duty, American-made power tools from the likes of Porter-Cable.

Product: Porter-Cable 330 Speed-Bloc Sander

Manufacture: Originally manufactured by Rockwell Manufacturing Co.; currently by Porter-Cable Corp.

Design Credit: Ken Leach, project engineer

Date: Introduced in 1965

The Porter-Cable Sander combines an ergonomic design with rugged mechanical components.

IBM Selectric Typewriter

A milestone in typewriter design, the IBM Selectric's eighty-eight characters appear on interchangeable spherical balls instead of on traditional typing keys. Type faces and point sizes can be easily changed, making the typewriter a more versatile machine.

Eliot Noyes was the product designer for the Selectric and for many other IBM products. Prior to his relationship with IBM, Noyes worked for Norman Bel Geddes. Later in his career he briefly directed the Industrial Design department at New York's Museum of Modern Art. Noyes is credited with solidifying IBM's product and corporate image; he also hired Paul Rand to design the minimal, highly effective IBM logo. Rand, considered one of America's premier graphic and logo designers, also designed logos for such giants as ABC, Westinghouse, and UPS. Rand's design relationship with IBM continues and includes packaging, product, and corporate literature.

Product: IBM Selectric Typewriter

Manufacture: International Business Machines Corp.

Design Credit: Product design by Eliot Noyes; IBM logo designed by Paul Rand

Date: Introduced in 1961

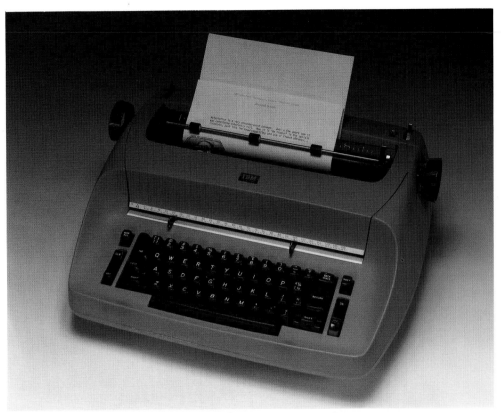

The IBM Selectric represented a quantum leap forward in typewriter technology.

Rolodex Rotary Card File

The Rolodex's simple, logical design has become almost universal for the office chore of organizing names, addresses, and phone numbers. Files can be kept in perfect order at phone side, making them easy to use and update. The color-coded cards come in several sizes. Described as an economy model, the Rolodex 5024 is appropriate to any desktop, from high-tech to rolltop. Although designed in the precomputer age of the 1950s, the Rolodex has adapted marvelously to computer filekeeping by offering computer software that allows databases to be printed out on continuous, pin-fed Rolodex cards.

Product: Rolodex Rotary Card File, model 5024X

Manufacture: Rolodex Corp.

Design Credit: Developed by Arnold Neustadter, company president, and Hildaur Neilsen, engineer

Date: Introduced in 1958

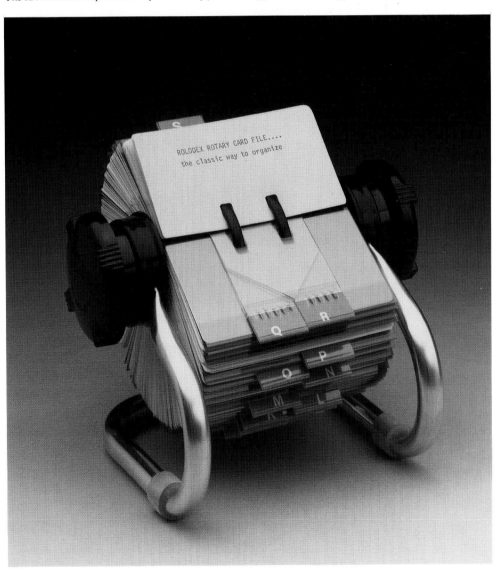

The Rolodex file is a desktop classic that not even computers can render obsolete.

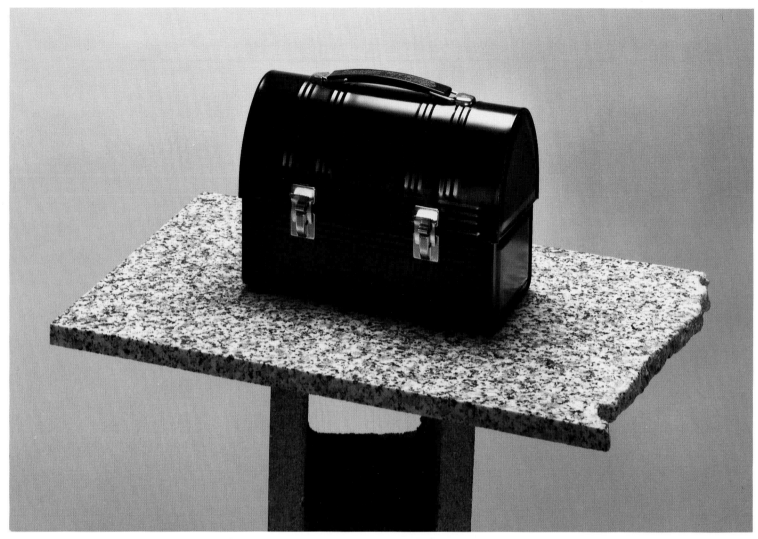

Aladdin Workman's Lunch Kit has become a working class icon.

Aladdin Workman's Lunch Kit

As iconographic as the hardhat at construction sites is Aladdin's Workman's Lunch Kit. The rounded top contains a thermos for beverages and has ample room below for sandwiches, chips, and fruit. Originally constructed of metal, the Workman's Lunch Kit is now made of unbreakable plastic. Aladdin has recently introduced a new line of brightly colored children's lunch kits, of all-plastic construction, inspired by the classic Workman's Kit.

Product: Aladdin Workman's Lunch Kit, black

Manufacture: Aladdin Industries Inc.

Design Credit: Not available

Date: Introduced circa 1921

Stanley Steel Thermos

William Stanley created the Stanley vacuum bottle in 1913. It was the first and, until the mid-1960s, only all-steel thermos made. Other Stanley vacuum container products have served industrial tasks ranging from transportation and storage of human organs to insulating instrument shrouds for NASA's lunar and Martian space probes.

The Stanley Thermos, currently manufactured by Aladdin, does not have to be treated as the fragile instrument that some thermoses are. Systematically improved since its introduction, the Stanley Thermos offers greater thermal efficiency and durability. It is capable of withstanding all the abuses the workplace has to offer and was restyled in the late-1960s. It features a threaded stopper and insulated cup. Like the Workman's Lunch Kit, the Stanley Thermos has a basic, functional appeal that fits in comfortably in the working class environment.

Product: Stanley Steel Thermos, No. A-943C, one-pint capacity

Manufacture: Originally manufactured by Stanley Insulating Co.; currently by Aladdin Industries Inc.

Design Credit: Invented by William Stanley with subsequent design modifications by Harry Badger and John Eza

Date: Designed in 1913 and introduced in 1915; current style based on modifications made in 1953 and 1968

Using steel instead of glass, the Stanley Thermos transforms a delicate product into a rugged one.

FURNISHINGS AND FIXTURES

To an almost equal extent that the Housewares chapter has a thirties bent, this chapter pays tribute to design styles that prevailed in the fifties. The reason is quite simple. When it comes to furniture design, the fifties were a decidedly American era. Europe was in a shambles and rebuilding from the devastation of World War II, while America enjoyed unprecedented prosperity and dominance on the international scene. Out of this era a distinctly American lifestyle emerged and with it a design look now enjoying a resurgence of popularity after two decades of disdain.

In the fifties, the painter's palette was considered the ultimate shape. Everything was patterned to look like it. Free-form tables with tapered legs complemented molded plywood chairs, while atomic-looking wall clocks counted the minutes to the start of "The Honeymooners," beamed electronically to contented, modern suburban homes.

In designing the Molded Plywood Chair, Eames followed his design credo: "Get the most of the best to the greatest number of people for the least."

Eames Molded Plywood Chair

Charles Eames, one of America's most important designers, conducted exhaustive tests and experimented with plywood molding techniques. The results are several now-classic chair designs. Although comfort is frequently an overlooked criterion when accolades go out to furniture designs, Eames' molded plywood chair is unusually comfortable. (The much-heralded Aalto bent plywood chair is as extremely uncomfortable as it is beautiful; similar complaints have been lodged against Breuer's Wassily chair.) Eames' designs using wood and fiberglass molding techniques fit the human form. Like all of his furniture, the molded plywood chair bears an unmistakable signature— his work never had a derivative quality.

In addition to his chair designs, Eames designed toys, modular storage systems, and a house built entirely of ready-made industrial parts. The Metropolitan Museum of Art curated a one-man show of his furniture design in 1946, and in 1978 Eames received the gold medal of the American Institute of Graphic Arts.

Product: Eames Molded Plywood Chair

Manufacture: Originally manufactured by Evans Products Co.; currently by Herman Miller Inc.

Design Credit: Charles Eames, designer

Date: Designed circa 1946

Formica Decorative Laminate

Developed in 1913 by Dan O'Conor, an engineer for Westinghouse, Formica—meaning *instead of mica*—was not marketed initially as a decorative laminate surface; rather, it replaced mica as an insulating material for commutator rings in electric motors. Soon after applying for a patent, O'Conor left Westinghouse to join Herb Faber, an ex-Westinghouse sales manager, to form a company to market the new product.

Formica's first attempts to make a decorative laminate came in the mid-twenties. The first product was a wood-grained sheet used on the front panel of radios. At the behest of the Liquid Carbonic Corporation, Formica developed an imitation marble laminate used for soda fountain counters. By the early thirties designers used black and chrome designs extensively, making black laminate the biggest seller. Proof of the durability of Formica laminate as a countertop surface came when Formica's laminate was specified on the Queen Mary. After World War II, when the Queen Mary was refitted for civilian service, the Formica surfaces were found to have survived the war unscathed.

Over the years Formica has produced many decorative designs for its laminates. Designs like Nettie Hart's skylark pattern are successful primarily because the shapes do not imitate patterns occurring in another material, such as wood grain or stone, thus making the design unique to Formica laminate.

Product: Formica, white skylark pattern

Manufacture: Formica Corp.

Design Credit: Formica invented by Dan O'Conor, engineer and joint founder of Formica Corp.; skylark pattern originally designed by Brooks Stevens Assoc.; redesigned by Nettie Hart, a designer in the Chicago office of Raymond Loewy Assoc.

Date: Formica developed in 1913; Formica decorative laminate first introduced in mid-1920s; skylark pattern first introduced in 1950, reintroduced in 1954

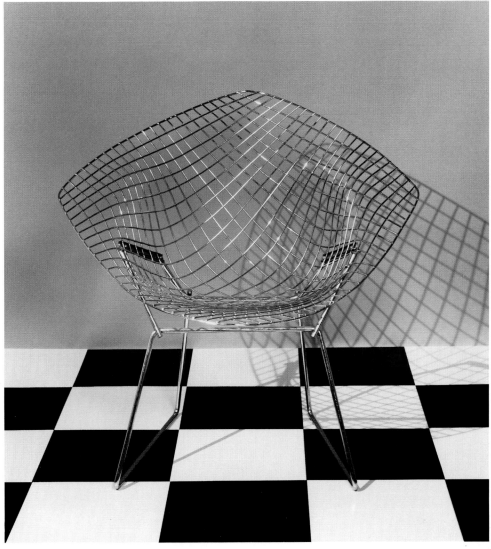

The Diamond Chair is functional sculpture.

Formica's skylark pattern doesn't attempt to imitate patterns occurring in other materials; it is unique.

Bertoia Diamond Chair

The Diamond Chair, designed for Knoll by Harry Bertoia, has been in production since 1952. Its decidedly fifties style is enjoying a tremendous rebirth. Designed to be covered with a cushion, the diamond grid of chrome wire is so stunning that most people leave the cushion off. An associate of Charles Eames, Bertoia taught with Eames at Cranbrook Academy. He later went with Eames to California to collaborate on chair designs. Bertoia said of his diamond chair, his most remembered furniture design, "When you get right down to it, the chairs are studies in space, form, and metal, too. If you look at them, you will find that they are mostly made of air, just like sculpture. Space passes right through them."

Product: Diamond Chair

Manufacture: Knoll International

Design Credit: Harry Bertoia, designer

Date: Introduced in 1952

The Servador Table Smoker is the "smoker's article of distinction."

Smokador Ash Stand

The ash stands made by the Smokador company graced the interiors of smoking lounges, theater lobbies, and similar public and private spaces in an era when smoking was a social activity to be executed with style and grace. Introduced in 1934, the Servador Table Smoker was reissued in 1958 and not taken out of production until 1974. Its lengthy production cycle testifies to its enduring popularity.

Smokador products feature a patented smoke trap baffle with a Mason jar beneath to provide a receptacle for burning stubs. This design prevents butts from accumulating in the ash stand and automatically extinguishes them, both of which make smoking a neater endeavor. Another interesting line of Smokador products was the Whirl-o-Matic, an ash receptacle that disposed of butts through a spinning device.

Product: Servador Table-Smoker Ash Stand

Manufacture: Smokador Corp.

Design Credit: Smokador staff

Date: Introduced in 1934

Sears Modern Freestanding Fireplace

Many freestanding fireplaces of modern design are patterned after the designs of Seattle architect and furniture designer, Wendell Lovett. Lovett, who created his fireplaces for residential commissions primarily on Puget Sound, made the innovative design decision to incorporate this fireplace into American homes. One of his most popular and influential designs was the firehood fireplace of 1953. His original firehood design was manufactured first by Condon-King Company and then, until the mid-seventies, by the Majestic Company.

Clearly a modern design descendant of the wood stoves used in frontier homes for heat and cooking, these fireplaces today turn up most often in vacation homes and other rustic settings. The fireplace pictured is a knock-off of Lovett's firehood, made by that great American institution, Sears and Roebuck.

Sears' knock-off of Lovett's firehood produces a modern twist on nineteenth-century wood stoves.

Product: Sears-Roebuck knock-off of Lovett Firehood Fireplace

Manufacture: Fireplace pictured manufactured for Sears-Roebuck; original manufactured by Condon-King and later by Majestic Co.

Design Credit: Based on original design by Wendell Lovett

Date: Firehood introduced in 1953; fireplace pictured manufactured in mid-1970s

The Philco Predicta was an abruptly innovative television design.

Philco Predicta Television

In 1958 Philco boldly introduced the Predicta television line. Although Philco used the design services of Norman Bel Geddes for its radio designs in the 1930s, the Philco Predicta was a striking departure for a company not hitherto noted for innovative styling. The Predicta lived up to its name in numerous ways: It predicted future design directions for television that treat the television as the high-tech instrument it is rather than disguise it as a piece of furniture. The Predicta line also featured a model with a completely detachable picture tube connected only by a cable to the chassis, a design that anticipated the modularization of television components. This design eliminated the need for remote control, since the chassis could be located within arm's reach while the picture tube remained across the room.

Watching television on a Predicta is an experience as unique as the Predicta's design. Since the cathode ray tube is detached, the screen image seems to float in space, making the viewer aware of just what a remarkable process television broadcasting is.

Product: Philco Predicta Television
Manufacture: Philco Corp.
Design Credit: Philco staff
Date: Introduced in 1958; model pictured is of early 1960s vintage

Holophane Prismatic Luminaire

Holophane's prismatic reflector was developed and patented in Paris near the end of the nineteenth century. A Holophane plant began operations in the United States a few years later as a subsidiary of Holophane of England. So successful was the American division that it became independent of the English parent in the 1920s, and later bought it out.

All Holophane light fixtures use the patented glass prismatic reflector to direct a beam of light from an incandescent bulb. Like the Abolite RLM fixture, Holophane was developed to light such large, high-ceilinged workplaces as warehouses and factories. Seventy percent of the radiant light is beamed down to the work plane; the remainder increases the ambient light level and prevents a cavern effect.

Although many styles of light fixture were marketed internationally under the Holophane name, the American-designed Holophane Lobay Luminaire differed substantially from models in other countries. Designed by Vearl Wince and Kurt Franck in the mid-1930s, it was the first Holophane fixture to use exposed struts to hold the reflector in place—a feature since used extensively on American holophane models. The Holophane Lobay Prismatic Luminaire has outgrown its early industrial applications and is used today in a variety of ways.

Product: Holophane Lobay Prismatic Reflector Luminaire #684

Manufacture: Originally manufactured by Holophane Co. Inc.; currently by Holophane Div./Manville Corporation

Design Credit: Designed by Vearl S. Wince and Kurt Franck

Date: Introduced in 1935–1936

Today, the Holophane's radiant glow lights more than warehouses.

The Abolite RLM is yet another example of an industrial product that gained universal acceptance.

Abolite RLM Fixture

The RLM, an industrial fixture, made its reputation as an excellent light source for factories and warehouses. Abolite is one of the oldest and largest, but not the only, American manufacturer of RLM fixtures (RLM, an abbreviation for Registered Luminaire Manufacturers Institute, has become a generic name for porcelain-over-metal reflectors). Over the years its universal appeal has spread to virtually all lighting situations in the workplace and in the home. The porcelain enamel finish, which comes in a variety of colors, makes the RLM suitable for use outdoors. Socket types that can be hung from a cord or conduit or attached directly to a canopy are available.

RLMs are widely imitated by other manufacturers who make pendant fixtures, sometimes calling them "warehouse" lamps, a reference to the RLM's initial application. The RLM has had a profound design influence on pendant type lighting designs in general. In addition to Abolite's standard dome series of reflectors, the radial wave is a playful reflector design used extensively in the era preceding mercury vapor lights as a reflector for incandescent street lights.

Product: Abolite RD150 RLM Fixture, standard dome, white

Manufacture: Originally manufactured by Adams-Bagnall Electric Co; currently by Abolite Lighting Inc.

Design Credit: Not available

Date: First Abolite RLMs appeared in early 1900s; current "standard dome" style appeared in 1930s

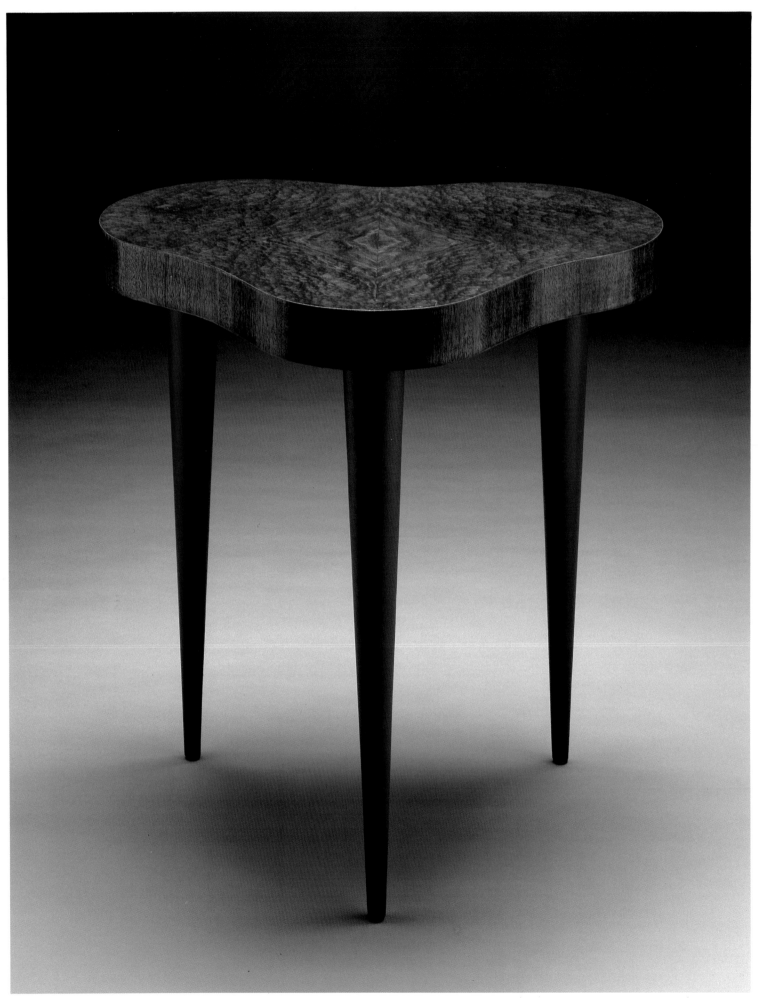

Rohde's Occasional Table for Herman Miller is one of the earliest free-form designs.

Rohde Occasional Table

Gilbert Rohde's occasional table for Herman Miller is a progressive piece of design that preceded by a decade the intense popularity of the free-form, curvilinear shapes of the fifties and early sixties. Rohde was a very important American furniture and product designer who, although never excluded from major retrospectives on American design, generally does not receive the acclaim that other designers such as Nelson, Eames, or Loewy do. Rohde was a founding member of the Industrial Designers Society of America and a prolific designer for Herman Miller.

Product: Rohde Occasional Table, mink-stained, myrtle burl veneer top with leathercloth covered legs

Manufacture: Herman Miller Inc.

Design Credit: Gilbert Rohde, designer

Date: Introduced in 1941

Nelson Platform Bench

Timelessly contemporary, George Nelson's platform bench was designed for multiple use: as a bench for sitting, as a coffee table, or as a base for a modular cabinet system. The Platform Bench is probably not Nelson's most famous design, although it is a personal favorite of mine. His most-remembered design is probably his wall clock resembling the spokes of a wheel, with large spheres marking the hours. It is considered one of the more outrageous timepieces of the 1950s.

Nelson succeeded Gilbert Rohde as design director at Herman Miller and was responsible for Charles Eames' employment there. During his remarkable career, he served for nine years as editor of *Architectural Forum* and was a regular contributor to *Industrial Design.* He has written three books on product design.

Product: George Nelson Platform Bench, black

Manufacture: Herman Miller Inc.

Design Credit: George Nelson, designer

Date: Introduced in 1947

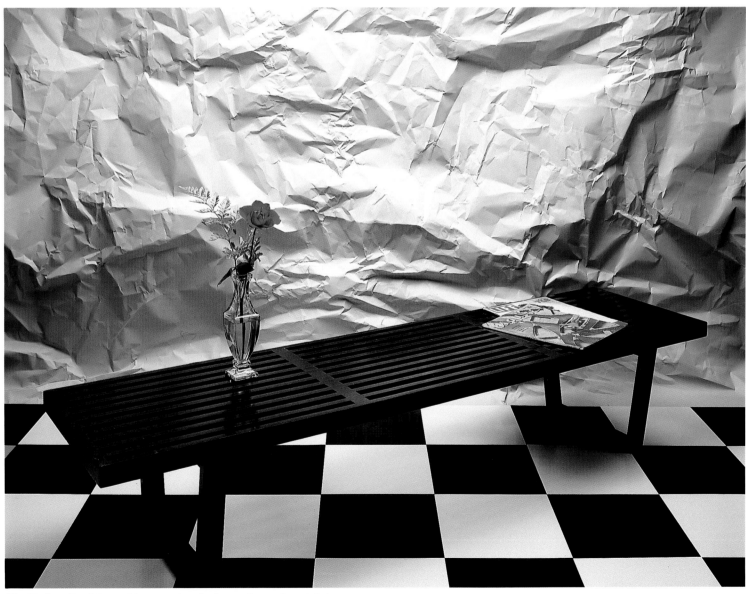

The Platform Bench is a multipurpose piece that has not become a period piece.

PHOTOGRAPHIC PRODUCTS

If there is a modern American folk art, it is the snapshot. The voracious appetite Americans have for documenting their existence with photographs is without equal. American innovators such as George Eastman and Edwin Land helped fuel this national obsession by inventing the technology and products necessary to the creation of ubiquitous slide shows and home movies—endeavors that have long since crossed over into the realm of family ritual.

America is a world leader in the pursuit of photography as an art form; from Matthew Brady to Ansel Adams, we make a legitimate claim to the most impressive list of masters of the photographic art. In this environment, photography is pursued as a serious creative endeavor with a larger and more ardent following than in any other culture.

With a technology jointly developed by George Eastman and Thomas Edison, the motion picture evolved, in front of a rapt and accepting audience, from still photography into an infant art form. Today we are the world's leading producer and exporter of motion pictures. Whether as a weekend hobby, a serious art form, or a provider of pure entertainment, the photographic process plays a major role in American life.

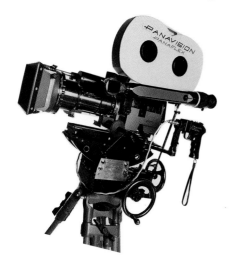

No darkroom is complete without the Gra-Lab Timer.

Gra-Lab Timer

The Gra-Lab Timer is a fixture in virtually every darkroom in America. The Gra-Lab Timer lasts forever; a photographer need buy only one in a lifetime. Virtually identical to the first timers the company made in the mid-1940s, today's Gra-Lab 300 features a dial with large, easy-to-read numerals that glow in the dark. The metal case has a polyurethane finish and can be wall mounted or used on a table top. Its outlets can control the operation of safelights or enlarger. With its early low-tech charm, the Gra-Lab 300 also doubles as a kitchen timer or turns other household appliances on and off.

Product: Gra-Lab 300 Timer
Manufacture: Dimco-Gray Co.
Design Credit: Floyd Gray, company founder
Date: Introduced circa 1944

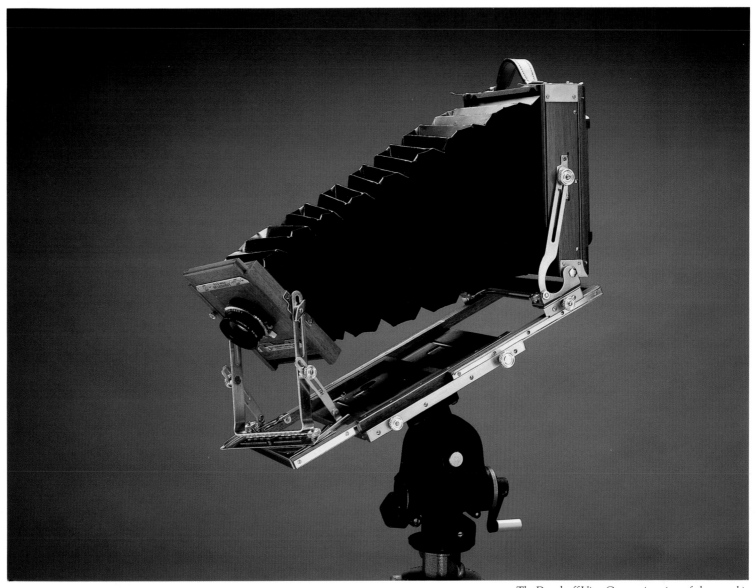

The Deardorff View Camera is a piece of photographic history.

Deardorff View Camera

First introduced in 1923, the Deardorff View Camera's basic design has been modified over the years and applied to all the cameras made since by L. F. Deardorff & Sons. A family-run business, Deardorff believes that tradition and craftsmanship mark a great product. The newest piece of equipment Deardorff uses in their factory dates from 1923; other equipment boasts nineteenth century origins.

Deardorff View Cameras are crafted from Honduran mahogany cured for seven years before being brought to the United States for kiln drying. (The mahogany is the only component not made in the United States.) The original 1923-vintage cameras were hand lacquered and hand rubbed to a piano finish and all metal work polished and rubbed with French emery.

Laben Deardorff, the founder of the company, belonged to the Dunkard (Church of the Brethren) faith, a completely self-sufficient religious group. His motto was: "If you need anything, make it yourself." Still hand-made, this same meticulous attention to detail remains a constant in contemporary Deardorff cameras. A lengthy and international list of commercial photographers and serious amateurs swear by Deardorff cameras, as do organizations ranging from NASA to the Metropolitan Museum of Art.

Product: Deardorff 4 x 5 Special View Camera

Manufacture: L. F. Deardorff & Sons

Design Credit: First camera designs, Laben Deardorff; since modified by Deardorff staff

Date: Deardorff 8 x 10 View Camera, on which the 4 x 5 Special is based, introduced in 1923

The Domke Camera Bag was designed by a photographer to meet the demands of location photography.

Domke Camera Bag

James Domke was a staff photographer for the Philadelphia *Inquirer* in 1976 when he first used the camera bag he designed for himself at the behest of his newspaper. Tired of buying bags that didn't hold up to the grueling demands of photojournalism, the *Inquirer* commissioned Domke to design something that would. Other photojournalists saw the bag—referred to as the *Inquirer* bag at that time—and became interested in it. The newspaper began selling so many bags that Domke took over the business in 1977, finally quitting the paper altogether in 1980.

The Domke bag has since become the most popular bag among press photographers. They manufacture a full line of bags for photo gear from light stands to tripods. Domke's first product, the

original F-2 bag, introduced the idea of wrapping the strap around the bottom of the bag for extra security. A patented modular system of inserts made the bag easy to customize to each photographer's specific gear. All Domke bags are made of 100 percent cotton duck instead of the more common synthetics. In addition to having a nicer feel than the synthetics, cotton duck can be treated to be water repellant.

Product: Domke F-1 Camera Bag, navy blue and tan

Manufacture: Originally manufactured by James G. Domke, proprietor; currently by J. G. Domke Enterprises Inc.

Design Credit: James G. Domke, designer and product developer

Date: Introduced in 1976

Graphic Press Camera

The Speed Graphic and Century Graphic Press Cameras were a fixture with American photojournalists for decades, until they lost out to the smaller, newer 35mm cameras. The Press Camera was a modification of a flatbed view camera that could be hand held; it focused and composed an image without having to view through the lens—a tedious and time consuming process with view cameras. Although no longer produced, the basic design of the Graphic Press Camera has been emulated in many technical cameras of German and Japanese manufacture. The Graphic Press had an outstanding reputation for its ability to take the kind of abuse that photojournalism demanded. Photojournalists always said they carried two Graphic Press Cameras

for location assignments—one to stand on and the other to photograph with. This was the camera used by many well-known American photojournalists, including Weegee the Famous.

Weegee the Famous played an instrumental role in developing the American style of photojournalism. A blare of light from the Graphic Press Camera's powerful flashbulbs froze everything in Weegee's nighttime photographs of murderers and the murdered, mobsters and Mafiosi. His stark and intrusive style was ideally suited to the macabre and bizarre scenes he favored; his photographs often appeared on the covers of sensationalist dailies whose primary concern was selling newspapers. This photographic parallel to yellow journalism contrasted markedly to the more compassionate, naturally lit photographs made by European photographers like Henri Cartier-Bresson, who preferred the 35mm camera.

Product: Century Graphic Press Camera

Manufacture: Graflex Inc.

Design Credit: Graflex staff

Date: Designed in 1946–1947; camera pictured is of mid-1950s vintage

Kodachrome Film

Kodachrome film was the first color film in the world simple enough for amateur use. To many photographers, professional and amateur alike, it is still the best color slide film available. Known for its incredibly rich colors (especially reds), high contrast, and extremely fine grain, it is almost mythic in its reputation in the photographic community. Most experts would acknowledge that anyone can take professional-looking pictures given a bright sunny day, nature's beauty, and a roll of Kodachrome.

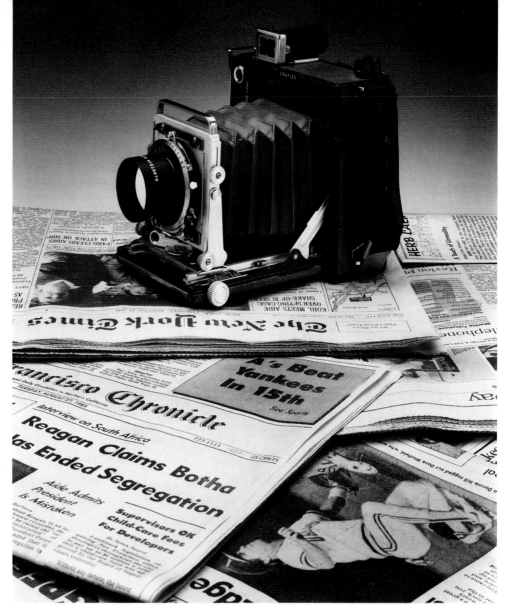

The Graphic Press Camera became a fixture with American photojournalists.

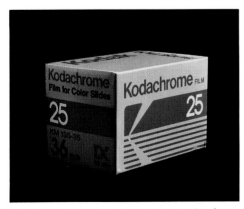

Kodachrome film is a favorite of professional and amateur photographers the world over.

The film originally was developed by two unlikely candidates, Leopold Mannes and Leopold Godowsky, both of whom came from families renowned in the music world. Mannes was the son of David Mannes of the Mannes School of Music in New York and Godowsky was the nephew of George Gershwin; both Mannes and Godowsky were professional musicians by training. They shared a fascination with color photography and spent almost twenty years of their lives developing a practical color process.

Kodachrome film, which requires a proprietary processing method available from Eastman Kodak, yields a color transparency or color positive, not a negative. While this was a logical end product for home movies, it was awkward for the still photographer. However, in a farsighted move, Kodak mounted the color positives in 2 x 2-inch cardboard mounts that could be projected onto a screen. Voila! The home slide show was resurrected from

the era of lantern slides shown in Victorian parlors. Kodak later marketed a well-designed projector and slide tray system—the Carousel—to facilitate home and commercial slide viewing.

Product: Kodachrome 25, 135-36, 35mm film

Manufacture: Eastman Kodak Co.

Design Credit: Leopold Mannes and Leopold Godowky in conjunction with Kodak Research Laboratories

Date: Kodachrome movie film introduced in 1935; Kodachrome slide film introduced in 1936

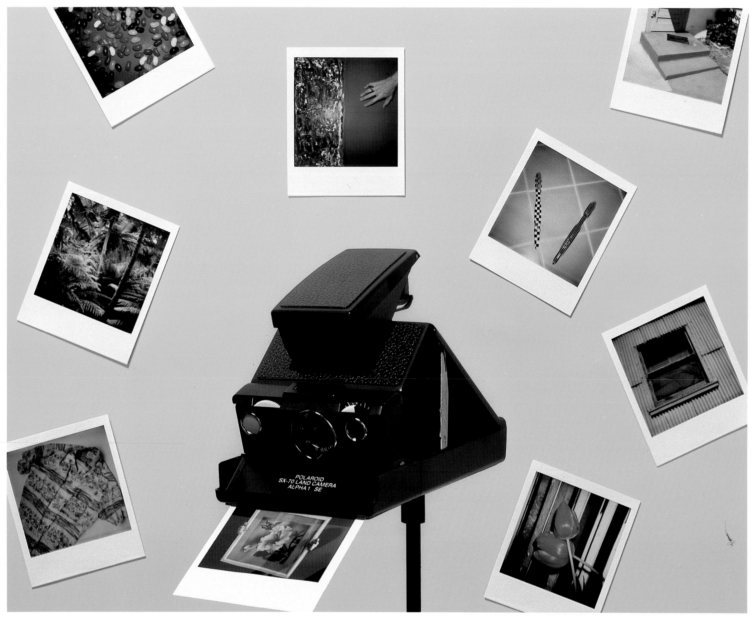

The SX-70 camera is yet another jewel in Polaroid's studded crown.

Polaroid SX-70 Camera

On February 21, 1947 the Optical Society of America witnessed a truly remarkable milestone in the history of photography: Dr. Edwin Land's announcement of his invention of the instant-picture process. The impact to both professional and amateur photography was dramatic and sustained. Augmented and refined continuously since that time, the instant-picture process has continued to evolve. In 1972 Polaroid introduced an astounding camera system, the SX-70. Designed by Henry Dreyfuss just prior to his tragic suicide in 1972, the SX-70 is a sophisticated single lens reflex camera that collapses compactly for storage or transport. The color film develops instantly in normal indoor light; there is nothing to peel or throw away.

With the SX-70, snapshooters experience the thrill of instant gratification and professionals achieve images noted for their unique, stylized photographic properties. Within the arts community, the acceptance of the SX-70 is substantial. Multimedia artists and photographers as diverse as Lucas Samaras, Andy Warhol, Helmut Newton, Ansel Adams, and David Hockney have produced serious photographic work with the SX-70.

The Polaroid Corporation enjoys universal respectability. Financiers consider Polaroid to be a prestige stock and covet it for investment portfolios; the photographic community stands in awe of the company for their continuing innovations in instant photography; and the design community has honored Polaroid frequently for product packaging—William Fields' striking design for the Swinger package comes to mind—and many Polaroid cameras have been included in product design collections. Polaroid's product and corporate literature has also garnered awards for excellence in graphic design.

Product: Polaroid SX-70 Camera, Alpha 1 SE

Manufacture: Polaroid Land Corp.

Design Credit: Henry Dreyfuss, product designer; Polaroid staff designed electronics, optics, and camera mechanics

Date: Introduced in 1972

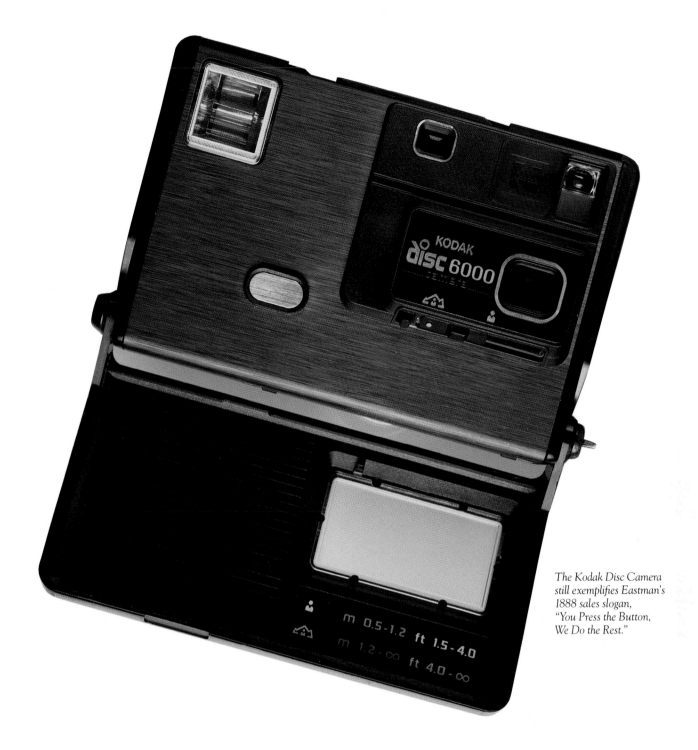

The Kodak Disc Camera still exemplifies Eastman's 1888 sales slogan, "You Press the Button, We Do the Rest."

Kodak Disc Camera

In 1888, George Eastman introduced a box camera measuring 3¼ × 3¾ × 6½ inches. The consumer purchased it preloaded with film sufficient for 100 exposures; when the roll was finished, the entire camera was mailed in for processing. Along with the finished prints came a newly loaded camera. Eastman called his camera a Kodak, a word he chose himself because it was short; could be pronounced in any language; and, he hoped, was easy to remember. The Kodak brought photography to the masses and produced that modern American folk art—the snapshot.

Through the years, Eastman Kodak Company has produced many classic "automatic" cameras. In the 1930s some Kodak Brownie cameras were designed by Walter Dorwin Teague, who had an illustrious design relationship with Kodak. The contemporary descendant of that first Kodak box camera is the Kodak disc camera, a thin, compact camera that offers cartridge film loading, automatic exposure, and automatic film advance. A built-in automatic flash engages indoors and in low-light situations. The lithium cells, with their long shelf life and sufficient energy for years of use, make replacing batteries obsolete. The disc camera incorporates the latest advances in film technology, giving the photographer the space-saving benefits of a very small camera while maintaining picture quality.

Product: Kodak 6000 Disc Camera

Manufacture: Eastman Kodak Co.

Design Credit: Developed by the Kodak Apparatus Division of Eastman Kodak Co.

Date: Introduced in 1982

Panavision Movie Camera

It is only proper that the world's greatest movie camera be made in southern California near Hollywood's legendary studios. The Golden Panaflex is a pin-registered 35mm reflex camera that can be converted from a studio to a hand-held configuration in sixty seconds. With its impressive array of state-of-the-art features, the Panaflex's list of movie credits is longer than those of Cecil B. DeMille and Frank Capra combined. Used by filmmakers throughout the world, the Panaflex is the quintessential movie camera.

Panaflex's marketing is as innovative as the camera's design. Not available for sale at any price, the Panaflex camera can only be rented. This arrangement is ideal for the movie industry in many ways: Maintenance and quality can be controlled by Panavision, making the Panaflex the most reliable camera in the world. Panavision gets direct feedback from users and can make immediate changes in equipment whenever necessary. By renting on a when-needed basis the user is always assured of having the world's best and most up-to-date camera, without any of the headaches of servicing, updating, and financing.

Product: Panaflex Golden Movie Camera

Manufacture: Panavision Inc.

Design Credit: Robert Gottschalk, designer and company founder

Date: Introduced in 1973

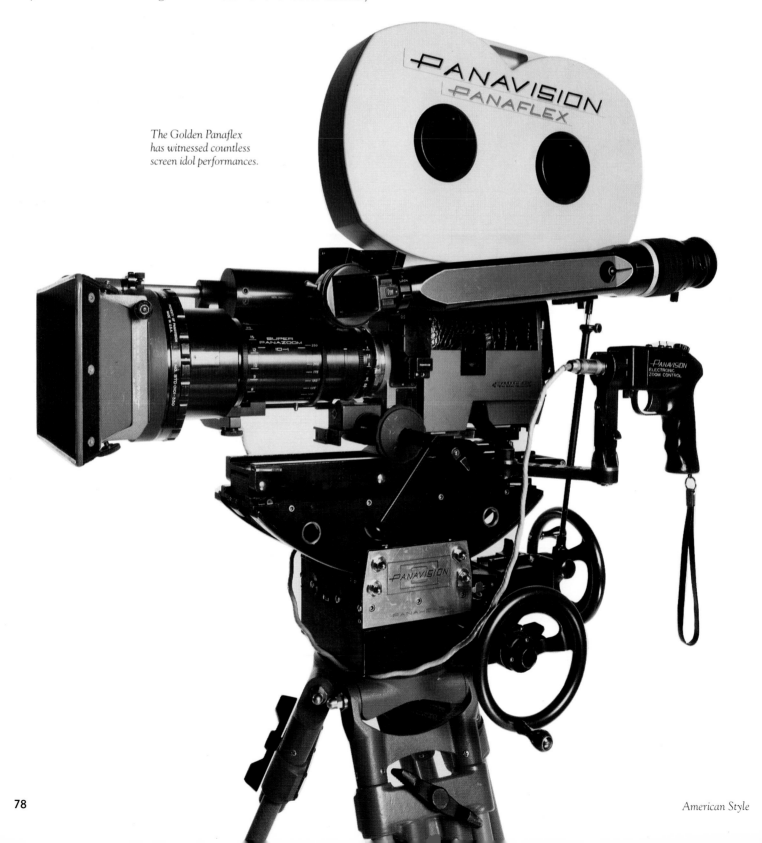

The Golden Panaflex has witnessed countless screen idol performances.

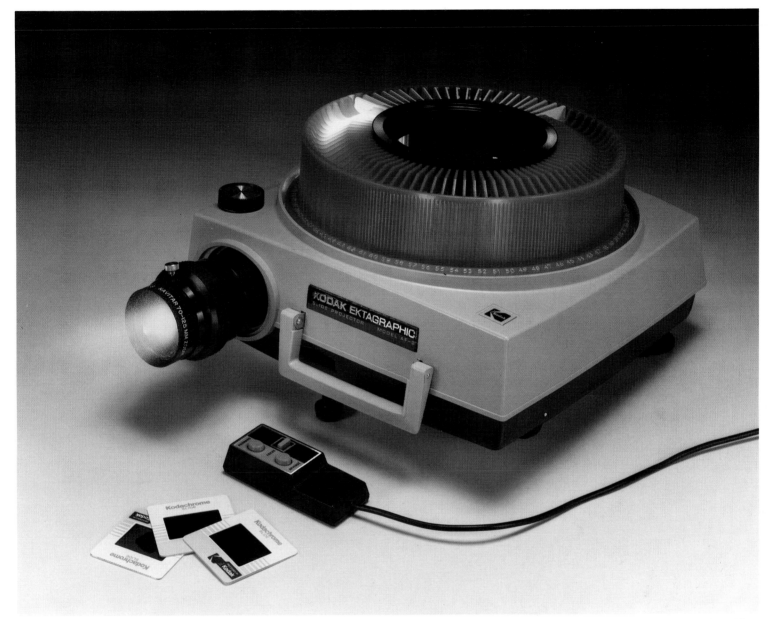

The Kodak Ektagraphic Slide Projector brings a superior projection system to slide viewing.

Kodak Carousel Projector

The Kodak Carousel projector system was introduced in 1961 and quickly became the American standard for projecting 35mm color slides. Its superiority to other traying and viewing systems is manifold: The circular design permits continuous operation without reindexing after each viewing; it is spillproof, unlike the European slide tray, which has to be meticulously inserted and removed to prevent spillage. Finally, with the circular tray positioned on top of the projector rather than on the side, slides are gravity-fed to the projection gate, with the result that very few slides jam. The Kodak Ektagraphic projectors are the workhorses of the audiovisual industry and perform flawlessly for indefinite periods of time.

Product: Kodak Ektagraphic AF-2 Slide Projector and Ektagraphic Universal Slide Tray

Manufacture: Eastman Kodak Co.

Design Credit: Developed by Kodak Apparatus Division of Eastman Kodak Co.

Date: First Carousel projector introduced in 1961; Ektagraphic AF-2 model introduced in 1971

Fashion, Accessories, and Personal Effects

America's contribution to the world of fashion and related accessories is more easily recognized than defined. Perhaps this is because, as with many consumables, most specific items of dress predate the American scene; it is the design nuance of these items, however, that creates their American quality.

Observed with keen interest on the international scene, the nuances of an identifiably classic American Style—like the ensemble of Levis, Wayfarers, and Weejuns—appear first on the boulevards of Los Angeles and are immediately ingested; they then turn up, instantaneously—as if by magic on the streets of Tokyo and Paris.

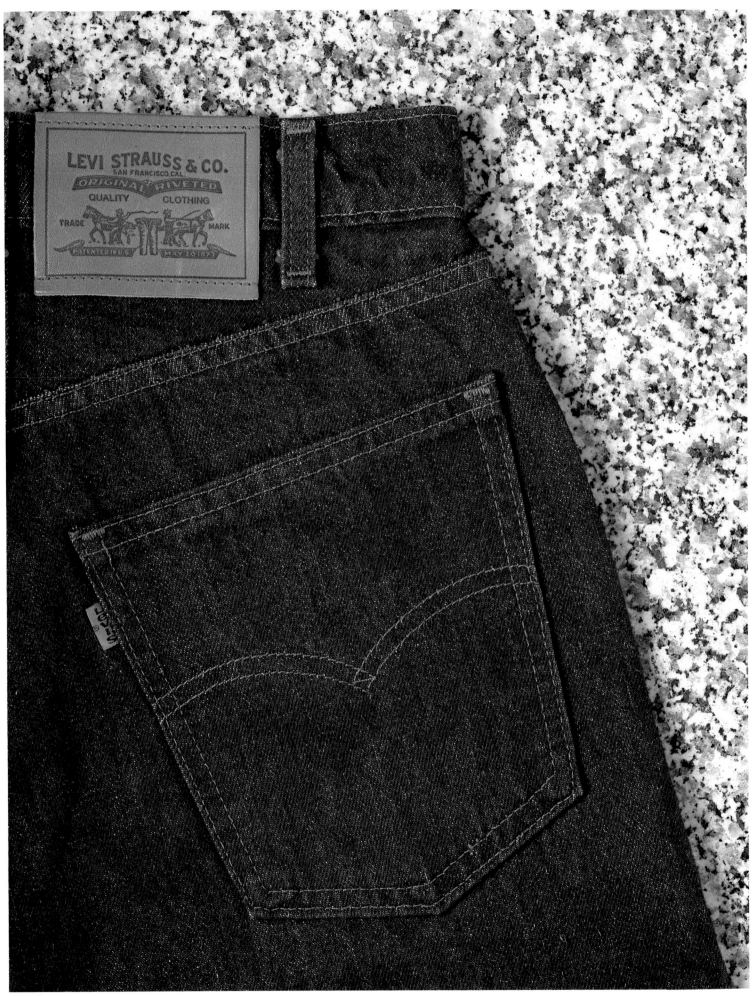

Levi Jean's cachet helped create legends of James Dean and Marlon Brando.

Levi Jeans

Introduced by Levi Strauss in 1853, Levi jeans were sold as miner's pants; "501" refers to the original lot number assigned in the 1880s. Although they continued to evolve, the jeans have remained basically unchanged to the present day. Rivets and the stitching pattern, which looks like a seagull in flight, were added in 1873; the leather guarantee patch in the 1880s; and belt loops in 1922. The seagull in flight is the oldest trademark in apparel history.

The unorthodox addition of rivets to Levi jeans resulted when Jacob Davis, a tailor in Virginia City, Nevada "repaired" the pockets of a local miner, Alkali Ike, by taking the pants to a harness maker and having rivets added as a joke. (Alkali Ike was notorious for ripping out his pockets by stuffing them with tools and ore.) Davis told this story to Levi Strauss. Sensing an important achievement, Strauss immediately patented the idea and put Davis to work for him in San Francisco.

Found in the permanent collection of the Smithsonian and honored with a Coty fashion award, Levi jeans have flourished for more than 133 years. A tremendous number of garments, fashion trends, and stylistic features of clothing have come and gone during that period. One of the most imitated articles of clothing in the world, both by garment manufacturers and by top fashion designers, Levis are coveted the world over. In some countries, where they are not legally imported or manufactured, a black market for them exists.

Product: Levi 501 Jeans

Manufacture: Levi Strauss & Co.

Design Credit: Levi Strauss, inventor and designer

Date: Introduced in 1853

The Eagle Shirt offers consumers tradition over trendiness.

Eagle Shirt

Eagle Shirt Makers, one of the oldest shirt manufacturers in America, is noted for a classic, traditional approach to the craft. Founded in 1867 by the Amish in Quakertown, Pennsylvania, the company is now located in nearby Allentown, Pennsylvania. Eagle shirts feature a split yoke on the back, single-needle tailoring, and the finest imported and domestic fabrics. The line of stitching seven-eighths of an inch up the cuff is an Eagle hallmark that originally made a convenient folding line: Cuffs could be turned back to keep them out of ink wells, preventing inkstains.

The shirt pictured is a contemporary model with button-down collar made of oxford cloth fabric; these two elements are intrinsic to the American "ivy league" look.

Product: Eagle Shirt, blue oxford cloth with button-down collar

Manufacture: Eagle Shirt Makers Inc.

Design Credit: Eagle staff

Date: First Eagle shirts introduced in 1867; shirt pictured is a current style

Stetson *"Indiana Jones"* Hat revives the classic fedora.

Stetson Hat

John B. Stetson invented the cowboy hat in the 1850s while en route via wagon train from St. Joseph, Missouri to Pike's Peak, Colorado. Some time after this trip, he returned east and established a hat-making business in Philadelphia. Believing his broad-brimmed, high-crowned hats would be popular, he marketed them to hat and clothing dealers throughout the American West. To this day the Stetson company is most well known for their cowboy hats, although, throughout their history, they have made other hat styles as well. These styles included a classic fedora model advertised consistently in *Vanity Fair* in the twenties and thirties.

With the advent of the Spielberg movie, *Raiders of the Lost Ark,* set in the thirties, came a resurgence of popularity in the wide-brimmed fedora worn by the movie's swashbuckling hero, Indiana Jones. Capitalizing on the popularity of the movie, Stetson introduced the "Indiana Jones" fedora style hat and revived a styling tradition that had languished for decades.

Product: Stetson "Indiana Jones" Hat

Manufacture: Stetson Hat Co. Inc.

Design Credit: First Stetson models designed by John B. Stetson; "Indiana Jones" model patterned after the fedora hat worn by Harrison Ford in the movie *Raiders of the Lost Ark*

Date: Stetson fedora models date from at least the late 1920s; "Indiana Jones" model dates from the early 1980s

Tuxedo

The tuxedo evolved shortly after the turn of the century in Tuxedo Park, New York, improvised by American millionaires who lived there and who constantly dined with each other. Feeling that the traditional tailcoat was excessively formal for their small dinner parties, they brought in the less formal and more comfortable short coat with a rolled silk collar.

Europeans consider the use of the term *tuxedo* a solecism: The English call the tux a *dinner jacket*—a reference to its original use—and the entire ensemble *dress lounge*. Call it what you will, the tuxedo is an American innovation that reflects the more casual American attitude toward attire. Even in Europe, the tuxedo has virtually replaced the tailcoat for evening wear.

The black tie ensemble shown here consists of tuxedo and pants by Hart, Schaffner & Marx, one of the premier names in American clothing since 1887 and famous for traditional men's suits. The formal shirt is a Shoreham model by Arrow, which, like Hart, Schaffner & Marx, is one of the classic names in American clothing.

Product: Tuxedo by Hart, Schaffner & Marx with Arrow Shoreham Shirt

Manufacture: Various manufacturers produce tuxedos; tux pictured is manufactured by Hart, Schaffner & Marx; shirt by Arrow Shirt Co.

Design Credit: Developed by the millionaires of Tuxedo Park, N. Y.

Date: First appeared after turn of the twentieth century, prior to World War I

The tuxedo reflects the less pompous American attitude toward attire.

The Aviator Jacket and Ray-Ban Shooters kept American flyers in style.

Aviator Jacket

The G-1 Aviator jacket was a naval-issue flight jacket worn by Navy flyers in World War II. Made of goatskin with an expandable yoke allowing for greater freedom of movement and a collar of dyed sheeps' wool, the jackets were first issued around 1942. They were manufactured under government contract by scores of different manufacturers who, during peacetime, had produced leather goods of all types, from shoes to articles of clothing. Design specifications came from the Navy, although black and gold labels inside the jacket identified the manufacturer of each jacket. The satin lining had inside pockets for storing maps.

American pilots set the pace for the Allied forces with the G-1 and A-2 (Army Air Force issue) aviator jackets. The popularity of the aviator jacket continued after the war and is still going strong; it is particularly favored by motorcyclists. A ground crew member of the original Hell's Angels, a nickname for World War II's 303rd Bomber Group, started the notorious Hell's Angels motorcycle club.

Product: Aviator G-1 Leather Jacket, contemporary reproduction

Manufacture: Various manufacturers commissioned by U. S. Navy; jacket pictured is custom-made, contemporary reproduction of the G-1

Design Credit: Design specifications from U. S. Navy

Date: Designed in early 1940s

Los Wigwam Weavers Ties reinterpret tradition with a slight regional twist.

Ray-Ban Shooter Sunglasses

In the early 1930s, the U. S. Army Air Corps commissioned Bausch & Lomb to create a sunglass design that would protect pilots from the intense glare and bright sunlight experienced during flight. Out of this research came the Ray-Ban lens which absorbs 98 percent of ultraviolet light and 70 to 90 percent of the light in the visible spectrum. The classic aviator shape of the sunglass—with its universal fit and unrestricted peripheral vision—also emerged from this project.

The aviator frame soared to popularity during World War II and became a fixture, along with a corncob pipe, on the face of General MacArthur. The Shooter is one of the most handsome of the aviator frames. With a distinctive browbar and a bull's eye below, its 23 + carat gold finish—or black chrome—is bonded to the frame's core metal.

Product: Ray-Ban Shooter Sunglasses

Manufacture: Bausch & Lomb Inc.

Design Credit: Brian O'Brien and Franklyn C. Hutchings, designers

Date: Introduced in 1938

Los Wigwam Weavers Ties

Phil Greinetz founded Los Wigwam Weavers in 1936 in Pueblo, Colorado. They've been making fine handwoven wool and alpaca neckties ever since, although the company moved to Denver in 1940. A blend of Mexican and Indian words, the name was chosen because these cultures have a great influence in the Pueblo area, which Greinetz wanted to capture in his company name and product.

While the design of Los Wigwam Weavers ties is basically no different from the conservative Ivy League look of many American clothiers, they have a slight western flair that makes them unique and appealing. They can be worn with a wide range of clothing styles; their feeling of richness outweighs their moderate price.

Product: Los Wigwam Weavers assorted neckties and bowties

Manufacture: Los Wigwam Weavers

Design Credit: Phil Greinetz, designer and company founder

Date: Introduced in 1936; ties pictured are current styles

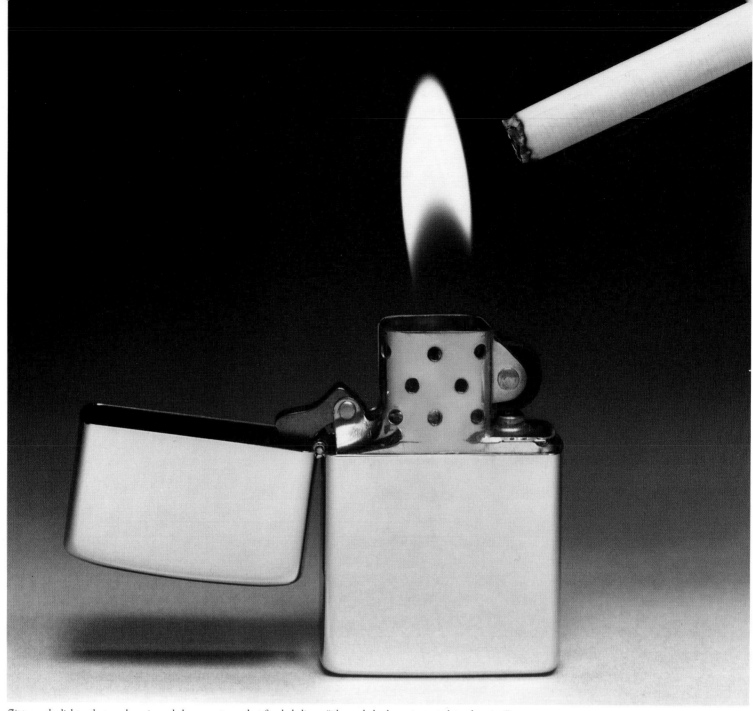

Zippo—the lighter that works—is made by a company that firmly believes "planned obsolence is a repulsive doctrine."

Zippo Lighter

George Grant Blaisdell obtained the United States distribution rights to a cheap Austrian lighter in 1932. He proceeded to redesign it, naming the new lighter—much improved in looks and function—after a recent invention that had impressed him: the zipper. Although that Zippo was more square-cornered than the current design, it remains virtually unchanged to the present day.

During World War II, Zippo's entire production went to the military. To this day, the Zippo lighter is extremely popular with servicemen and sportsmen, due, no doubt, to its windproof design and to the fact that no control needs to be pressed to keep the lighter lit.

The Zippo lights effectively at high altitudes, making it useful to pilots in nonpressurized cockpits and to mountain climbers. One Army pilot brought his disabled plane to safety using a Zippo to illuminate his darkened instrument panel.

The Zippo's reliability is beyond reproach. It carries a lifetime guarantee with no restrictions. Zippos have been mangled beyond recognition by golf fairway gang mowers, and one lighter was recovered from a fish's belly. No matter what the cause of damage, all Zippos are repaired or replaced free (including return postage) within forty-eight hours. Zippo is proud of the fact

that "no one has ever paid a cent for the repair of a Zippo lighter." Repaired Zippos come back with a note expressing thanks for the opportunity to repair them, along with a couple of extra flints. Zippo repairs around 500,000 lighters each year at a cost to the company of over $200,000.

Product: Zippo Lighter, polished chrome finish

Manufacture: Zippo Manufacturing Co.

Design Credit: George Grant Blaisdell, designer and company founder

Date: First introduced in 1932; current designs first appeared late 1930s

Bulova Accutron Watch

Perhaps no other product has been subjected to as much dysfunction in the name of styling as the analog watch. Watch designers have reshaped the case, removed the numerals, and added superfluous information and ornament with the intent of making a more attractive watch. In contrast, the railroad face shown here was designed for one purpose: to make telling the precise time a simple endeavor. Railroad lines and other transit authorities specified this Bulova design adaptation of a classic watch face for employees whose job responsibilities included timekeeping. True to the "form follows function" credo, the railroad criteria produced a striking aesthetic design.

The Accutron movement added the essential element of accuracy to a functional face design. Using a tuning fork stimulated by an electronic circuit instead of the traditional geared movement, the Accutron movement was one of the greatest technical achievements for the New York watch company founded in 1875 by Joseph Bulova. The first nonmechanical, electronic timepiece, the Accutron was the first new development in watch technology since Thomas Mudge's detached lever escapement in 1771.

The watch was considered so accurate that the railroad-approved Accutron had no stem on the case; Accutron timepieces were also used extensively in the American space program — from the satellite launchings in the late fifties through the lunar missions of the seventies. Accutron was also the first timepiece with a guarantee of specific accuracy — to within one minute per month — in writing. The watch never required winding. Accutron provided a flip-out lever on the back for the rare occurrences when the watch needed to be reset.

The introduction of the Accutron movement left the Swiss watch industry shocked and furious. The fact that a key researcher and engineer, Max Hetzel, was Swiss didn't help matters any. In response to Accutron, the Swiss established the Horological Electronics Center in 1962 to develop a competing product. Ultimately, this Swiss R&D think tank produced the quartz movement, which revolutionized timekeeping.

This Bulova Accutron's precision movement was a perfect complement to its classic styling.

Product: Bulova Accutron Watch, railroad approved model

Manufacture: Bulova Watch Co.

Design Credit: Accutron movement developed by Max Hetzel in conjunction with Bulova engineering staff

Date: Accutron movement introduced in 1960; Accutron pictured was manufactured in 1965

Ray-Ban Wayfarers were winners in the fifties; their classic styling has made them a phenomenon of the eighties.

Ray-Ban Wayfarer Sunglasses

Ray-Ban Wayfarers, epitomizing the styling and spirit of the fifties, have become the fashion phenomenon of the eighties. Although never really out of style, Wayfarers are enjoying a surge of popularity that shows no sign of diminishing. Available in a variety of colors and finishes, including tortoise shell and bright red, Wayfarer sunglasses are as contemporary today as they were thirty years ago, a true measure of their standing as modern classics.

Product: Ray-Ban Wayfarer Sunglasses

Manufacture: Bausch & Lomb Inc.

Design Credit: Ray Stegeman, designer

Date: Introduced in 1952

Bass Weejun Penny Loafers

Bass Weejuns are based on a Norwegian (hence the name Weejun) shoe given to Bass by an editor of *Esquire* magazine. The editor thought — his hunch turned out to be correct — that Bass would be interested in producing a similar shoe for the American market. Enduringly popular since their introduction in 1936, Bass Weejuns have enjoyed waves of popularity but have never gone out of style.

Though the Weejun has some design roots in Norway, its genuine moccasin construction is typified by hand-sewn stitching on the toe top and the extension of the soft leather upper all the way under the foot. This technique, noted for its great comfort, is patterned after Indian moccasins of American folklore fame.

Product: Bass Weejun Penny Loafers, tan

Manufacture: G. H. Bass & Co.

Design Credit: Adapted from Norwegian shoe design, and incorporating moccasin construction

Date: Introduced in August 1936

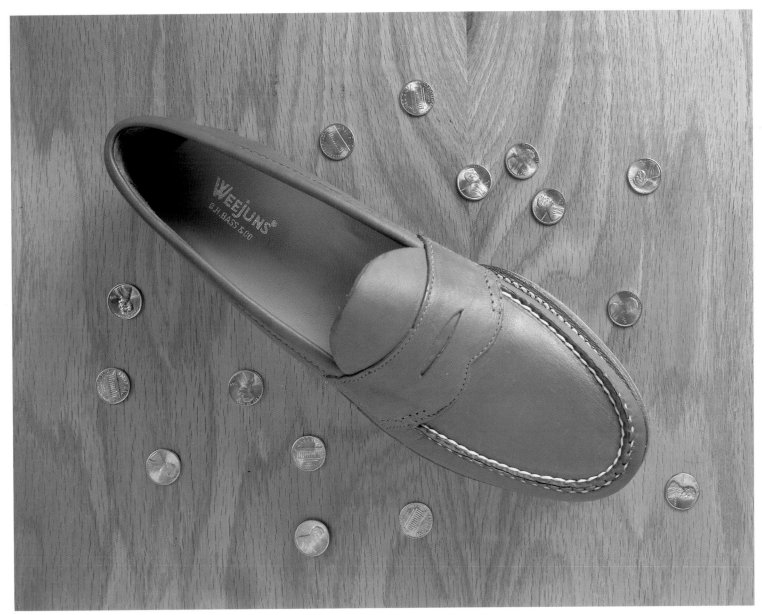

The Bass Weejun Penny Loafer is an intrinsic part of the American look.

Brooks Brothers sells the unabridged American diary.

Brooks Brothers Diary

The Brooks Brothers Diary, in addition to being a daybook for appointments and notes, is an almanac of facts and information that no good American should be without — the names and dates of birth of United States presidents, the names and phone numbers of senators and representatives, a map of the country, a list of all fifty states and their capitals, postal rates, population and immigration figures, national income and productivity figures, and so on. The diary is tastefully and conservatively styled, reflecting the image for which Brooks Brothers Clothiers is well known. Large enough to keep records for a busy schedule, the user need not wade through information printed in four or five languages to find out what day it is, as is the case with "universal" diaries.

Product: Brooks Brothers Diary

Manufacture: Produced for Brooks Brothers by James Aridas

Design Credit: James Aridas, designer

Date: Introduced in 1970

Zero Halliburton Luggage

Zero Halliburton cases combine distinctive styling with outstanding product function. Photographers and other professionals who travel extensively with fragile equipment swear by them. Zero Halliburton also manufactured the cases NASA used to bring moon rocks back to earth.

Zero Halliburton's aluminum alloy shell with a strength-to-weight ratio four times greater than cold-rolled steel, custom latches, tempered hardware, and a gasket closure seal all give maximum protection to valuable contents. The company's files are filled with user testimonials. One of the most convincing came from a traveler whose plane was blown up—after passenger evacuation—by terrorists. Of all the passengers' property, only the Halliburton luggage and its contents survived the explosion.

Product: Zero Halliburton Executive Attache Case, model ZH-104S

Manufacture: Originally manufactured by Erle Halliburton Inc.; currently by Zero Halliburton

Design Credit: Developed by Erle P. Halliburton, Sr.

Date: Introduced in 1938; current design introduced in 1946

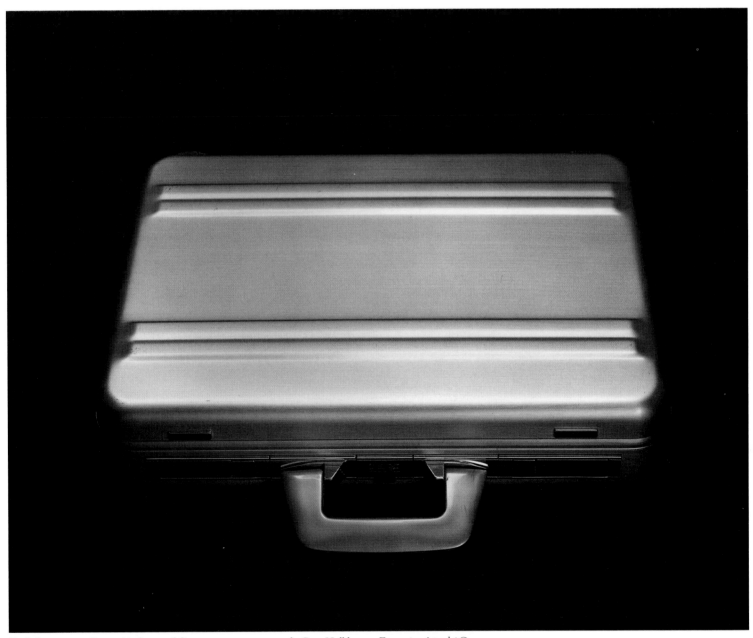

Both distinctive styling and indestructibility attract consumers to the Zero Halliburton Executive Attaché Case.

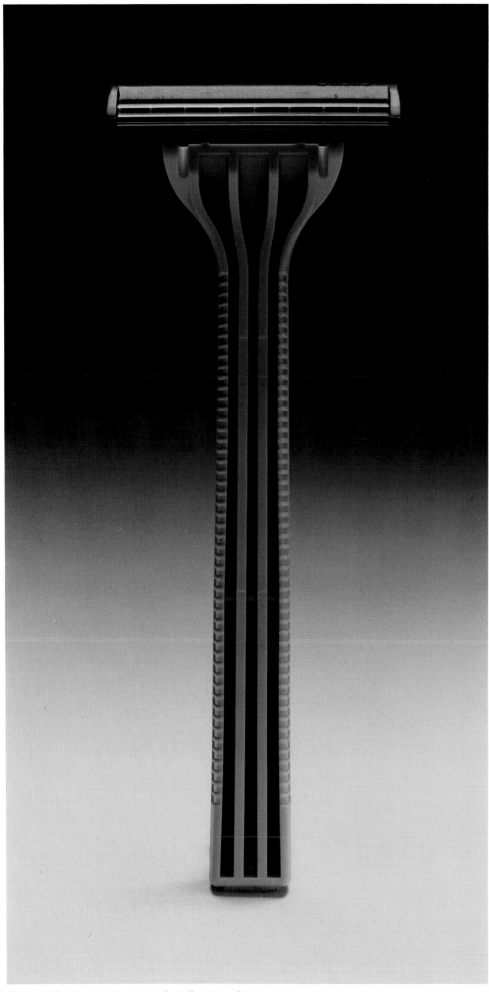

Gillette Swivel Disposable Razor

In 1895, King C. Gillette conceived the idea of the safety razor, a thin piece of steel with sharpened edges held by a clasp and handle. This steel blade would be thrown away rather than resharpened. Gillette produced his first safety razor in 1903; it received a U. S. patent in 1904. Since beginning with safety razors, the Gillette company has pioneered several developments in shaving technology.

In 1981 the company introduced the Swivel disposable razor. This was the first disposable razor to incorporate the pivoting head, an integral feature of Gillette's Atra shaving system introduced in 1977. The Swivel also features a twin blade razor, introduced in 1971 with the Trac II razor. The Swivel disposable is currently being phased out by Gillette and will be replaced by the Good News Pivot, which incorporates the Swivel's features and a similar design.

Gillette's Swivel is a superb example of the excellent design that can be found even in a disposable product. Though manufactured of inexpensive material, it is quite sophisticated in design, both in its engineering, with twin blade and pivoting head, and in its graceful form.

Product: Gillette Swivel Disposable Razor
Manufacture: Gillette Safety Razor Division of Gillette Inc.
Design Credit: Gillette staff
Date: Introduced in 1981

It's a tragedy to have to throw away the Gillette Swivel Razor.

Converse All-Star
Basketball Shoe

Charles H. "Chuck" Taylor was a professional basketball player during pre-NBA days of pro barnstorming teams. He joined Converse in 1918 and lent his expertise to the redesign of the basketball shoe. Taylor's signature was added to the Converse shoe in 1923. By 1931 the All-Star had evolved to its current design, which features a #10 duck cloth, loose-lined upper, and vulcanized rubber outsole.

One indication of the popularity and acceptance of a product is the consumer's dogged refusal to use it only for its intended purpose. The Converse All-Star is such a product. Popular not just for basketball, the Converse All-Star turns up everywhere: You are just as likely to see it on the gym floor at Saturday night dances as at Thursday night basketball practice.

Product: Converse All-Star Basketball Shoe, gray

Manufacture: Converse Inc.

Design Credit: Developed by Charles H. Taylor, professional basketball player and first Converse sales and promotional consultant

Date: Current style introduced in 1931

Converse All-Stars are for playing basketball and much more...

SPORTS AND LEISURE GOODS

The American commitment to sports and leisure activities is nothing short of maniacal. Perhaps for this reason, sports and leisure goods are an area of American manufacturing that retains a strong share of the market despite foreign competition. Because American manufacturers are closer to the ceaseless search for new and better ways of spending leisure time both culturally and geographically, they manage to outpace the competition and are able, in some cases, to export that success abroad.

Americans pursue their leisure activities so seriously that, without the proper paraphernalia, they consider work a more enjoyable alternative. Playing baseball without the A2000 glove to give that competitive edge would be a complete disaster; camping-out without a Buck knife or Coleman lantern would be unthinkable.

The Hobie Cat makes up the largest, most competitive catamaran racing class in the world.

American Style

Hobie Cat Catamaran

Quite frequently, tales of entrepreneurial expertise are followed by an "only in America" tagline, though many of them could have been accomplished in any vibrant, capitalist economy (such as Japan, for instance). But the story of Hobart "Hobie" Alter, I believe, could have happened only in America.

Portrayed as a beach bum by the media, Hobie Alter enjoys cult leadership status usually reserved for rock stars and screen idols. He attained that status by repeatedly developing innovative, superior product designs whose immediate success started phenomenal trends that sustained popularity over a period of decades. In the early sixties, Alter developed his Phil Edwards surfboard, which gained the reputation of being the state-of-the-art production board. In the late sixties, he pulled off his greatest design coup with the Hobie Cat.

The Hobie Cat is a revolutionary craft that began as a sketch in the sand on a southern California beach. Its asymmetrical, foam core-filled hulls do not require a keel for stability. Easy and fun to sail, the Hobie Cat can be set up quickly and launched by one person directly from the beach (the Hobie 16 weighs only 350 pounds, for example); when done sailing, the boat can be steered right up on to the beach for trailering.

The Hobie Cat is fast—the Hobie 16 has recorded speeds of twenty-six miles per hour. Each year, in the more than seven hundred Hobie regattas inspired by the camaraderie of Hobie Cat ownership, Hobie sailors match their sailing prowess against each other and share the excitement of racing like the wind across the water.

Product: Hobie Cat 16 Catamaran

Manufacture: Hobie Cat

Design Credit: Hobie Alter, designer and product developer

Date: The Hobie Cat 14 produced in 1968; the Hobie Cat 16 in 1970

Frisbee Flying Disc

Since the late 1950s the Frisbee has entranced its audience, gliding aerodynamically through space, proving itself to be more than a mere fad. Only a simple plastic mold, it flies as though fitted with gyroscopes and guiding devices. Wham-O, which gave us the equally minimal but less enduring Hula Hoop, has produced many models of the Frisbee over the years, including professional and glow-in-the-dark models.

The Frisbee has inspired ever greater levels of throwing and catching skills. National competitions such as the World Junior Frisbee Disc Championship for competitors aged fifteen and under and the United States Frisbee Disc Open test the skills of devoted users. Independent organizations have also sprung up, such as the Freestyle Players Association, a group dedicated to "the advancement of freestyle disc play as a competitive sport and a lifetime recreation." Further evidence of the Frisbee's landmark status is the evolution of team sports using the disc. Though several are acknowledged, the two most popular are Ultimate and Guts.

Product: Frisbee Flying Disc, professional model

Manufacture: Wham-O Inc.

Design Credit: Walter Frederick Morrison, inventor

Date: Introduced January 13, 1957

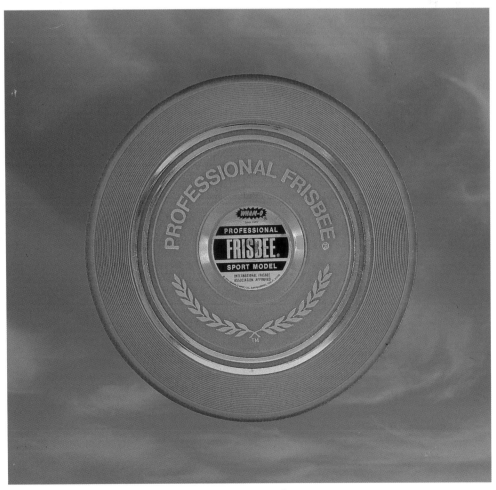

The Frisbee, a hypnotic flying device, has inspired the creation of new team sports.

Airstream Trailer

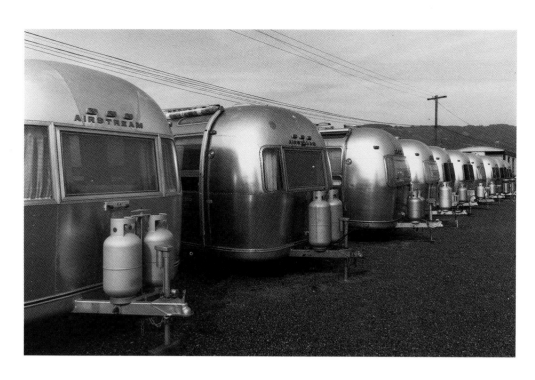

Wally Byam became interested in building trailers in his backyard during the late 1920s. He proved to be so adept at it that by 1934 he had conceived the name *Airstream* for his products; by 1936 he introduced the Clipper, which contained the basic design features the Airstream is known for today. The shell's aerodynamic profile yields superior towability; the rust-free, high strength-to-weight ratio aluminum body and frame never need to be painted; and a dropped bed over the axle and a raised ceiling on the early Airstreams allowed for upright movement inside.

Superior product design is only the beginning of the Airstream legend, however. Byam wanted to be sure his customers got the most from their Airstreams, so he began organizing rallies — events where Airstream owners converge and mingle in a carnival-like atmosphere — and caravans — planned excursions to faraway lands. The first caravans were limited to North America, but later the development of harnesses permitted Airstreams to be loaded onto cargo ships and taken abroad. With this harness, previously landlocked Airstreams could be taken anywhere. Caravans have been to Europe, Africa, and, believe it or not, one caravan — Singapore to Lisbon Overland — went around the world. On one African caravan, the Great Pyramid was one of the stopover points, though Byam's dream of encircling the pyramid with Airstreams was not realized. Nonetheless, those Airstreams juxtaposed against the Great Pyramid made for an impressive sight.

To place the great wide world at your doorstep for you who yearn to travel with all the comforts of home . . . from The Wally Byam Creed

Product: Airstream 31-Foot Excella, 1986 model trailer

Manufacture: Airstream Inc.

Design Credit: Wally Byam, inventor and company founder

Date: Originally designed in 1932; Airstream pictured is 1986 model

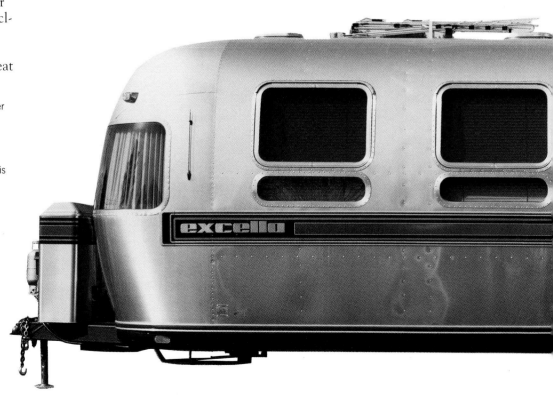

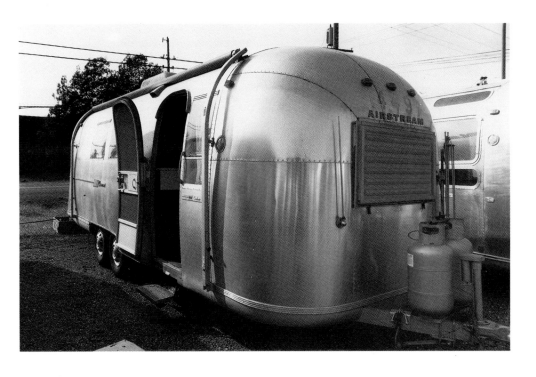

The thirty-one-foot 1986 Airstream Excella offers all the comforts of home, including stereo, a kitchen complete with refrigerator and micro-wave oven, bath, air conditioning, cedar-lined closets, built-in TV antenna, and more.

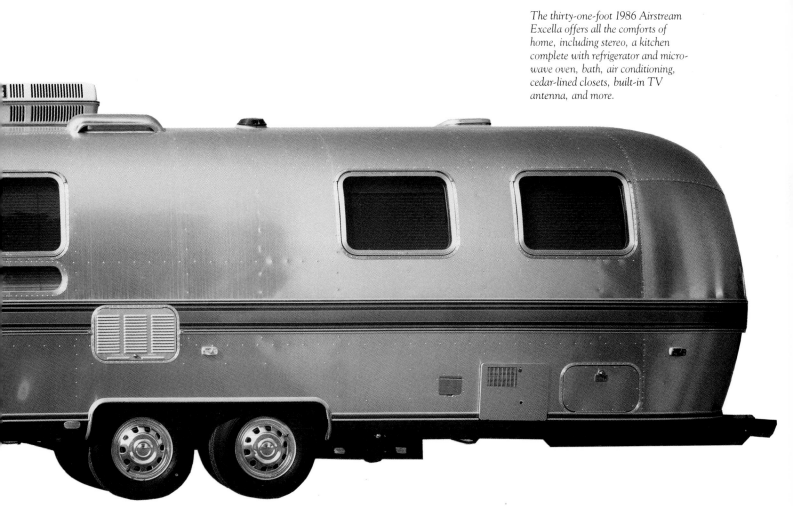

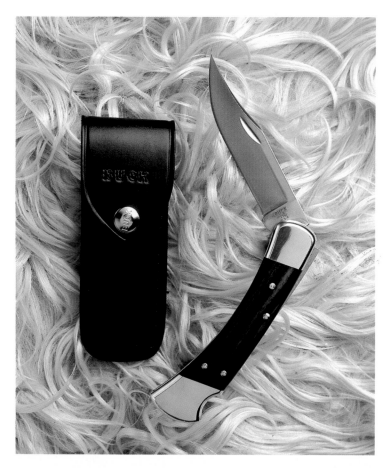

The Buck Hunter is the "Most Copied Knife in the World."

Buck Knife

The most popular knife made by Buck Knives, the Buck Hunter is, according to the company, the "most copied knife in the world." Styled in the tradition of the Bowie knife blade, the knife features a four-inch, single-locking blade and a brass handle inlaid with macassar wood. The Hunter is very popular with sportsmen as a general purpose hunting knife.

Buck Knives' reputation began at the turn of the century based on the ability of their knife blades to hold a sharp edge. Buck has kept their blade-making a family secret for four generations, but they will admit that the steel blade's high carbon content coupled with a proprietary tempering process is what makes the Buck blade so outstanding. Every Buck knife comes with a lifetime guarantee.

Product: Buck Hunter Knife, model #110

Manufacture: Buck Knives Inc.

Design Credit: Developed by Al Buck, Chuck Buck, Don Ham, and Howard Craig; all officials of Buck Knives Inc.

Date: Designed 1962–1963; introduced in 1964

The Sierra Designs Stretched Domicile Tent weighs in at a miraculous 7½ pounds.

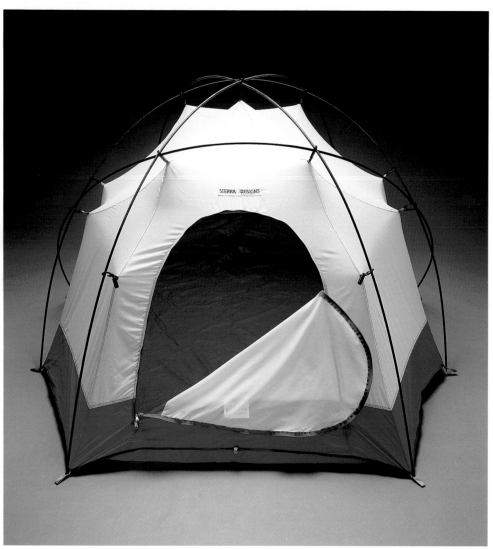

Sierra Designs Tent

Tents have been a part of human existence for eons. Before the evolution of architecture and building methods as we know them today, the tent was used for shelter. In some cultures, tents still serve as the primary form of shelter. In America, however, tents have become the temporary shelter of choice for camping out or other leisure time activities.

The Sierra Designs Stretched Domicile is the result of the blend of inventive design and modern lightweight materials. A totally portable shelter, the Stretched Domicile provides 46 square feet of floor area and 46 inches peak height for three people. The patented swift-clip suspension system gives the tent its beautiful, geodesic shape and makes it fast and easy to pitch. It collapses to a packable 7 × 21 inch cylinder weighing only 7½ pounds.

Product: Sierra Designs Stretch Domicile Tent

Manufacture: Sierra Designs Inc.

Design Credit: Paul Kramer, director of research and development

Date: Introduced in 1981

Coleman Lantern

Around the turn of the century, William Coleman, a Kansas school teacher and part-time salesman, discovered that a gasoline-burning lamp made by the Irby-Gilliland Company was far superior to traditional oil and kerosene lamps. The Irby lamp produced an intense white light by pressurizing gasoline and then vaporizing the gas in a generator. On release, the gas combined with air and ignited, giving off an intense glow.

Coleman began his business by offering a lighting service in the Oklahoma Territory. He rented out the Irby lamps, with fuel and maintenance service, for $1 per week. Coleman purchased all rights to the Irby lamp in 1902 and began to improve it, putting its technology to use in more elaborate and varied lighting systems. He developed a large business around his arc lamps and lanterns by selling them as primary sources of illumination in the countryside prior to rural electrification.

Since World War II, the Coleman Lantern has been known and appreciated primarily as an extremely reliable, efficient, and well-designed source of illumination for outdoor and leisure time use. And despite the spread of electricity to all parts of the country, the Coleman Lantern is more popular than ever. By the end of 1986 the Coleman Company expects to have sold its forty millionth lantern.

Coleman Lanterns are bugproof and windproof. The typical model holds enough fuel for twenty-five to thirty hours of operation. The Kerosene Lantern is actually a modification of the more common "white" gasoline, or naptha, models. It has the basic features of Coleman's naptha appliances but uses the commonly available, multipurpose fuel: kerosene.

Product: Coleman Kerosene Lantern, model 201

Manufacture: Originally manufactured by Hydro Carbon Light Co; currently by The Coleman Co. Inc.

Design Credit: Originally developed by William Coffin Coleman, company founder, and Hiriam Strong, chief engineer/factory manager

Date: First "arc" lanterns introduced in 1914; first kerosene lantern introduced in 1928; lantern style pictured here first introduced in late 1930s

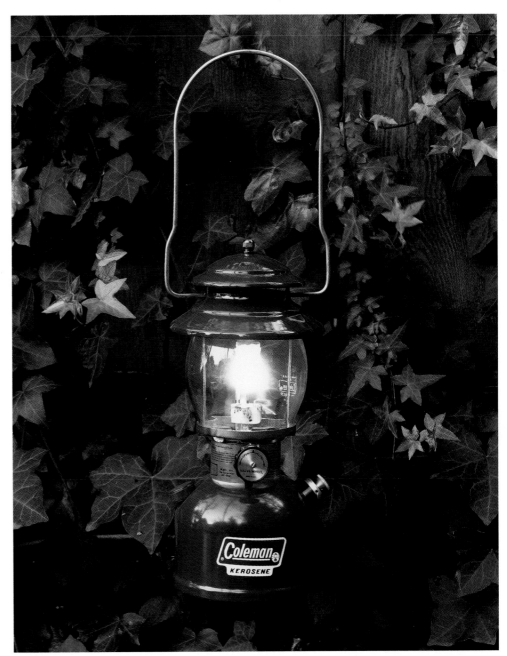

The Coleman Lantern was developed by a Kansas school teacher who recognized a "better mousetrap" when he saw it.

With Gato you relive—or at least attempt to—the American triumph over the Japanese in the Pacific.

Gato Computer Simulation

Gato is a product from a burgeoning industry in which America is a clear leader: the computer software industry, a phrase not even a part of our vocabulary a few years ago. A real-time submarine warfare simulation, Gato is named after the American Gato fleet of World War II fame. Bill Graves, a retired U.S. Navy captain, consulted with the developers to make the game as authentic as possible. (For example, if on a mission prior to 1943, your sub will not have radar, since radar had not been invented yet.) Your submarine computer is as identical as the creators could make it to an actual Gato class submarine; a list of specs and a history of the Gato class submarine come with the software.

Playing Gato is an incredibly lifelike experience. Using your strategic and tactical skills, you must attempt to complete your mission against the Japanese and return to Allied-controlled waters. You gaze into your computer screen, experiencing helplessness when you stray too near the surface and are bombarded with depth charges or the rush of adrenalin as you watch a destroyer go down at the hands of a well-aimed torpedo. After a game or two you'll swap war stories with the best of them.

Product: Gato Computer Game, Macintosh version

Manufacture: Spectrum Holobyte Inc.

Design Credit: Paul Arlton, Ed Dawson, programmers and designers; Jeffrey Sauter, designer

Date: IBM version introduced in 1984; Macintosh and Apple II versions introduced in 1985

Head Tennis Racket

Head's Composite Edge tennis racket is a general purpose racket designed for players of varying levels of skill and style. The graphite/fiberglass composite is formed by a high-tech process that allows synthetic materials to be combined and results in specific control over the properties of the construction material—the degree of flexibility, for instance. More dimensionally stable than wood, composite rackets don't have to be kept in a frame to prevent warping.

The innovative materials used in the Composite Edge allow for a graceful, sculptural shape—older wooden rackets seem stodgy by comparison. Head was one of the industry leaders in developing composite materials and injection-molding techniques in the construction of sports rackets.

Product: Head Composite Edge Tennis Racket

Manufacture: Head Racquet Sports

Design Credit: Head engineering staff

Date: Introduced in 1984

The Composite Edge Tennis Racket's high-tech materials contribute to its flowing shape.

With eighty-eight coils of steel wire, the Slinky "walks."

Tinker Toys let children make their own toys.

Tinker Toys

Many generations of children have tested the breadth of their imagination for the first time with a set of Tinker Toys. Composed only of round wooden spools and different size and color wooden rods, a wide variety of things—from cows to ferris wheels—can be constructed. Over the years plastic pieces have been added to increase the range of construction possibilities. Tinker Toys are one of the few and diminishing number of construction toys that allow children to make their own toys, thus filling a dual role of education and entertainment.

Product: Tinker Toys, set #330

Manufacture: Originally manufactured by Toy Tinkers; currently by CBS Toys/Div. of CBS Inc.

Design Credit: C. Pajeau, designer

Date: Introduced in 1914

Slinky Toy

A unique toy made of spring steel, the Slinky performs a monotonous but entrancing task: It oscillates in a manner as fascinating as the whirl of a gyroscope or the spin of a top. The Slinky seems surprisingly animated for a device made only of eighty-eight coils of steel wire. Somewhere in its sixty-nine feet there must be a dose of magic, for the Slinky has thrilled many a child seeing it "walk" down steps for the first time. The fact that it has been with us since 1945 is proof that it is no mere fad and will probably go on entertaining children of all ages for many years to come.

Product: Slinky Toy

Manufacture: James Industries Inc.

Design Credit: Richard T. James, inventor

Date: Introduced in 1945

Wilson A2000 Baseball Glove

Many a Little Leaguer has dreamed of owning a Wilson A2000, the glove used by major league idols. Popular among baseball players at all levels of play, the A2000 blends quality with sound design. An important innovation is the glove's enlarged pocket area—the part of the glove where the baseball is caught—which was moved farther back from the palm to the web. The wider, deeper web makes it much easier for fielders to snare hard-hit balls. This feature dramatically affects the style and quality of play—an example of the profound influence of equipment design on the world of sports.

Product: Wilson A2000 Baseball Glove

Manufacture: Wilson Sporting Goods Co.

Design Credit: Developed by Arch Turner and Ted Javor

Date: Introduced in 1957

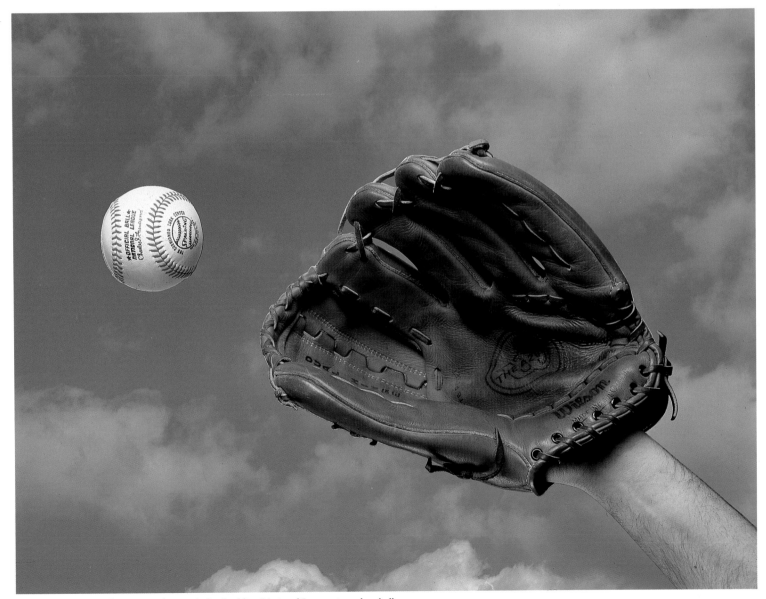

The Wilson A2000 glove is poised to catch this Spalding National League-issue baseball.

MUSICAL PRODUCTS

Т he development of jazz, rhythm and blues, country and western, and the rock and roll genres has culminated in a pervasive American influence on the contemporary world music scene. Charlie Christian, Chuck Berry, Merle Travis, T-Bone Walker, and B. B. King are just a few of the American music legends whose innovative work is appreciated worldwide. Behind these achievements in music are innovations in musical instrument design that have had a profound influence on music's new directions.

Audio electronics have expanded the music world and have given the public broad access to an art form previously restricted to a privileged few. Until the Japanese came along, consumer audio was an area of American domination. With the pervasive entry of the Japanese into this market, it has become easy to forget that so many of the innovations of audio reproduction—from the transistor to high-fidelity—were developed by American companies. Japan's domination of this market frequently overshadows the fact that American audio products continue to enjoy considerable success.

Gibson Les Paul Guitar

As early in this century as the twenties and thirties, experiments in electrical amplification attempted to enhance the acoustic guitar's volume to make it viable in ensembles like big dance bands. Various manufacturers and individuals simultaneously working on the development of the electric guitar claim to have invented it. No one, however, questions that the electric guitar was an American innovation with a pervasive influence on music, both in this country and around the world.

The Gibson Company, founded by Orville Gibson in the 1870s, produced mainly mandolins until the mid-1920s, when they were superceded by the banjo. Since the fifties, Gibson has been known primarily for their guitars. Introduced in 1952, the Les Paul model electric guitar was named after the popular country and western performer Les Paul, who approached Gibson several years earlier to produce an electric guitar. The guitar went on to become a legend in rock 'n roll music. All Les Paul guitars made since 1955 feature the "humbucking" pickup invented by Seth Lover. This pickup eliminates noise and interference and reduces response to high frequencies. It is the primary difference in sound between Gibson and Fender instruments.

Product: Gibson Les Paul Guitar, twentieth anniversary model (1972), cherry sunburst

Manufacture: Gibson Guitar Co.

Design Credit: Gibson design staff; endorsed by Les Paul, country musician

Date: Introduced in 1952

Gibson's Les Paul Guitar is a rock 'n roll classic.

Fender Bass

Leo Fender, a pantheon inventor and designer of contemporary musical instruments, invented the electric bass and introduced it in 1951 as the Fender Precision Bass. In 1948, three years earlier, Fender and George Fullerton designed the first commercially manufactured, solid-bodied electric guitar, the Fender Broadcaster. The Broadcaster became the Telecaster in 1950; the instrument maintains a strong following in country and western music circles. The Fender Stratocaster was introduced in 1954; it featured the Fender tremolo arm and was the first Fender guitar to have a contoured body.

The Precision Bass, as originally designed, looked similar to the Telecaster guitar and came to be referred to as the Tele Bass. In 1968 Fender reissued this design as the Telecaster Bass. The popularity of Fender's line of bass guitars made Fender, in its heyday, a generic term.

Product: Fender Telecaster Bass, 1972 model

Manufacture: Fender Musical Instruments/CBS Inc.

Design Credit: Based on original Fender Precision Bass, designed and invented by Leo Fender

Date: Fender Precision Bass introduced in 1951; Fender Telecaster Bass introduced in 1968

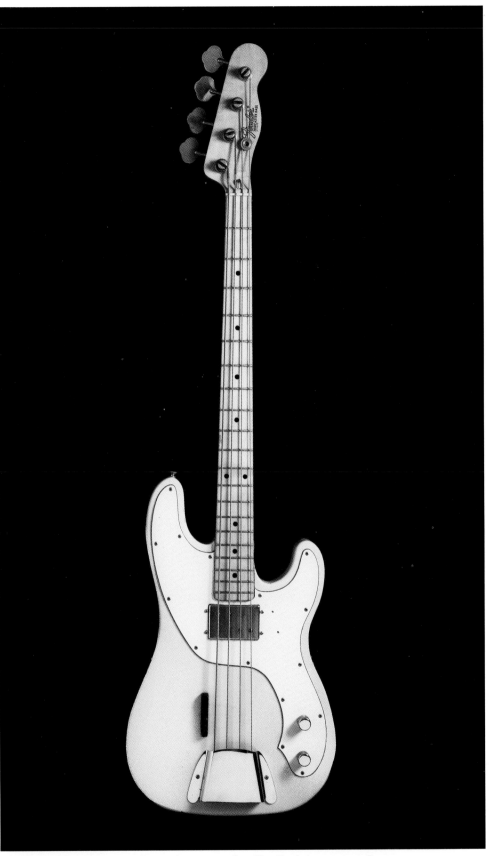

The Fender Telecaster Bass is only one of many examples of Leo Fender's pervasive influence on contemporary musical instruments.

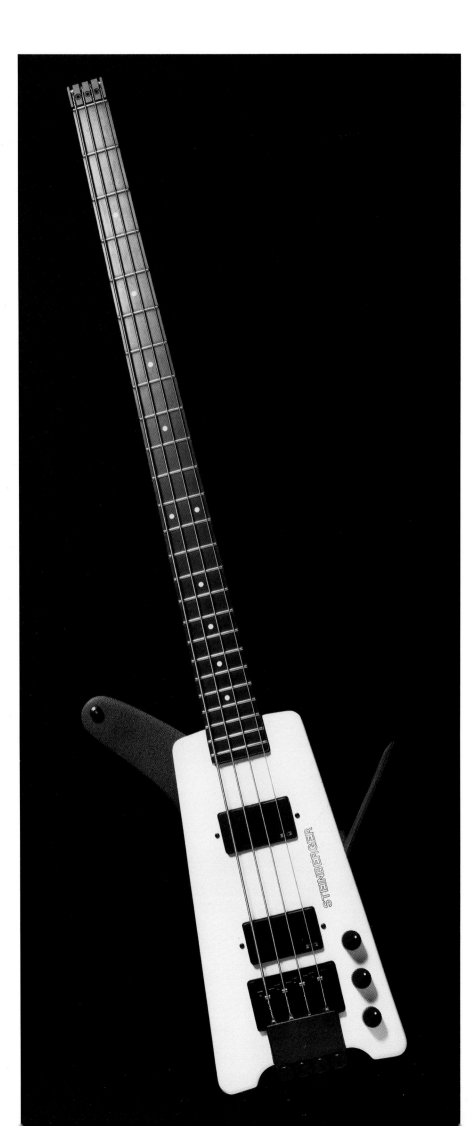

Steinberger Bass

The Steinberger Bass Guitar is a very rare achievement. Musical instrument design is typically an evolutionary process, not a revolutionary one, but the Steinberger Bass Guitar is revolutionary. Steinberger relocated the tuning mechanism from the neck to the bridge, making the instrument "headless." The redesigned instrument balances better and tuning becomes easier and more accurate. Instead of wood, the body is made of reinforced plastic, which has better sonic properties and is more dimensionally stable and durable. Along with these major technical improvements, Steinberger's major redesign also creates visual excitement.

The reviews both from the musical and the design communities have been positive about Steinberger's new radically engineered design. The Steinberger Bass Guitar is used by an impressive array of rock and jazz musicians; it has received design awards from the Industrial Designer's Society of America, Society of the Plastics Industry, and *Time* and *Materials Engineering* magazines.

Product: Steinberger XL-2 Bass, white body

Manufacture: Steinberger Sound Corp.

Design Credit: Ned Steinberger, designer and product developer

Date: Designed in 1979; introduced in 1981

*The Steinberger
Bass Guitar's radical
design works musically
and visually.*

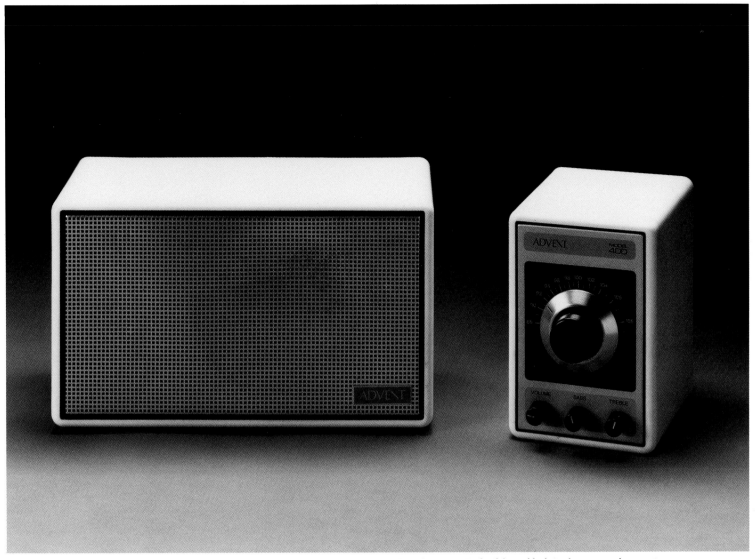

The Advent 400 Radio delivered high quality at a moderate price.

Advent 400 Radio

In its era, the Advent 400 Radio was considered a landmark in table radio design and audio quality. Most table radios lacked the audio capabilities and attention to detail of a full-fledged stereo system, but Advent changed all that. Like so many of Advent's products, the intent was to offer the most quality possible for the least price. The Advent 400 was a spartan, FM only, monaural radio; the sole controls were for volume, bass, treble, and tuning. What it lacked in extras, it made up for in performance; reviewers compared its audio quality and reception to music systems costing significantly more. Later, due to the accolades bestowed on its audio quality, Advent marketed the 400's extension speaker in pairs, to be used with a component system.

The styling of the 400 radio was probably Advent's best effort. Due to their "best-for-price" philosophy, their products were never noted for excellent styling. One of the radio's nicest design features was the separation of the control unit from the extension speaker, which allowed the user to position the control unit for greatest convenience and the speaker for best acoustics. Like so many American audio products in its price range, the Advent 400 radio ultimately lost out to Japanese competitors who compensated for merely adequate audio quality by offering more "blinking lights" for the dollar.

Product: Advent Model 400 Radio

Manufacture: Advent Corp.

Design Credit: Henry Kloss and Tomlinson Holman, engineers; Andrew Petite, acoustic design; David Roche, industrial design

Date: Introduced in mid-1970s

A state-of-the-art product twenty-five years ago, the McIntosh Amplifier is still sought after today.

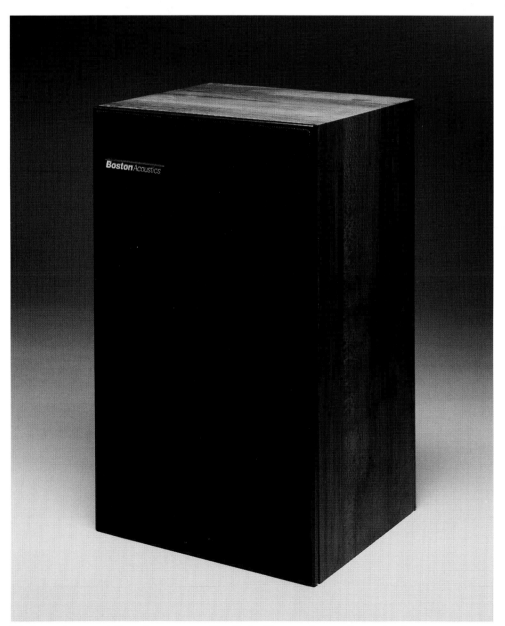

The Boston Acoustics A40 speaker continues a New England heritage of outstanding speaker design.

McIntosh Amplifier

McIntosh monophonic tube amplifiers of late fifties to late sixties vintage are highly valued by audiophiles, particularly in Japan, for their musical qualities. Only the most expensive, class A transistor amplifiers of today outclass them. The MC-60 McIntosh amp is a 60 watt, class A, monophonic amplifier—two are required for stereo sound—popular for use in the home as well as for amplifying church organs and for stage sound. The MC-275, a later, more powerful model, commands more than its original selling price in today's market; it is particularly sought after by audiophiles. Considering the exponential growth of electronics technology in the past twenty-five years, it is astounding that an electronic product made twenty years ago is still capable of outperforming many contemporary products.

A perfect example of the beauty of anonymous industrial design, the MC-60 amplifier itself is nothing more than a rectangular base into which tubes are planted. The amplifier creates a formidable overall effect. The tubes glow softly, giving the appearance of a teeming metropolis in miniature. The exposed tubes have practical value as well, allowing for convection cooling and easy replacement.

Product: McIntosh MC-60 Tube-Type Amplifier, class A, monophonic, 60-watt

Manufacture: McIntosh Laboratory Inc.

Design Credit: McIntosh staff

Date: Estimated to be late 1950s or early 1960s

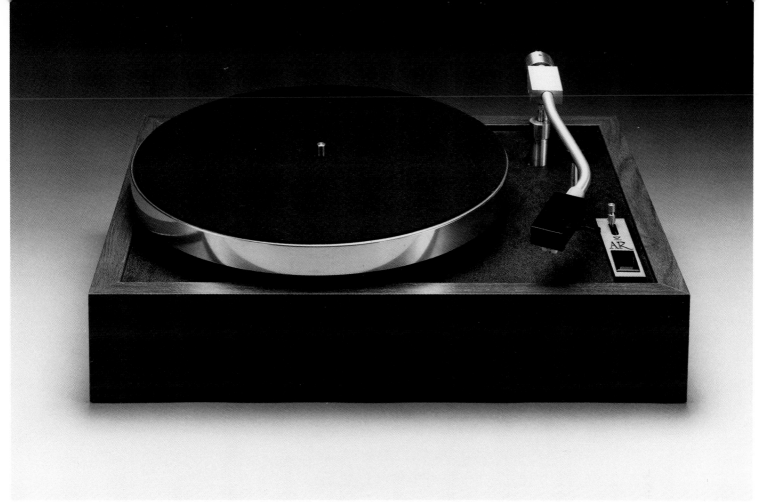

The AR Turntable's no-frills design approach resulted in a landmark audio product.

Boston Acoustics A40 Speaker System

The Boston Acoustics A40 speaker is an outstanding speaker that delivers sonic quality at a modest price. In fact *Stereo Review* says that "the A40 comes surprisingly close to matching the essential sound quality and character of the best and most esteemed speakers." An outstanding example of the American no-frills approach to moderately priced audio electronics, the A40 judiciously applies innovative acoustic engineering to the production of a low-cost speaker system.

Boston Acoustics is a part of a tradition of New England-based speaker design and manufacturing. The technical and production personnel at Boston Acoustics have been a part of many important audio companies in the area, beginning with Acoustic Research in the 1950s and followed by KLH in the 1960s and Advent in the 1970s.

Product: Boston Acoustics A40 Speaker

Manufacture: Boston Acoustics Inc.

Design Credit: Andrew Petite, concept and acoustical design; Charles Rozier, industrial design

Date: First introduced in 1981; updated in 1985

Acoustic Research Turntable

The Acoustic Research, or AR, Turntable is a minimal turntable design in both styling and function. Many audiophiles consider the AR to be the first properly designed turntable. Its tremendous success was due to the fact that it performed better than many turntables costing considerably more, with a retail price that even by the early 1970s remained less than $100. Its suspended T-bar subchassis with damped three-point suspension system and belt drive is widely emulated in current designs. The AR turntable is quite spartan: changing turntable speed is accomplished by removing the platter and moving a belt from one pulley to another; tracking force is manipulated by adjusting the counterweight with a small screwdriver; and early ARs had no cueing mechanism.

Edgar Villchur, the founder of AR and designer of the AR turntable, was also an industry leader in loudspeaker design. He invented acoustic suspension speakers in the late fifties and was the designer of the classic AR-3 loudspeaker, which for a decade was an audio industry standard.

As is so often the case, the purely functional criteria of the AR turntable's design resulted in a completely appropriate style — a style that told the consumer that the no-frills approach represented excellent value.

Product: Acoustic Research Turntable

Manufacture: Originally manufactured by Acoustic Research Inc.; currently by Teledyne Acoustic Research

Design Credit: Edgar Villchur, designer and company founder

Date: Introduced in 1957

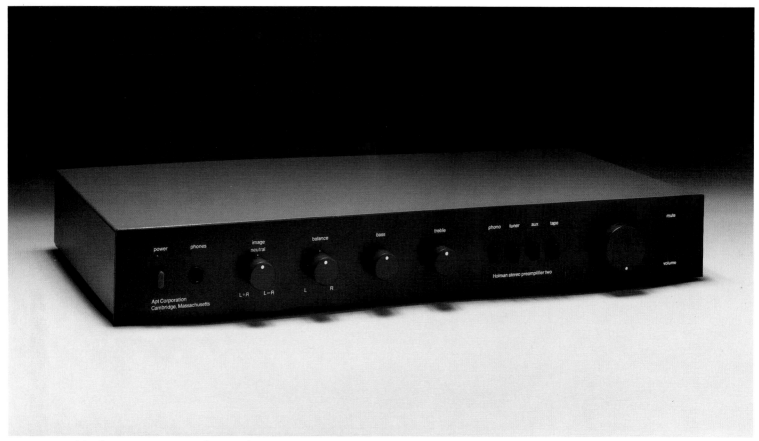

Apt P-2 preamplifier design is, as its name implies, suited to its purpose.

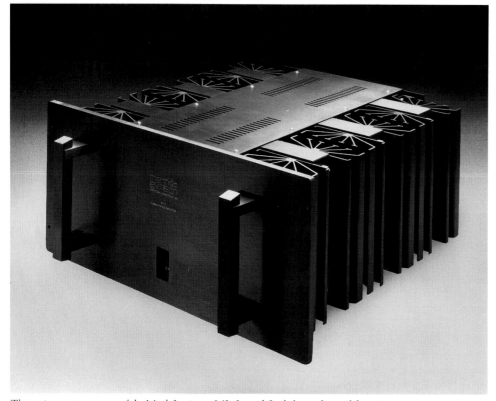

The ominous appearance of the Mark Levinson ML-2 amplifier belies its beautiful sonic properties.

Mark Levinson ML-2 Amplifier

The Mark Levinson ML-2 amplifier is the ultimate choice for the ardent audiophile for whom money presents no object. Two ML-2, monophonic, class A power amplifiers in conjunction with a preamp produce stereo sound of stunning sonic quality. This minimalist machine with black anodized, brushed aluminum case is adorned only by an on-off switch and graceful cooling vents on the sides.

In their continuing effort to manufacture a state-of-the-art amplifier, Madrigal Audio Laboratories recently released the Mark Levinson No. 20 monaural reference amplifier. While very similar in appearance to the ML-2, it has added power and re-engineered circuitry for the best possible sonic performance.

Product: Mark Levinson ML-2 Amplifier

Manufacture: Madrigal Audio Laboratories Inc.

Design Credit: Tom Colangelo, engineer

Date: Introduced in 1976

Apt Holman P-2 Stereo Preamplifier

The Apt P-2 is a lower-cost model of the Apt P-1, a critically acclaimed preamp considered by many audiophiles to be one of the finest available. It is an excellent input source for power amplifiers, such as those manufactured by McIntosh and Mark Levinson. The P-2 contains most of the highly touted engineering features of the P-1 which were developed by the engineer of both products, Tomlinson Holman. Before becoming a principal at Apt, Holman was chief electrical engineer at Advent Corporation. He is currently chief technical director at Lucas Films.

Elegance is immediately apparent in the understated styling of the P-2. The name of the manufacturer, Apt, is also the most appropriate term to describe this product's design.

Product: Apt P-2 Holman Stereo Preamplifier

Manufacture: Apt Corp.

Design Credit: Frank Kampman and Tomlinson Holman, engineers; Charles Rozier, industrial designer

Date: Introduced in 1983

Apogee Full-Range Ribbon Speaker System

The Apogee Full-Range Speaker System uses ribbon speakers, traditionally used only for tweeters, to reproduce the full range of the audible spectrum. Ribbon speakers generate sound differently than traditional cone speakers and have unique sonic properties not obtainable with cone speaker designs. With a current retail price of $8,000, Apogee's ribbon speakers are clearly designed for serious audiophiles for whom money is no object. The expensive price tag is not without its reward — some audio reviewers claim that the Apogee is the finest speaker made.

Ribbon technology frees speaker design, both visually and sonically, from the conventional box design required by cone speakers. An imposing monolith with nonrectangular, radial-shaped front panels, the Apogee fuses fifties styling with a futuristic, sculptural face.

Product: Apogee Full Range Ribbon Speaker System

Manufacture: Apogee Acoustics Inc.

Design Credit: Leo Spiegel, chief engineer and president of Apogee Acoustics

Date: Introduced in 1981

The Apogee Ribbon Speaker is distinctive sonically and visually.

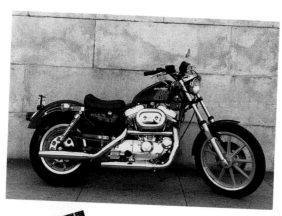

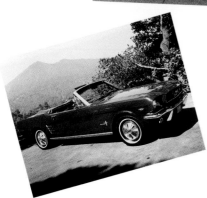

TRANSPORTATION

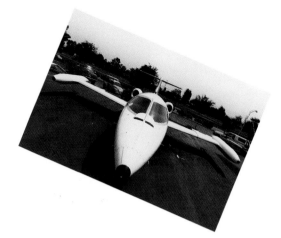

Few products are closer to the hearts of American consumers than those having to do with transportation. Our love affair with the automobile is well-chronicled by observers of the American scene, but this is not a simple infatuation with chrome, dual exhausts, or hood ornaments. In a country as large as this one is, getting from place to place involves covering great distances. For the average American, the place of greatest occupation, after home and workplace, is a vehicle.

We have confronted this situation with flair by making transportation an art form. As if all the time we spent in our automobiles were not enough, on weekends we launch the mahogany Chris-Craft for some aquatic cruising. Whether in a sleek-finned convertible or an opulently furnished Learjet, whether on a Schwinn Deluxe Hornet or a red Harley Softail, Americans love to travel in style.

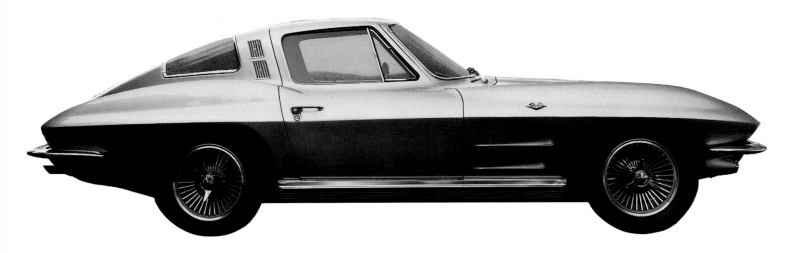

Corvette Sting Ray

The Corvette was first introduced by Chevrolet in 1953, in large part as a response to the growing popularity of the English sports cars, the MG and the Jaguar, both of which had been trickling into America in the hands of American servicemen returning from World War II. The first Corvette was made of glass-reinforced polyester resins, selected in large part to save the time and tooling costs needed to produce a conventional metal body. However, the fiberglass body soon became a design hallmark of the Corvette line.

This first Corvette has been described as a "hastily contrived, incompletely conceived, radically departing, insufficiently powered, eccentrically styled 'sports' car." Nonetheless, the Corvette had no trouble finding an accepting audience willing to live with its limitations and to ignore its problems.

The 1964 Corvette was designed by William Mitchell, GM's vice president of styling from 1958 to 1978. Mitchell was also an automotive engineer and a protegé of Harley Earl, designer of the 1953 Corvette. Zora Arkus-Duntov, a mechanical engineer who joined the Corvette research and development team in 1953, was also involved in the Corvette's development. In 1963 Duntov was assigned responsibility for the Corvette engine and chassis; in 1968 he was named chief Corvette engineer. Duntov played a major part in transforming the Corvette from, as he phrased it, "a shell with no engine; no personality" to the high performance sports car it became.

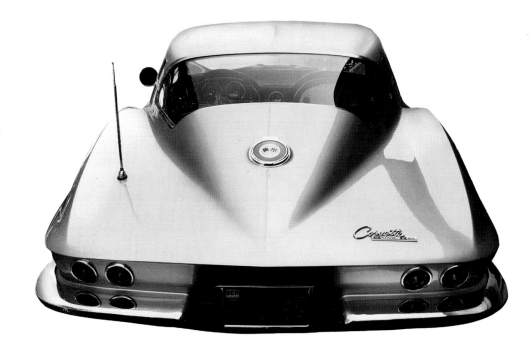

Product: Chevrolet Corvette, 1964 model, silver metallic paint, 327-cubic-inch block, 365 horsepower, 4-speed transmission

Manufacture: Chevrolet Motor Division of General Motors Co.

Design Credit: General Motors Corp. Styling: William L. Mitchell, styling director

Date: First introduced in 1953; Corvette model pictured introduced in 1964

The Corvette Sting Ray became America's sports car.

Ford Thunderbird

In 1955 the Ford Motor Company added a new car model to its line—not just any new model, but an entirely new type of car. Up until then, there had been sedans, coupes, station wagons, and sports cars. But Ford's new car, the Thunderbird, was being called something else: a personal luxury car. Combining the appearance of a sports car with the power and creature comforts of an American luxury sedan, the Thunderbird captured the hearts of Americans in a special way.

Considered one of the best examples of automotive styling in the world, the 1955 through 1957 Thunderbird model exhibits impeccable design. That the Thunderbird was a product of the fifties, a styling era ruled by extravagance and excess, makes its design all the more remarkable. Though it had sports car looks, most Thunderbirds came with power steering, power brakes, automatic transmission, and a big V-8 engine with dual exhaust and a distinctive roar. Of the 1955 through 1957 model Thunderbirds, only 21,380 were produced; the base price of the 1957 model was $3,408.

In 1958 the Thunderbird was restyled completely. A back seat was added, making the car more practical, and sales increased even further. Still promoted as a personal luxury car, the 1958 and subsequent model year Thunderbirds spawned competition from all major American car companies. The position of the personal luxury car solidified to the extent that it has become a permanent part of the American car market.

Product: Ford Thunderbird, 1957 model, gun-metal gray with black interior

Manufacture: Ford Motor Co.

Design Credit: Developed under direction of Lewis Crusoe, Ford general manager; designed under direction of Frank Hershey, Ford design director

Date: Designed 1953–1954 and introduced October 22, 1954; body style changed drastically with 1958 model

Wombat, Whizzette, Whirlicane, Jet-off, Swiftster, Hep Cat, and Ty Coon . . . are just some of the names officially considered, but ultimately rejected, by Ford for the car eventually named Thunderbird.

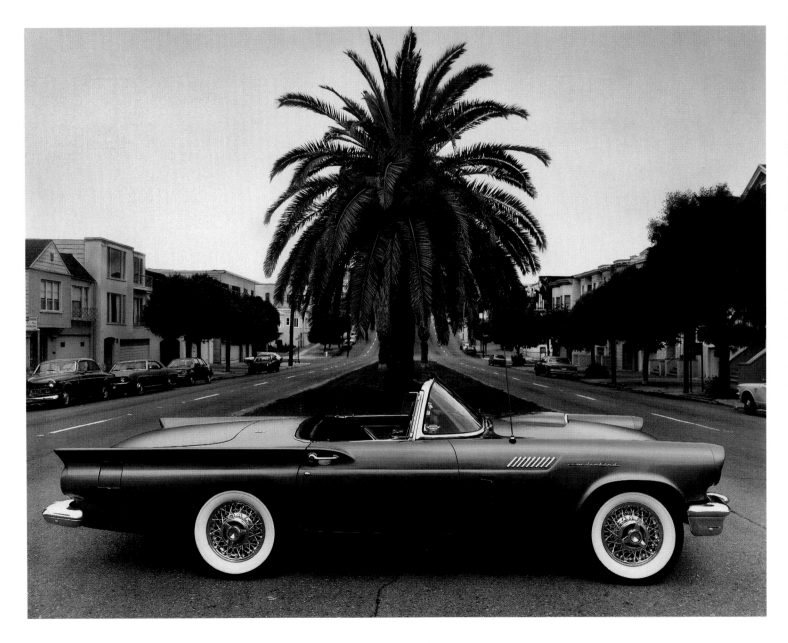

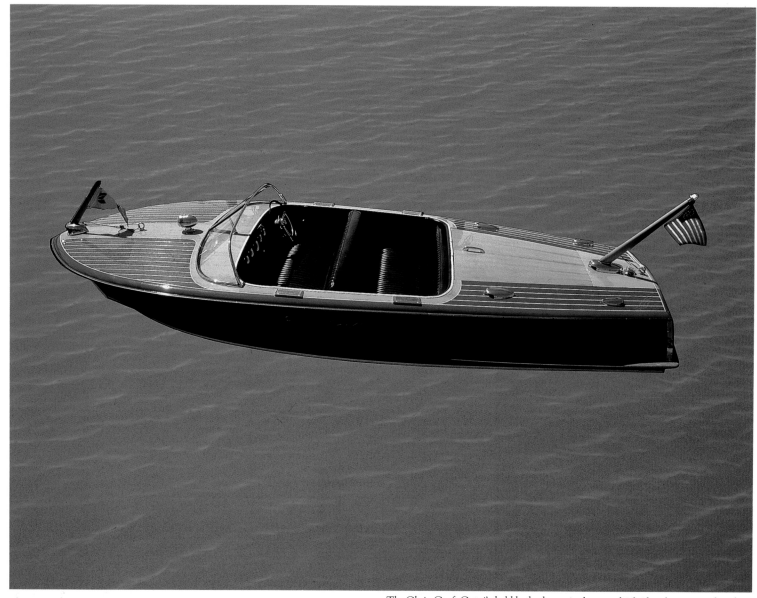

The Chris-Craft Capri's bold hydrodynamic shape and inlaid mahogany produced a classic runabout.

Chris-Craft Motorboat

Wooden boats have been superceded technologically by fiberglass, just as rotary dial telephones and tube-type amplifiers have been outdone by touch tone and the transistor respectively. Nonetheless, classic Chris-Craft wooden boats are kept alive by devoted owners who cherish their beautiful finish and distinctive style over low-maintenance, but less romantic, fiberglass boats.

The Capri model Chris-Craft, constructed of solid dark mahogany inlaid with blond mahogany to create a distinctive visual deck pattern, was produced from 1954 through 1958 and reissued in 1960 and 1961. Fewer than 1,000 Capri's were built over the entire production cycle. Chris-Craft phased out wooden boat construction in favor of fiberglass during the mid-to late sixties. They built one of their last wooden boats in the early seventies for NFL commissioner Pete Rozelle.

Few products so clearly evoke the seductive properties of wood as do Chris-Craft motorboats. The Chris-Craft successfully combines a sleek, hydrodynamic shape with the elegance of wood; its rare juxtaposition of design elements gives the product a special quality.

Product: Chris-Craft Capri 19 Motorboat, 1956 model

Manufacture: Chris-Craft Co.

Design Credit: Chris-Craft staff

Date: Introduced in October 1954

Schwinn Hornet Bicycle

The Schwinn Hornet epitomizes the styling of American bicycles. After the demise of the bicycle craze of the 1890s and the post-World War I proliferation of the automobile, the great majority of bicycles purchased in America were for children. The bicycle was relegated to secondary status for adults. Schwinn alertly realized this and began to restyle the bicycle to suit its new audience.

The Schwinn Hornet satisfies the American child's fantasies of what a bicycle should be. Its cantilever frame has a more aerodynamic profile than the diamond frame of European bicycles. It is equipped with gadgets like the Delta Rocket Ray lamp; even essentials, such as the tires, are embellished with Schwinn Typhoon Cord whitewalls. The finish is a stunning two-tone paint combination of red and cream.

The Deluxe Hornet had many features not commonly found on contemporary bicycles—the front fork has the Schwinn cyclelock and spring fork shock absorber, the tank holds batteries and conceals wiring for the horn and lamp. The Schwinn Spring Fork and shock absorbers on the seat, coupled with large tires, gave the Hornet a silky smooth ride. Its cantilever frame has been passed down to contemporary Schwinn models, such as the popular Cruiser.

Product: Schwinn Deluxe Hornet Bicycle, 1952 model, with Schwinn Cycelock and Delta Rocket Ray lamp

Manufacture: Arnold, Schwinn & Co.

Design Credit: Schwinn staff

Date: The Schwinn cantilever frame evolved from the Aerocycle of 1934 and reached Hornet's basic frame style with the Autocycle of 1936; Deluxe Hornet pictured here is a 1952 model

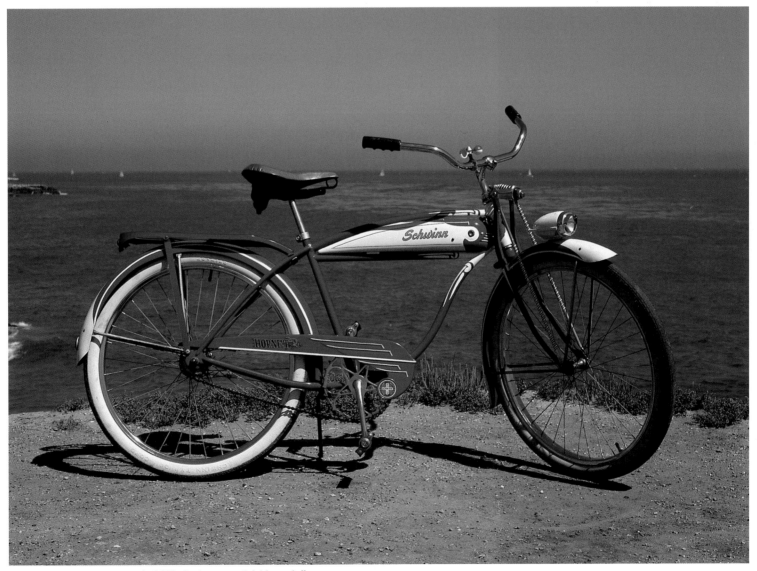

Schwinn Deluxe Hornet Bicycle fulfills the fantasies of children of all ages.

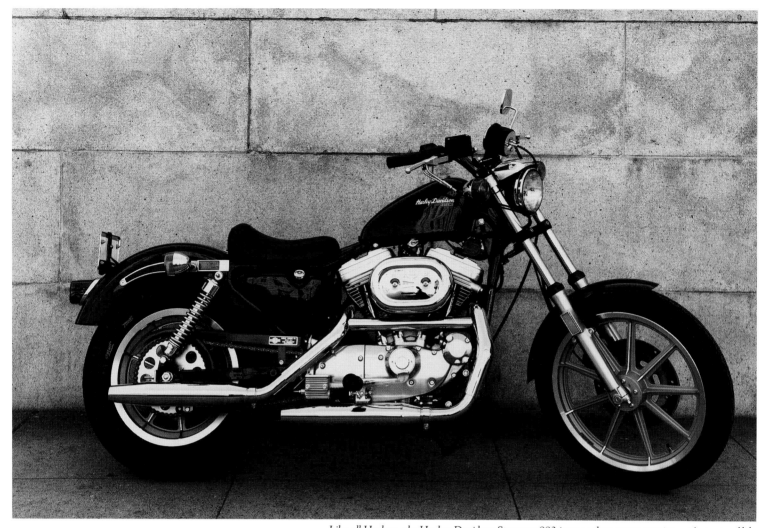

Like all Harleys, the Harley-Davidson Sportster 883 is more than transportation—it's a way of life.

Harley-Davidson Motorcycle

Harley-Davidson has been making motorcycles since 1903, when William Harley and the three Davidson brothers collaborated to produce their first bike. Harley-Davidson has persevered, facing intense foreign competition, and is the only remaining American motorcycle company (its only domestic competition, Indian, ceased production in 1953). Harley-Davidson has been immortalized in such American films as *The Wild One, Easy Rider,* and *Electraglide in Blue.*

If imitation were the primary gauge of product superiority, the Harley-Davidson motorcycle would be a major contender for top honors. Its distinctive teardrop gas tank, rakish front fork, classic twin-V engine, and unmistakable dual exhaust rumble are copied by every major Japanese bike maker. Many current Harley models are similar in styling to bikes the company made in the thirties and forties. Unparalleled in transportation manufacture, Harley-Davidson's commitment to its enduring design makes it possible to buy a new Harley today with virtually the same classic styling as its predecessors fifty years ago. That's like buying a new Cord Phaeton with all the features of a modern car.

Product: Harley-Davidson Sportster 883 Motorcycle, black

Manufacture: Harley-Davidson Motor Co., Inc.

Design Credit: Willie G. Davidson, styling vice president; Louis Netz, designer

Date: Sportster 883 introduced in 1985; first Harley bikes with Sportster name introduced in 1957; first Harley-Davidson introduced in 1903

Learjet Aircraft

Since the first Learjet was produced in 1965, it has represented the ultimate in business and personal aircraft. Developed by William Lear, a longtime leader in aircraft systems development, the Learjet was the first jet aircraft developed specifically for the corporate market. Lear developed the first successful jet autopilot in 1950 and saw a need for turbojet-powered aircraft for business aviation. Preliminary design studies for the first Learjet were conducted in Switzerland; some airframe components for it were borrowed from the F-16 jet fighter-bomber.

Learjet aircraft hold numerous aviation records. Neil Armstrong, the astronaut, set five aviation records with his Learjet 28. During the American bicentennial in 1976, pro golfer Arnold Palmer and crew flew around the world at a record-setting pace in a Learjet 36. The Learjet has one of the most distinctive profiles of any aircraft. In commercial aircraft design its sleekness is rivaled only by the Concorde. A direct descendant of the original Learjet 23, the Learjet 25D has a cruise speed of 510 miles per hour and is certified to fly as high as 51,000 feet.

Product: Learjet 25D Aircraft

Manufacture: Originally manufactured by Lear Jet Corp.; currently by Gates Learjet Corp.

Design Credit: Developed under direction of William Lear, founder and president of Lear Jet Corp.

Date: Design studies began in early 1960s; first Learjet introduced in 1965; Learjet 25 introduced in 1968

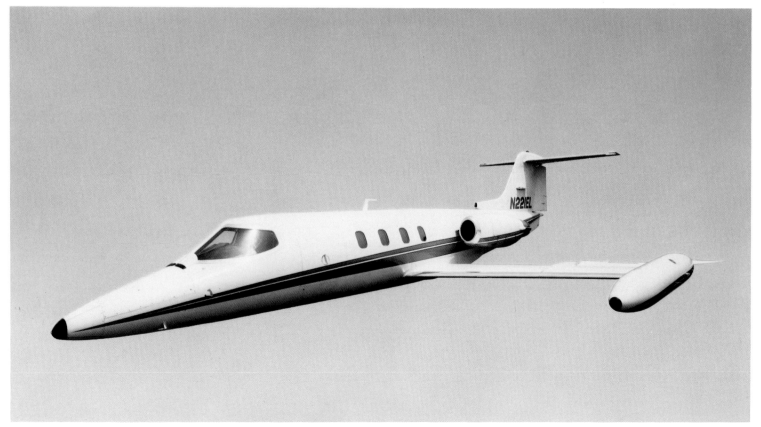

Learjet produces the ultimate in business jets.

Ford Mustang

When the Mustang was introduced in 1964, it was the first of the pony cars. An unbridled success, the Mustang struck just the right chord in the American car market. Lee Iacocca, the primary force behind the development of the Ford Mustang, was pictured with a red Mustang hardtop on the cover of the April 20, 1964 issue of *Newsweek,* three days after the Mustang's release. Sales of the Mustang exceeded all expectations; it immediately became the third most popular nameplate in America behind Ford and Chevy full-size sedans.

The Mustang's success—more than 2 million Mustangs were sold by the end of 1966—can be attributed to its relatively low price coupled with its sporty looks and a long option list. While a base model could be had for very little ($2,368, fob Detroit in 1964), the buyer could customize it into as elaborate and expensive a car as the pocketbook allowed. This was America's idea of a "people's car." (The "people's car" was, in fact, originally an American concept; Ferdinand Porsche was inspired by Ford's Model T to create a people's car for Germany—the Volkswagen.)

The Mustang's design is a modern classic. In fact, the car became a collectible almost as rapidly as it broke sales records. Never before had a car with the Mustang's cachet been this affordable— a fantastic marketing coup for Ford.

Product: Ford Mustang, 1966 model, candy apple red with red interior, convertible

Manufacture: Ford Motor Co.

Design Credit: Ford Motor Co. Design Center: Eugene Bordinat, Vice President Product Planning & Design; Joseph Oros; L. D. Ash; D. C. Woods; John Najjar; J. B. Foster; R. H. Wieland

Date: First introduced April 17, 1964; original styling remained in production with minor changes through 1966 model year

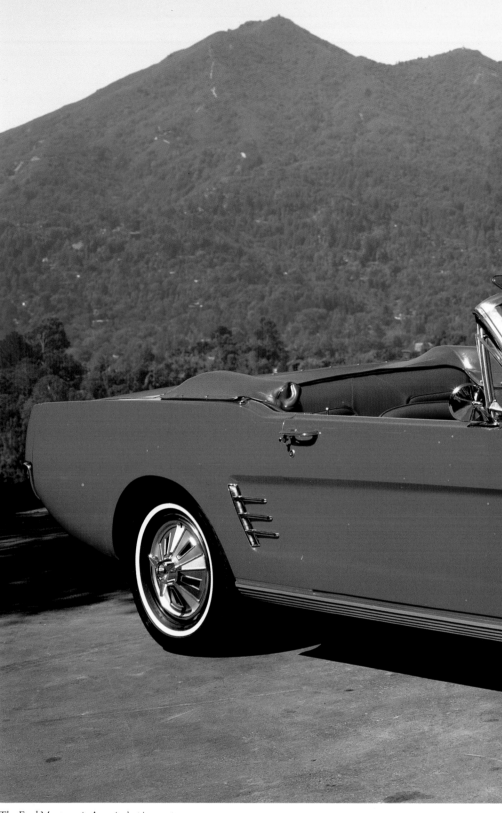

The Ford Mustang is America's pioneer pony car.

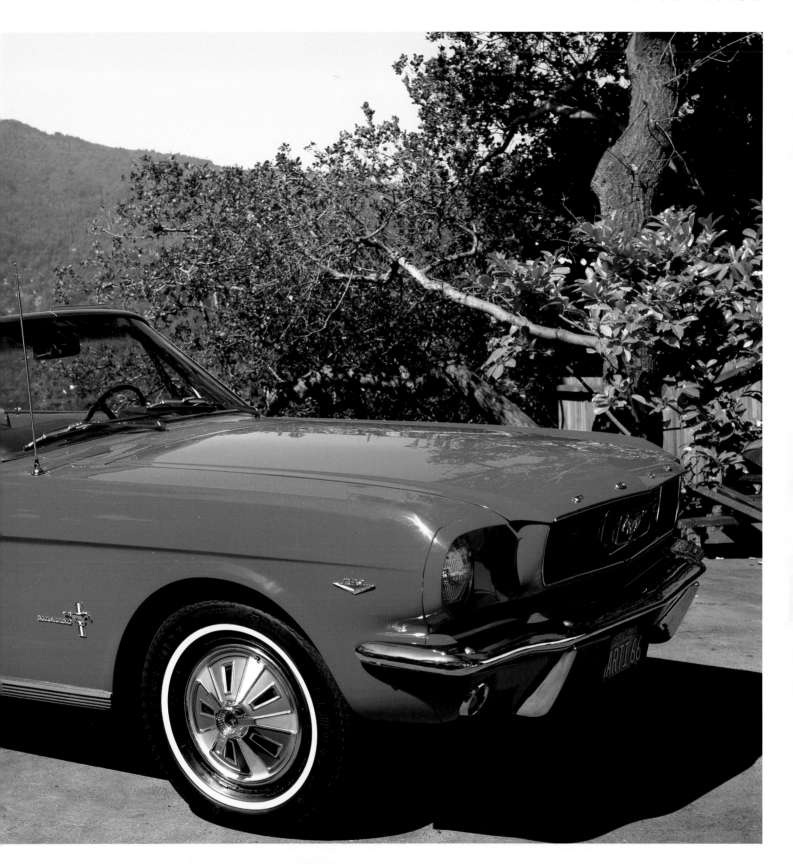

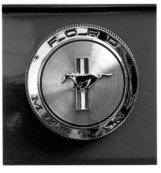
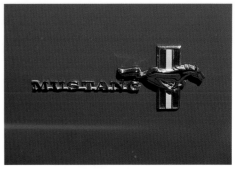

The Mercury's styling makes it the Darth Vader of outboard motors.

Mercury Outboard

Carl Kiekhaefer, the founder of Mercury, began his career in 1939 repairing defective outboard motors made by another manufacturer. By 1947 Kiekhaefer had established Mercury Marine and introduced the 10 horsepower Mercury Lightening, which outperformed competitive outboards rated twice as powerful. Mercury's reputation continued to grow; today the company claims more than a hundred major innovations and firsts in outboard technology. In addition to engineering achievements, the Mercury outboard line maintains a distinctive styling tradition that features a slender, aerodynamic profile and classic black-and-silver paint.

The Mercury 20's tiller-shift control, introduced by Mercury in 1979, combines steering, gear shift, throttle, and stop in a single control. Other features include thunderbolt ignition, EDP painting process for added corrosion resistance, and shallow water drive for maneuvering in water too shallow for normal outboard operation.

Product: Mercury 20 Outboard Motor
Manufacture: Mercury Marine
Design Credit: Mercury Marine staff
Date: Introduced in 1980

Jeep Cherokee

The stunning Jeep Cherokee, whose current body style was introduced in 1983, is one of the contemporary progeny of the famed Willys Jeep of World War II. Although Willys-Overland, later purchased by AMC, gained renown for its production of the Jeep—*jeep* is Army lingo for "general purpose" vehicle—Willys was only one of three companies producing Jeeps for the military during the war. The other two companies were Ford and American Bantam Car Company. The first prototype was built by Bantam; the Jeep that resides in the Smithsonian is a Bantam product. Willys and later the Jeep division of AMC produced a four-wheel drive vehicle in the classic tradition of the Army Jeep for consumer use.

The American passion for off-road vehicles and for towing leisure time vehicles like boats and campers contributes to the continued success of the Jeep Cherokee. The Cherokee combines the comfort of a sedan or station wagon with workhorse engineering features: Command-Trac (two-wheel to four-wheel shifting without stopping), Trac-Lok differential, and towing packages designed to accommodate specific trailer weights.

Product: Jeep Cherokee, 1984 model, 4 x 4, dark gray metallic, Selec-Trac transmission
Manufacture: Jeep Corp./Div. of American Motors
Design Credit: American Motors design staff: Richard A. Teague, vice-president
Date: Introduced in 1983

The essential American vehicle for the great outdoors— the Jeep Cherokee—is equally suited to the freeway.

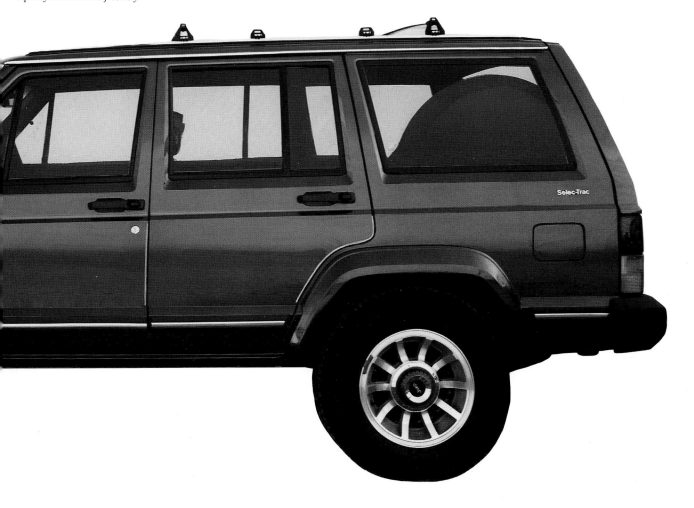

PERIODICALS

Americans have always relied on various types of communication to keep in touch culturally and politically with the rest of the nation. Few products have had the cultural significance of magazines in this regard, particularly in the era predating television, as a common source of information about what other Americans were doing, thinking, wearing, or saying. While the daily newspaper reached only the local and regional area in which it was published, magazines were subscribed to nationwide, in some cases by millions of readers.

Magazines like those included here provided a common cultural experience for the farm couple in Kansas and the corporate president in Manhattan. Though not products in any objective sense, they are objects of design in that they are packaged to have visual appeal, just as other products are, and are marketed in the same ways.

Periodicals

The Saturday Evening Post was founded less than four decade. after the American Revolution, over a century before its covers became a showcase for the illustrations of Norman Rockwell. The *Post* had already been in existence for 46 years when the firs *Harper's Bazaar* was published in 1867. *Harper's* catalogued the latest fashion trends and social events both nationally and world-wide. Shortly before the turn of the century, *Harper's* was joined by *Vogue* and then by *Vanity Fair* in 1914. The *National Geographic Society* and the first issue of *National Geographic* began to bring the wonders of the world to the American doorstep in 1888.

Time, founded in 1923, became the first national weekly with in-depth analysis of American and international news. In the thirties, *Time's* dynamic editor, Henry Luce, set out to create a special new publication based on the increasingly pervasive medium of photography. His brainchild, *Life,* pioneered the American photo-essay. It became during the pretelevision era a thread that wove American culture together. The midtwentie saw the advent of *The New Yorker,* a magazine containing seriou literature, intellectual cartoons, and a calendar of New York events.

Esquire, which began publication in 1933, devoted itself to the stylistic and substantive interests of the American male. For years it was *the* men's magazine. When *Playboy* was launched in the midfifties, men's magazines changed forever. *Playboy* brought together the unlikely combination of female anatomy and serious journalism for the first time.

The proliferation of television in the fifties and sixties provided intense competition for the national audience that magazines had previously dominated. Although television severely curtailed the circulation of mass-appeal, national magazines, most of those represented here have found a way to survive—even thrive—in the nineteen eighties. The others survive only in our collective memory.

Product: Harper's Bazaar: January 1933

Manufacture: Harper's Bazaar, Inc.

Design Credit: Arthur H. Samuels, editor; cover by Erté

Date: First issue published in 1867

Product: Vanity Fair: February 1926

Manufacture: Condé Nast Publications Inc.

Design Credit: Frank Crowninshield, editor; Heyworth Campbell, art director; cover design by Fish

Date: First issue published in 1914

Product: Vogue: January 1966

Manufacture: Condé Nast Publications Inc. (American Vogue)

Design Credit: Diana Vreeland, editor-in-chief; Priscilla Peck, art director; cover photo by Irving Penn

Date: First issue published in 1892

Product: Life: November 23, 1936, vol. 1, no. 1

Manufacture: Time Inc.

Design Credit: Henry Luce, John Shaw Billings, Daniel Longwell, editors

Date: First issue published November 23, 1936

Product: Saturday Evening Post: March 4, 1944

Manufacture: Curtis Publishing Co.

Design Credit: Arthur W. Kohler, manager; cover illustration by Norman Rockwell

Date: First issue published in 1821

Product: National Geographic: February 1937

Manufacture: National Geographic Society

Design Credit: Gilbert Grosvenor, editor

Date: First issue published in 1888

Product: Esquire: July 1952

Manufacture: Esquire Inc.

Design Credit: David Smart, editor and publisher; George Samerjan, art director

Date: First issue published in 1933

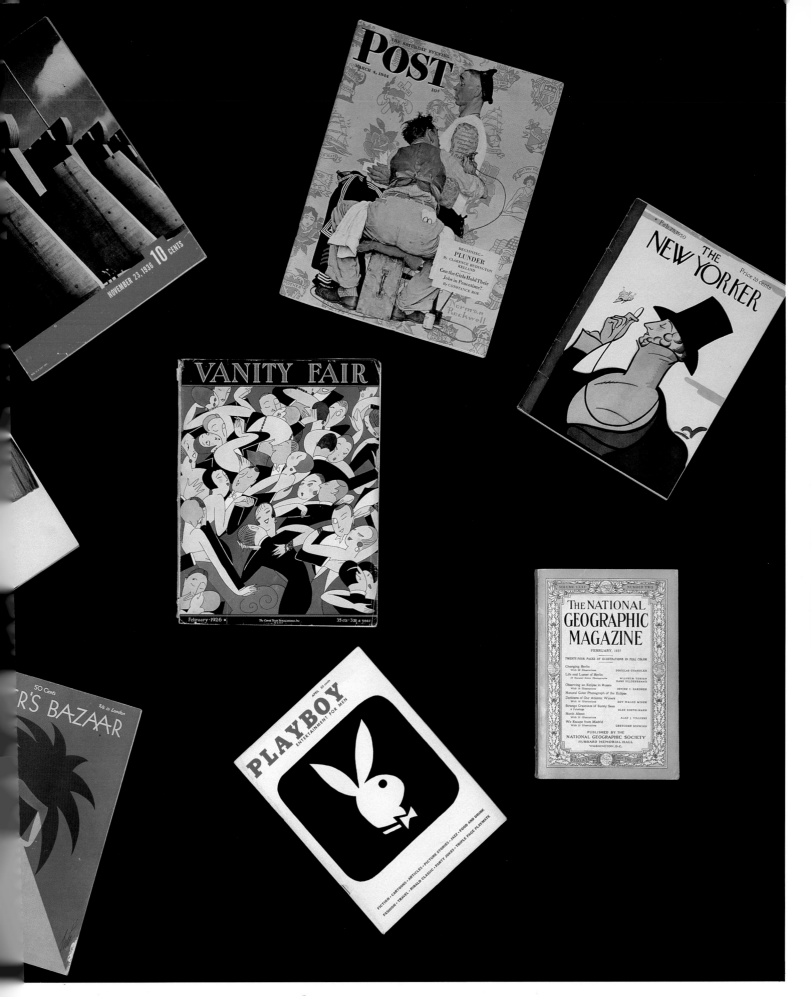

Product: Time: January 2, 1933

Manufacture: Time Inc.

Design Credit: Henry Luce, editor

Date: First published 12 March 1923

Product: Playboy: April 1956

Manufacture: HMH Publishing Co., Inc.

Design Credit: Hugh Hefner, editor and publisher

Date: First issue published in 1954

Product: The New Yorker: Feb 25, 1950

Manufacture: The New Yorker Magazine, Inc.

Design Credit: R. H. Fleischmann, president

Date: First issue published in 1925

SELECTED BIBLIOGRAPHY

The following list is an abbreviated selection of reference sources I used while researching this book. The primary source of information came directly from the various manufacturers and included product information and literature, clippings and excerpts of magazine articles in the company archives, annual reports, and so on.

Bayley, Stephen. *In Good Shape: Style in Industrial Products, 1900-1960.* New York: Van Nostrand Reinhold Co.,1979.

Cornfeld and Edwards. *Quintessence: The Quality of Having It.* New York: Crown Publishers, 1983.

Friedman, William, ed. *Twentieth Century Design: USA.* Buffalo: Albright Art Gallery, 1959.

Greenberg, Cara. *Mid-Century Modern.* New York: Harmony Books, 1984.

Greif, Martin. *Depression Modern: The Thirties Style in America.* New York: Universe Books, 1975.

Hall, Phil. *Fearsome Fords 1959-73.* Osceola: Motorbooks International, 1982.

Hiesinger and Marcus, eds. *Design Since 1945.* Philadelphia Museum of Art: 1983.

Industrial Designers Society of America. *Design in America.* New York: McGraw-Hill, 1969.

Jervis, Simon. *Dictionary of Design and Designers.* Middlesex: Penguin, 1984.

Katz, Levering, and Moskowitz, eds. *Everybody's Business: An Almanac.* San Francisco: Harper & Row, 1982.

Kron and Slesin. *High-Tech.* New York: Clarkson Potter, 1980.

Landau and Phillippi. *Airstream.* Salt Lake City: Peregrine Smith Books, 1984.

Langworth, Richard. *The Thunderbird Story: Personal Luxury.* Osceola: Motorbooks International, 1981.

Loewy, Raymond. *Industrial Design.* Woodstock: Overlook Press, 1979.

Marquette, Arthur. *Brands, Trademarks and Good Will.* New York: McGraw-Hill, 1967.

Newhall, Beaumont. *The History of Photography.* New York: Museum of Modern Art, 1964.

Sadie, Stanley, ed. *New Grove Dictionary of Musical Instruments.* New York: Macmillan Press, 1984.

Schaefer, Herwin. *Nineteenth Century Modern: The Functional Tradition in Victorian Design.* New York: Praeger Publishers, 1970.

Sparke, Penny. *Consultant Design: The History and Practice of the Designer in Industry.* London: Pembridge Press, 1983.

Time-Life Books, eds. *Color: Life Library of Photography.* New York: Time-Life Books, 1970.

Wallance, Don. *Shaping America's Products.* New York: Reinhold Publishing, 1956.

Whitney Museum of American Art. *High Styles: Twentieth Century American Design.* New York: Summit Books, 1985.

Wilson, Terry. *The Cart that Changed the World.* Norman: University of Oklahoma Press, 1978.

AMERICAN SPECIFICATIONS

Dynalite D805 power pack

Lowel tota-lights

Photogenic mini spot

The following American products played a major role in the production and design of *American Style:*

Photography

Deardorff 4 × 5 Special View Camera
Lowel Lighting
Dyna-Lite Electronic Strobe Lighting
Kodachrome 64 and 25 Professional 35mm films
Polaroid type 55, 552, 559 professional films
Beseler 45MXII enlarger chassis with Aristo cold light head

Writing, Organization, Correspondence, Research

Macintosh 512K personal computer with Microsoft File, MacWrite, and MacPaint software.

Typography

American Style was typeset in *Goudy Old Style* (Designer: F. W. Goudy, American Type Founders, 1915) and *News Gothic* (Designer: Morris F. Benton, American Type Founders, 1908).